DRAW LIKE AN EXPERT
IN 15 EASY LESSONS

LEARN PENCIL AND PASTEL TECHNIQUES THROUGH STEP-BY-STEP PROJECTS WITH 600 PHOTOGRAPHS

SHEILA COULSON

southwater

This edition is published by Southwater, an imprint of Anness Publishing Ltd,
108 Great Russell Street, London WC1B 3NA; info@anness.com

www.southwaterbooks.com; www.annesspublishing.com

Anness Publishing has a new picture agency outlet for images for publishing, promotions or advertising.
Please visit our website www.practicalpictures.com for more information.

© Anness Publishing Ltd 2014

A CIP catalogue record for this book is available from the British Library.

Editorial: Sally Harding, Nicole Foster, Janet Slingsby, Caroline Smith
Design: Keith Davis
Design production: Steve Rowling
Production: Harriet Maxwell
Photography: Andrew Sydenham
Index: Marie Lorimer

PUBLISHER'S NOTE

Although the advice and information in this book are believed to be accurate and true at the time of going to press, neither the authors nor the publisher can accept any legal responsibility or liability for any errors or omissions that may have been made nor for any inaccuracies nor for any loss, harm or injury that comes about from following instructions or advice in this book.

Contents

Introduction 4 • Getting started 5

Introduction

Every small child draws with confidence and delight. Sadly, many people abandon their childhood enthusiasm for paper and crayons because they somehow get the idea that they "can't draw." This book will reintroduce you to the pleasures of making marks on paper, in the hope that you will discover a rewarding and absorbing hobby.

There's really no great mystique involved in drawing and the basic skills can be learned quite easily. This book will show you everything you need to know to produce expressive and confident drawings of any subject you choose, from quick sketches of a pet to detailed studies of your favorite flowers and portraits of your family. All you need is patience, enthusiasm, and a willingness to experiment and try new things. Don't be afraid to make mistakes—sometimes a happy accident adds depth and character to a drawing, and sometimes the sheer energy and expressiveness of a line carries the day.

Be prepared to look at things in entirely new ways. A keen eye is your most valuable asset, and you'll learn to draw only what you see. Be prepared also to make friends with your materials. Each new drawing medium presents its own challenges and delights, so get to know it, play with it, and feel its character and capabilities. Lastly, be prepared to experiment with different ways of drawing. The projects in this book are by different artists with varied styles. Try their approaches and then explore and discover your own unique style so you produce work that pleases and excites you.

Above all, remember you're in this for pleasure! Relax and enjoy the journey. And keep all your drawings; they'll show you how far you've traveled.

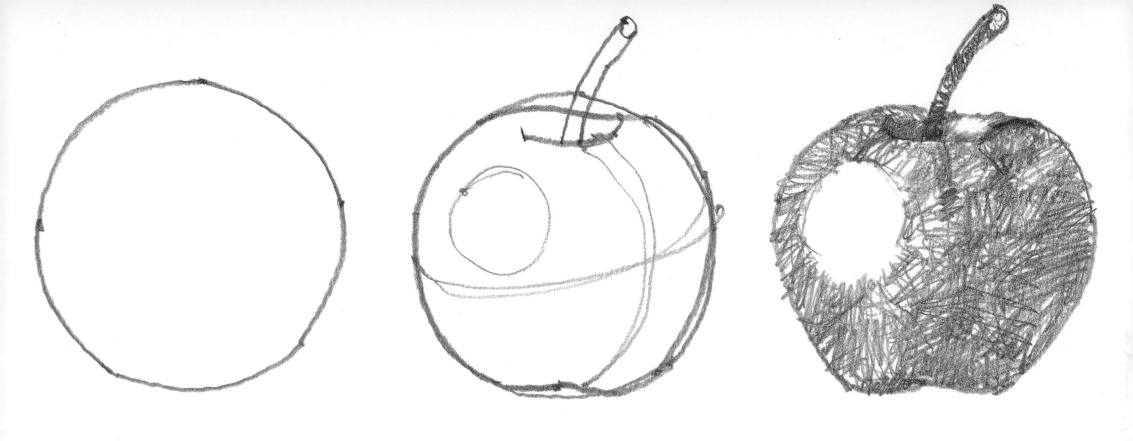

Getting started

How to use this book

You don't need any technical know-how to begin drawing—you simply need to start. The first section in this book includes some very simple techniques that will give you the confidence to put pencil to paper. Read it and refer back to it as often as necessary. The best way to learn is by doing, and to help you, this book contains 15 fully guided step-by-step projects for you to try. The projects are grouped according to subject, and each new subject is introduced with advice and techniques. Learn by following the steps and doing your own version of each project. Then you can branch out and select your own subjects.

GETTING STARTED
This section outlines the equipment you'll need when you start drawing, and introduces the mediums used in the projects in this book. It teaches you the essentials about composition and the techniques that help to make things easier—measuring, using viewfinders, looking for negative shapes, working from photographs, and using basic geometric shapes to help you tackle any subject.

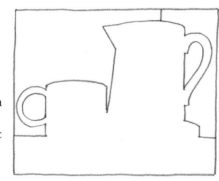

FLOWERS AND TREES
Nature provides endless inspiring subjects to study, and capturing flowers and trees on paper is one of the great pleasures of drawing. This section explains how to recognize the simple shapes inside every flower and tree. This will help you draw these subjects successfully. Three very different projects introduce you to drawing with pens, colored pencils, and soft pastels.

PEOPLE AND PORTRAITS
You don't need an in-depth knowledge of anatomy to draw figures. In this section you will discover how to measure basic proportions so you can depict adults, children, and babies accurately and convincingly. You will also learn about portraits and try out a traditional medium for figure drawing—conté crayons—to lend your works an air of the old masters.

STILL LIFE
At the start of this section, you'll find out how to set up and light an attractive arrangement of objects. Then you can get to grips with using graphite pencils, pastel pencils, and charcoal for your first drawings. You will discover the pleasure of creating a still life: you can arrange your choice of objects in a quiet corner and take your time to draw them. An ideal choice of subject!

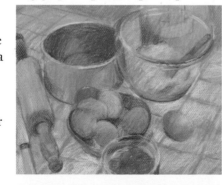

LANDSCAPE
Landscape is a hugely popular subject that can include anything from a garden to a mountain scene. Here, you will find some simple guidelines on perspective, including how to imitate the effects of aerial perspective to create a sense of distance in your pictures. Plus advice on simple perspective techniques to help you draw houses and other buildings convincingly.

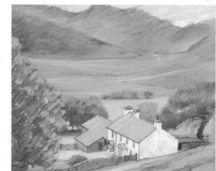

ANIMALS AND BIRDS
Tackle the varied forms of animals by identifying the simple shapes that lie beneath fur and feathers. Then enjoy discovering ways to render the varied textures of fur and feathers effectively. And complete your know-how about drawing mediums by trying out watercolor pencils.

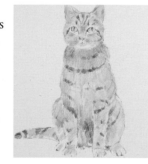

DEVELOPING YOUR SKILLS
Lastly, learn how to use your sketchbook to keep a record of your progress, to try out new techniques and mediums, and to refer to for ideas for future projects.

Are you sitting comfortably?

When you plan a drawing session, consider where you are going to work. Your drawing position is very important; if you're uncomfortable, you won't be able to relax and concentrate.

First, your drawing board should be almost vertical in front of you at the same angle as your subject. Prop it on your lap so it rests against the edge of the table or against the back of another

Make sure your board is far enough from you to allow your arm to move freely. Your arm should be comfortably relaxed but poised for action. Avoid chairs with arms that restrict movement.

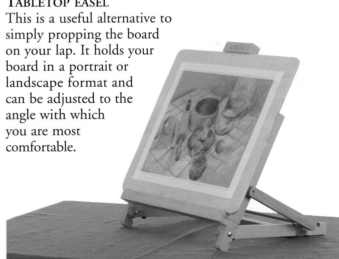

chair, or use an easel. If you place your board flat on a table, your view of your drawing will be distorted, making it impossible to sketch accurately.

Make sure that you can see both the drawing and the subject without moving your head. To do this, place yourself directly in front of the subject so you can simply glance over the top of your board and back. If you are right-handed, you could also arrange yourself slightly to the right so that you can glance past the left-hand edge of your board at the subject—still moving just your eyes, not your head. Reverse this if you are left-handed.

Finally, place a stool or small table nearby for your drawing equipment so you can reach it without changing position. Or place it on the table next to your board or easel.

FLOOR-STANDING EASEL
A fully adjustable floor-standing sketching easel holds your board at whatever angle and height you choose, whether you prefer to work standing or sitting. It is easy to position it so that you can glance at your subject without moving your head. With the drawing on a stand, you can step back from it to take stock of your progress, and it encourages you to work at arm's length, which will make your drawing freer.

Working from a photograph
If you are working from an enlarged photograph, prop the photograph up so it's at the same angle as your drawing board and you can glance from one to the other.

DRAWING BOARD
You need a good, rigid surface to draw on, so a drawing board is a must. The choice of size depends on the paper size you prefer. Fiberboard drawing boards are inexpensive and have a smooth, flat surface that

won't warp. Line your board with a spare sheet of paper to provide a slightly more receptive working surface.

TABLETOP EASEL
This is a useful alternative to simply propping the board on your lap. It holds your board in a portrait or landscape format and can be adjusted to the angle with which you are most comfortable.

Basic drawing equipment

Just a visit to an art store can be enough to inspire you to start drawing. The array of papers, drawing tools, and equipment is breathtaking and seductive. But beware! You could easily find yourself spending a small fortune on things you may never need. All you really require is something to draw on and something to draw with. You could begin drawing armed with nothing more than a graphite pencil and a piece of drawing paper.

There are, however, some extras that are necessary if you intend to take things a bit further. In this book these items are referred to collectively as "basic equipment" at the start of every "You will need" list and it will include a drawing board and the items shown below. This equipment will contribute to a pleasurable drawing session and a successful outcome. Before you buy anything, be sure to ask for advice at the art store.

A craft knife, artist's scalpel, or sandpaper block are necessary for sharpening drawing tools—don't use pencil sharpeners (see pages 28 and 37).

An eraser is not just for erasing mistakes. A soft putty eraser is good for lifting out highlights in charcoal and pastel drawings. A harder, general-purpose plastic eraser lifts off graphite pencil and burnishes colored-pencil work. Try both.

Masking tape, thumb tacks, or clips are needed to fix your drawing paper to the board and keep it stable.

"YOU WILL NEED" EXPLAINED

The box at the start of every project tells you what you'll need to complete the drawing. In addition to the items that come under the heading of basic equipment (see left), it specifies the kind of paper, and the drawing tools used, and any other special equipment needed for the project. Where a color medium is used—for example, pastels or colored pencils—the colors are given descriptive names, which are not necessarily the manufacturer's names.

Small sheets of spare paper are handy for testing drawing techniques. You will also need a large sheet of paper as a cushion for your drawing paper. Tape it to your drawing board before you start.

Fixative is necessary to protect powdery charcoal and pastel drawings from smudging. Choose an ozone-friendly product in a spray can, or use a bottle with a diffuser (see page 40).

You will need
- Basic equipment (see opposite)
- Sheet of smooth drawing paper
- 7B graphite pencil
- Colored pencils: Venetian red, vermilion, light violet, slate gray, juniper green, leaf green, lemon yellow, orange
- Putty eraser
- Long ruler

Keeping a sketchbook

A sketchbook is an invaluable tool for any artist. Between its covers, you can flex your drawing muscles and train your hand and eye to make fluent, expressive pictures. You can record family, friends, pets, occasions, and holidays. Anything you draw helps to develop your skills.

Make your sketchbook your constant companion and get into the habit of drawing something in it every day. The fact is that the more you practice, the better you'll get, and the better you get, the more your confidence will grow. Your sketchbook is the place for

quick drawings, visual notes, exploring compositions, recording details for future reference, trying out different mediums and techniques, and honing your powers of observation into the bargain. Moreover, it's a private visual journal that no one else has to see, so be spontaneous. Record anything that captures your eye, and if one sketch goes wrong, start another.

Above all, relax and have fun in your sketchbooks. And never throw them away. You'll enjoy looking back through them, remembering the people, places, and events you've sketched—and seeing how your skills have developed.

One of the artists whose work appears in this book has several shelves in his studio filled with a wonderful collection of sketchbooks that go back to his student days. He refers to them constantly for ideas, inspiration, and reference for the work that he does today. They bring back vivid memories of times, places, and occasions, too.

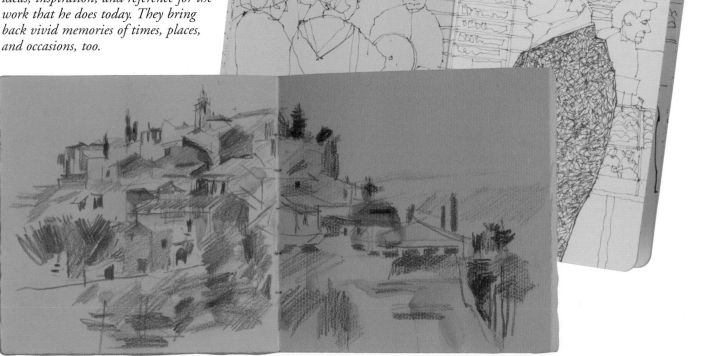

CHOOSING A SKETCHBOOK

Art stores offer such a tempting array of delicious sketchbooks of all shapes and sizes that it can be hard to know what to buy. You need to consider several things in making your choice. Different types of sketchbooks contain different kinds of paper, so select one suitable for the mediums you'll be using. Then there's the question of size; large sketchbooks give you the space to make bolder drawings or fill pages with several images, while smaller ones are easier to carry around. Lastly, consider the binding. Spiral-bound books or glued pads enable you to extract pages, while a bound book doesn't.

In all probability, and if your budget allows, you'll want to buy several sketchbooks. You can devote them to different subjects and even try one with an unusual paper— brown wrapping paper or handmade papers offer interesting possibilities.

Simple shapes—circles and spheres

The French artist Paul Cézanne is famously quoted as saying, "Treat everything in nature in terms of the cylinder, the sphere, and the cone." To this, add the cube and you have the four simple geometric shapes that will help you unlock any subject.

Everything you see, from a flower to a child, can be seen as a combination of these basic shapes. Practice drawing them, then use this approach to tackle subjects with more confidence and to draw them so they have a really three-dimensional feel.

DRAWING CIRCLES

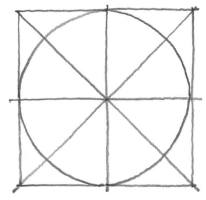

1 *To draw a convincing sphere, you first need to practice drawing circles. Draw a square, divide it into four quarters, and add the diagonals. Then draw a circle freehand, segment by segment, so that it just touches the sides of the square.*

2 *Now sketch a few circles of different sizes. Draw lightly, resting your hand on the paper and pivoting it from your wrist. Then try some larger circles with your wrist firm and moving your arm from the shoulder. Keep practicing until your circles are smooth and round.*

TURNING A CIRCLE INTO A SPHERE

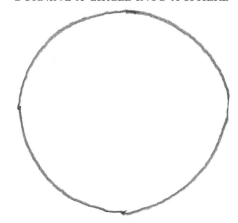

1 *First draw a circle, which is a flat two-dimensional shape with no three-dimensional form.*

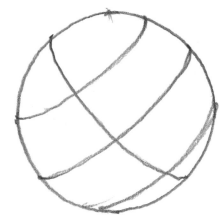

2 *Add some curved contour lines and the circle instantly gains a sense of volume and starts to turn into a sphere.*

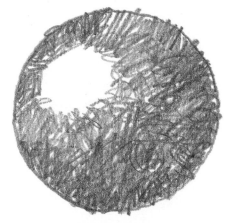

3 *For the illusion of a solid shape, add graduated shading, getting darker as it turns farther from the light.*

SPHERES IN PRACTICE

Many fruits and vegetables are basically spherical. Think of apples, oranges, tomatoes, and melons.

1 *To draw an apple, start with a large circle. Always draw the circle freehand; never be tempted to use a compass or your drawing will look rigid and mechanical.*

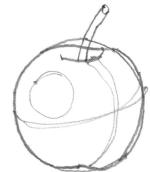

2 *Plot the position of the stalk, and establish the fruit's form with a few contour lines. Indicate the position of the highlight—the point closest to the light source.*

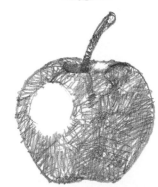

3 *Add shading, with the darkest tones where the surface curves away from the light. The white highlight indicates the direction of the light source and adds realistic sparkle.*

Simple shapes—ellipses and cylinders

You'll see many cylinders around you—a tree trunk, a can of beans, a mug, a chimney. Even human arms and legs are basically modified cylinders. Seen from straight above, the top of a cylinder is a circle. But look from a lower viewpoint and the circle flattens into an ellipse. You need to understand this changing shape and practice sketching it to draw a believable cylinder. Like circles, ellipses need to be well drawn to be convincing. They change shape and become shallower from a lower viewpoint.

DRAWING AN ELLIPSE

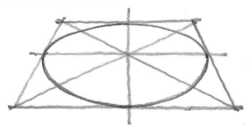

1 *Construct an accurate ellipse in the same way as the circle, but draw the square in perspective—that is, at an angle, not straight on. (For more on single-point perspective, see pages 103 and 104.) Divide the square into four and add the diagonals, then draw the curves of the ellipse so that they just touch the square.*

DRAWING A CYLINDER

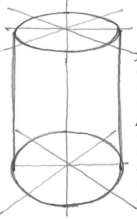

1 *Draw the sides of the cylinder first, then the ellipses, constructing them as before within squares in perspective. The base of the cylinder is seen from a higher viewpoint than the top, so the ellipses are different.*

2 *Erase the construction lines so you're left with a simple line drawing of a cylinder.*

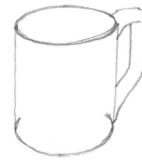

2 *Now draw a series of freehand ellipses, making them progressively shallower. Make the curves smooth and even, and keep your wrist and arm moving as you did when practicing circles on page 12. If this seems difficult at first, keep practicing. Eventually it will seem effortless.*

3 *Add shading to mold the curved surface of the cylinder. Leave a highlight and darken the tone as the sides turn progressively farther from the light.*

CYLINDERS IN PRACTICE

A simple straight-sided mug makes a good cylindrical still-life subject to practice your new skill.

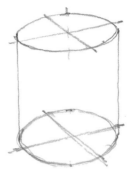

1 *Construct the basic cylinder of the mug as before. Measure the width and height of the mug to get the proportions right (see page 17).*

2 *Erase the construction lines and add the handle. Strengthen the line around the top of the mug to give a sense of the thickness of the pottery.*

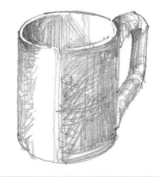

3 *Add shading to give the mug three-dimensional form. Include a highlight on the rim and shadow inside the mug. The handle is rounded, too, so shade that to suggest its form.*

Simple shapes—cones

A cone has a circular base from which it tapers to a point. Many familiar objects are basically conical in form—a fir tree, a pear, or the center of a daffodil. Other objects can be seen as modified or cutoff cones, such as a coffee pot, the head of a horse, or a lamp shade (see pages 30 and 157).

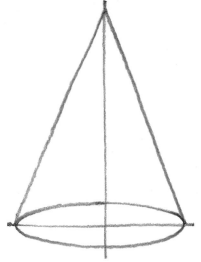

DRAWING A CONE

1 *Draw a triangle with two equal sides, using a center line to make it symmetrical.*

2 *Draw the base of the cone next. It will appear as an ellipse, the flatness of which depends on your viewpoint.*

3 *Mold the three-dimensional form with shading to lift it off the page. The highlight is triangular.*

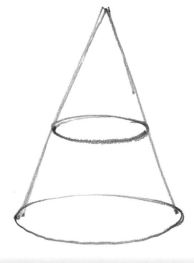

DRAWING A CUTOFF CONE

1 *To draw anything that has a cutoff cone shape, start by sketching a cone. Then use a contour line to indicate where the cutoff cone ends—this may be at the top of the cone or down below.*

2 *Remember that the top edge of a cutoff cone is an ellipse as well. Also, it will be seen at a different angle from the base, so the shape will change, as with the lamp shade study on page 31.*

CONES IN PRACTICE

A pear is basically conical in form and a good candidate for practicing the cone shape.

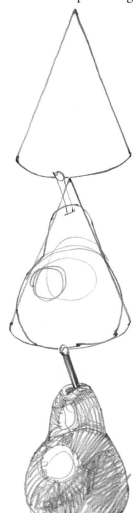

1 *Start with a cone of the right proportions; some pears are tall and thin, others short and wide.*

2 *Sketch the outline of the pear, including the stalk, so that it sits more or less within the cone. Because of a pear's irregularities, it is unlikely to fit perfectly inside the cone.*

3 *Add shading to give the pear a solid form. Often pears have a "waist," so there may be two highlights—one on the top, rounded form and one on the larger, lower section of the fruit.*

Simple shapes—cubes

It is said that there's no such thing in nature as a straight line. Nevertheless, the cube can be seen as the underlying simple geometric shape beneath many natural forms—a trimmed hedge, a green pepper, the body of a horse, or even the human torso. And then, of course, a building, a chair, a table, a television, a toaster, and many other man-made objects are basically a combination of cubes.

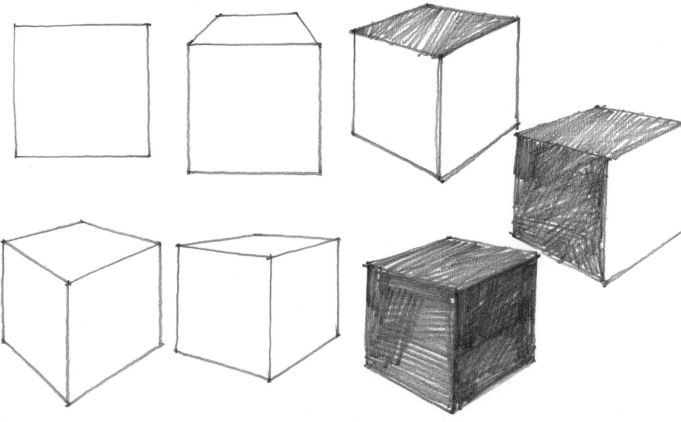

CUBES IN PRACTICE

A book, whatever its size and dimensions, is a cuboid form with sharp angles where the surfaces change direction.

1 *Represent the book as a basic rectangular cuboid form.*

2 *When the basic solid shape is in place, start to add details, such as the curved surface of the spine and the echoed curve of the edges of the pages.*

3 *Add some shading to give a sense of form. The lightest surface here is the front cover, while the spine is darkest because it faces away from the light. Using curved marks helps indicate the shape of the spine.*

DRAWING A CUBE OUTLINE
Try drawing the outline of a cube from different angles. If you look at a cube from directly in front, all you see is the front panel. As you raise your eye level, the top of the cube comes into view and it becomes a three-dimensional form. If you turn the box, you'll see two sides of the cube as well as the top. (For more on perspective, see pages 103 and 111.)

SHADING A CUBE
Practice shading a cube to give it solidity. A rounded form is described by a gradual change from light to dark as the surface turns away from the light. A cube, however, has hard angles, and the tone changes abruptly as the surfaces change direction. The light is from above and to the left of the cube here, so the lightest face is on top.

Negative shapes—another way of seeing

The instructions for the projects throughout this book often encourage you to "look for the negative shapes" to convey a subject properly. These negative shapes are the spaces between and around objects. Drawing these spaces, rather than the objects themselves, can help you capture the objects and their relationships to each other more accurately. In fact, this is a favorite technique that experienced artists use almost unconsciously as an aid.

When you try to draw a subject, your brain will often tempt you to make assumptions, to edit and draw what you *think* you know about the subject rather than what you actually *see*. Concentrating on the negative shapes forces careful observation and provides a way to check the precision of your drawing.

At first you may find it hard to ignore the objects and look only at the spaces between. However, once you become aware of the idea of negative shapes and get into the habit of looking for them, they will give a huge boost to your drawing skills. You'll see fascinating collections of abstract shapes and patterns instead of groups of objects. This approach is particularly useful for drawing complex subjects, like the human figure.

Try the exercise below to familiarize yourself with negative shapes. Copy this simple setup of three household items or use your own group of objects.

DRAWING NEGATIVE SHAPES

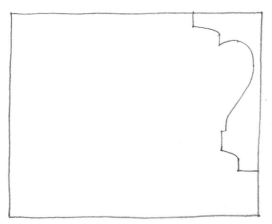

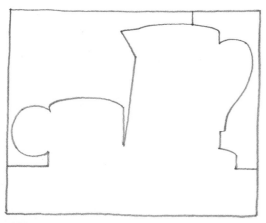

1 *Set up a small group of objects, such as a pitcher, mug, and bowl. Ignore the objects and concentrate only on the spaces between and around them. First draw a frame to contain the group; the straight sides of the frame provide helpful shapes.*
Start with the shape between the silhouette of the outermost object on the right of the still life (a pitcher handle in this setup) and the outer frame.

2 *Continue drawing the shapes between the top of the objects and the frame. Don't be tempted to look at the objects themselves, just concentrate on the interesting abstract pattern around and between them.*

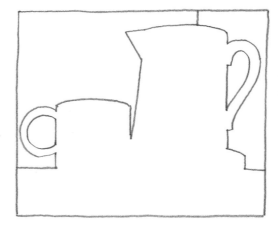

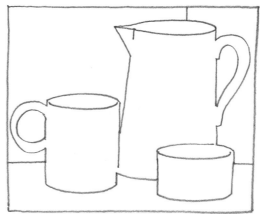

3 *The spaces inside the handles make important shapes that hint at the forms. If you draw these correctly, the mug and pitcher begin to emerge from the apparently abstract drawing.*

4 *Now draw the space below the group. With the objects correctly placed in relation and proportion to each other, the group suddenly takes on a convincing form. A few internal lines complete the drawing.*

Measured drawing

One of the keys to successful drawing is measuring. Guessing the dimensions and relative sizes of elements in a composition can lead to inaccuracies and an unconvincing drawing. The simple remedy is to take measurements at the start and keep checking as your drawing progresses. This works for any subject from a still life to a building or a landscape. Measuring is essential in figure drawing to correctly capture body proportions and the effects of foreshortening.

So stop guessing and try this easy measuring technique. All you need is a pencil and your thumb. Hold the pencil at arm's length, close one eye, and align the pencil with the element you want to measure. Then slide your thumb down the pencil to take the measurement.

You can transfer measurements to your paper in one of two ways. One method is to place your measuring pencil, with thumb still in place, on your drawing so you draw things the size that you see them. This is called drawing "sight size." Alternatively, take one key measurement—the size of a model's head, for example—and use that to check the proportion of everything else. Either system will help you achieve accurate drawings. Use the pencil to check key angles as well, like the tilt of your subject's shoulders or the angle of a roof.

Try out this measuring technique on a simple object like a table lamp. Measure with a new pencil because a used one will be too short.

HOW TO MEASURE

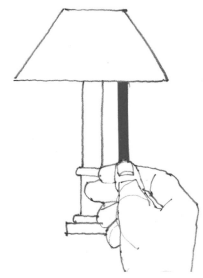
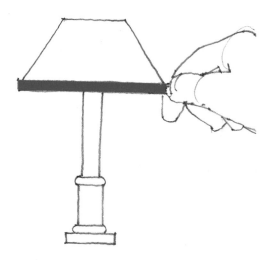
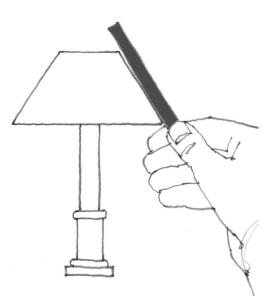
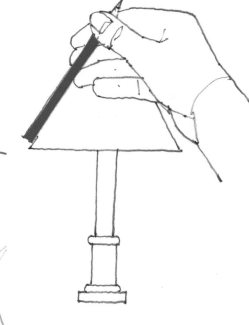

1 *Hold out the pencil at arm's length, close one eye, and line up the pencil end with the base of the lamp shade. Slide your thumb down to measure sections of the lamp base. Keeping your thumb in place, transfer the measurements to your paper.*

2 *Hold the pencil horizontally, measure the width of the base of the lamp shade, and transfer this to your drawing. Make sure you keep your arm straight with the elbow locked; if you bend your arm, your measurements won't be consistent.*

3 *Tilt your pencil, still at arm's length, so it lines up with the slope of one side of the lamp shade. Keep your pencil at this angle and lay it on your paper to transfer the right slant to your drawing.*

4 *To help make the shape of the lamp shade accurate and symmetrical, measure the angle of the other side, too, and transfer it to your drawing.*

Composition basics—the "rule of thirds"

Composition is simply the arrangement of objects within a picture area. The aim is to create a pleasing, well-balanced arrangement with visual impact that takes the eye on a journey into and around the picture. Over the centuries there have been many theories as to the ideal composition, usually based on mathematical principles of perfect proportion. However, the easiest approach to use is a simple and effective grid system known as the "rule of thirds."

A symmetrical composition in which the picture area is divided in half can be very dull. If the picture is divided into thirds in both directions, however, it is invariably more dynamic and visually exciting. You can imagine your page divided into sections, or you can draw the grid lightly on your paper before you start. Another method is to use a viewfinder divided into thirds (see page 19). The grid lines will help you position the key elements of your subject.

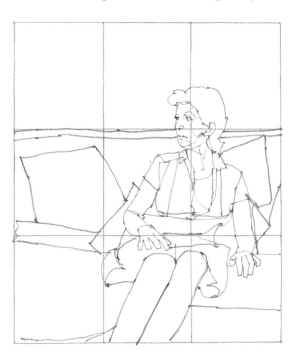

DRAWING WITH A PORTRAIT FORMAT
The portrait (upright) format of this drawing is divided into thirds both horizontally and vertically. The seated figure is centered on the right-hand vertical grid line. The viewer's eye is taken across the picture by the direction of her gaze and the slant of her legs and brought back again by the pillow, giving a sense of movement to the composition.

Placing the figure centrally within the picture area would create a less comfortable and more static composition.

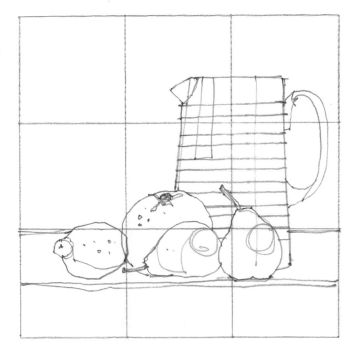

DRAWING WITH A SQUARE FORMAT
Using the "rule of thirds" is the best way to divide a square-format picture area to create an interesting and dynamic composition. The spaces around the still-life group help produce a pleasing balance.

If the pitcher were in the exact center of the picture with the fruit spread evenly around its base, the composition would be monotonous and lifeless. The viewer's eye would have nowhere to go except to the center of the image.

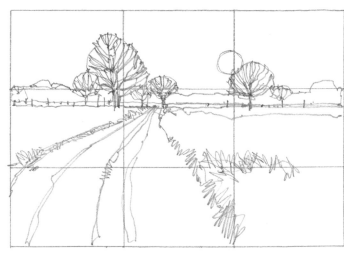

DRAWING WITH A LANDSCAPE FORMAT
The landscape format area of this drawing is divided into thirds in both directions. (A landscape format is a rectangle with the long sides positioned horizontally.)

The horizontal horizon line and the strong vertical of the large tree fall on the one-third grid lines. The path sweeps into the picture from the lower left-hand third of the picture and carries the viewer effortlessly into the scene, while the tree on the right-hand grid line stops the eye from wandering out of the frame.

Contrast this with an unexciting composition where all the main elements—the horizon, the path, and the main group of trees—are placed directly in the center, leaving the eye with nothing to explore.

Composition basics—using a viewfinder

The first important step in a drawing is to plan the composition. You need to select the main focus of the subject, decide on your viewpoint, and choose a format. Using a viewfinder helps to narrow the possibilities and makes the selection process easier. This is especially useful in a landscape. A viewfinder instantly isolates small areas of a wide vista so you can select the best option.

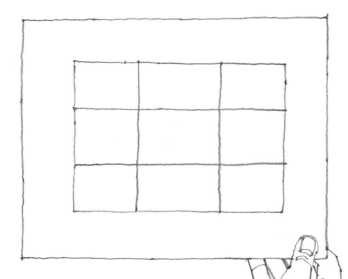

USING A VIEWFINDER WINDOW
You can make your own viewfinder by cutting a window about 4 x 6 in. (10 x 15 cm) from a piece of dark cardboard. Hold the viewfinder at arm's length, either upright (portrait) or horizontal (landscape). Shut one eye and look through the "window," moving it around until you like what you see. As an extra aid to composing the picture, you can tape threads or position elastic bands on the card to form a grid of thirds over the window, as shown above.

USING HANDS
If you don't have a cardboard frame at hand, simply position your hands to form a window. Close one eye and move your hands around, placing them closer or farther away to explore the compositional possibilities.

USING L-SHAPED BRACKETS
For an adjustable viewfinder, cut a pair of L-shapes from dark cardboard and use clips to form a frame. Adjust and reclip the pieces to change the size and format of the viewing aperture. Use this frame to scan a subject in front of you or to isolate areas in a photograph.

MAKING THUMBNAIL SKETCHES

Thumbnail sketches are tiny, quick drawings that help you try out different compositional options. It's easier to decide on format, viewpoint, cropping, horizon line, and focal point—all the things that make a pleasing composition—if you try the various options out on paper first. Thumbnails take only a few seconds, but they help you explore every aspect of your subject.

Shift your viewpoint along to the right, and the landscape looks more open and bleak.

A pencil is the easiest tool to use. Avoid detail and just block in the main shapes, indicating the dark areas to explore the tonal balance.

Move in closer and the mountains are almost obscured. The group of trees becomes the main focus.

A shift to the right and the rocks turn into the focus. The trees on the left and right now "frame" the subject.

Working from photographs

Photographs are a valuable reference for finished drawings. Your holiday photos, together with your sketchbook of course, can provide endless material for compositions once you are home. Not only that, you can use a single good photograph as a subject in its own right.

Some of the artists who created the projects in this book worked from photographs, while others preferred to work from life subjects. Unlike the human eye, the camera gives equal emphasis to everything, and subtleties of color and tone can be lost in the photographic process. However, even if you prefer to work from life, it's worth making a photographic record of your subject. You might want to return to your drawing over a period of days during which time things will alter—flowers wilt, the light changes, and skies cloud over.

Transfer your photographic subjects to your drawing by tracing an enlarged photograph (see right) or by using the grid technique (see below).

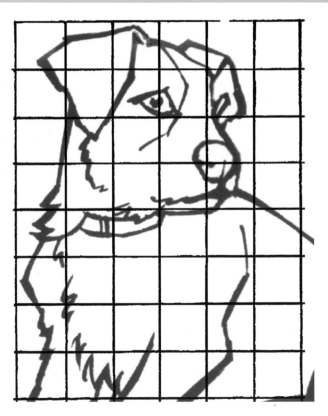

TRACING PHOTOGRAPHS

If you like, you can use an enlargement or digital printout of your chosen photograph to obtain the outlines of your subject. Trace the main elements on tracing paper and transfer them to your drawing paper with the aid of graphite paper (see page 93).

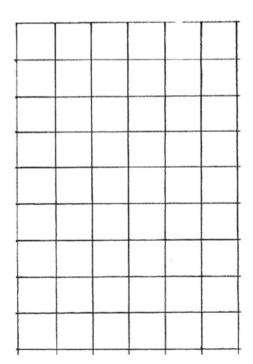

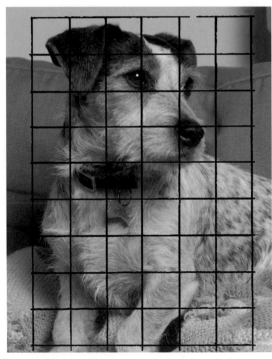

1 *To use a grid to transfer your photographic subject, first get a piece of clear acetate big enough to cover the photograph. Draw a grid of 1-in. (2.5-cm) squares on the acetate with a black pen.*

2 *Use masking tape to secure your photograph to a piece of cardboard. Then lay the acetate grid over the photograph and tape it in place. Prop this up near you at the same angle as your drawing board.*

3 *Draw a larger grid with the same number of squares on your drawing paper using light pencil marks. (Strong lines are shown here for clarity.) Copy the information you see in each square of the acetate onto the corresponding square on the paper.*

Making marks

All the drawing implements used in this book are versatile, easy to use, and inexpensive to buy. Each medium has its own characteristics and capabilities, so explore them all to find out which you like best. Some you'll feel at home with immediately; others might take a while to get used to. Take the time to make friends with each one before you tackle a project using it. Play with it, experiment, make marks, lines, and shapes. Familiarize yourself with the way it feels on the paper, sense its character, and let it show you what it can do.

Always hold your drawing tools lightly. You're making expressive drawings, not writing letters, so be free with your wrist and arm movements unless you're working in fine detail. Let the drawing tool do the work. Above all, relax and have fun!

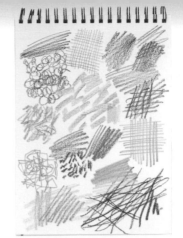

Devote a small sketchbook to your experimental mark-making. That way, you'll build up a useful library of shading techniques, color mixes, and line work for each medium.

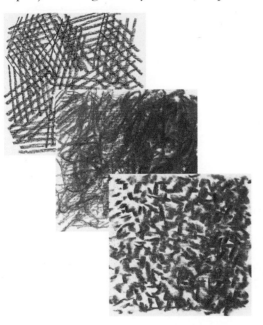

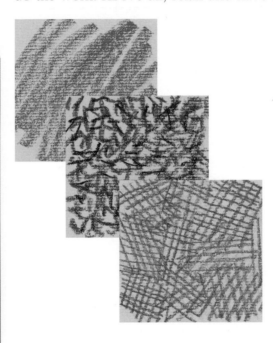

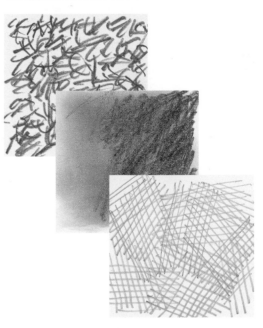

CHARCOAL
Traditional natural charcoal sticks create intense black marks that are wonderful for creating bold large-scale drawings. Charcoal pencils are slightly harder, cleaner to use, and better for finer lines and more detailed work.
For more on charcoal, see page 37.

PASTELS
Pastel is a powdery medium available as soft sticks or slightly harder pencils. Both are highly pigmented, giving a wide range of vibrant colors. You can use them to create painterly effects and color mixes on the page, as well as finer drawn marks.
For more on pastels, see pages 47 and 79.

GRAPHITE PENCILS
Graphite pencils range from very hard to very soft, giving lines that vary from fine and pale gray to bold and velvety black. A single pencil from the softer range, such as a 7B, can supply a host of different marks, textures, and shaded effects.
For more on graphite pencils, see page 28.

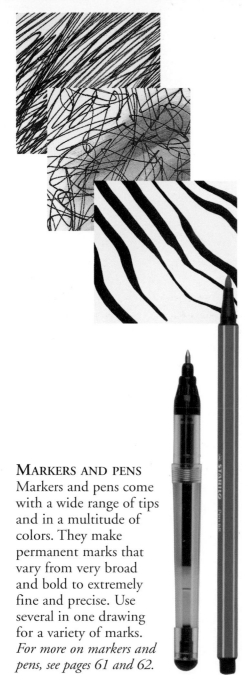

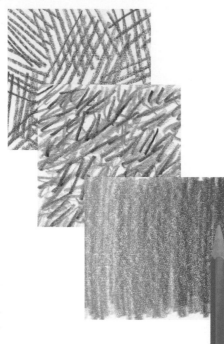

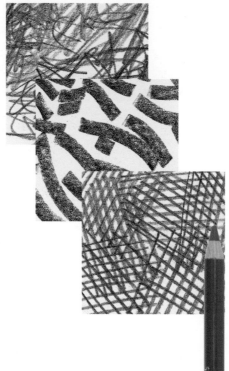

GETTING TO KNOW PAPER

There's a huge range of papers available. Base your choice on the medium you intend to use and the effects you want to achieve.

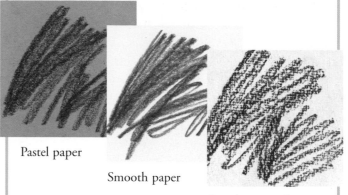

Pastel paper

Smooth paper

Rough watercolor paper

The paper surfaces above affect the look of the pastel pencil lines.

PAPERS WITH SOME TEXTURE
Papers with some texture or tooth, such as pastel paper and cold-pressed watercolor paper, suit most mediums, but especially pastels, conté, and charcoal, which need a little surface texture to hold on to the powdery particles. Limited detail can be achieved.

SMOOTH-SURFACED PAPERS
Smooth drawing papers and hot-pressed watercolor papers are good for graphite, colored-pencil, or pen work. Marks remain crisp and well-defined, and fine details are possible. These papers aren't suitable for powdery mediums like soft charcoal and pastel sticks.

ROUGH PAPERS
Papers with a pronounced texture break up marks and create surface interest in your drawing. Use them for bold work with charcoal, pastels, and soft graphite pencils, but not for detailed studies.

MARKERS AND PENS
Markers and pens come with a wide range of tips and in a multitude of colors. They make permanent marks that vary from very broad and bold to extremely fine and precise. Use several in one drawing for a variety of marks.
For more on markers and pens, see pages 61 and 62.

COLORED PENCILS
Colored pencils are clean and easy to use. There are many ranges available in a vast array of colors. They are great for subtle detailed effects, as well as broader, more emphatic marks. Some can be combined with water to make washes.
For more on colored pencils, see pages 70 and 162.

CONTÉ
The traditional conté colors are sanguine (a red-brown), brown, black, and white. They are available as square-shaped sticks or pencils, are silky smooth to use, and lend themselves to tonal studies as well as line work.
For more on conté, see page 128.

Auferstehung

Manchmal stehen wir auf
Stehen wir zur Auferstehung auf
Mitten am Tage
Mit unserem lebendigen Haar
Mit unserer atmenden Haut

Nur das Gewohnte ist um uns.
Keine Fata Morgana von Palmen
Mit weidenden Löwen
Und sanften Wölfen.

Die Weckuhren hören nicht auf zu ticken
Ihre Leuchtzeiger löschen nicht aus.

Und dennoch leicht
Und dennoch unverwundbar
Geordnet in geheimnisvolle Ordnung
Vorweggenommen in ein Haus aus Licht.

MARIE LUISE KASCHNITZ,
Schriftstellerin

DIE MENSCHEN HINTER TEXT UND BILD

MONIKA HÖFLER *1. Woche – Alles hat seine Zeit*

"Alles hat seine Zeit: Gerade beim Fotografieren ist das der Schlüssel zu einem guten Bild. Sich auf einen Ort oder Menschen einlassen braucht Zeit", sagt Monika Höfler, freie Fotografin. Ihr Fokus liegt auf Porträts und Reportagen. Dafür reist sie nach Mali, Indien oder Israel, fotografiert aber auch auf der Alm ADHS-Kinder.

INA SCHOENENBURG *2. Woche – Nicht sofort entscheiden*

Ina Schoenenburg interessiert sich in ihren Arbeiten für die gesellschaftliche Wirklichkeit. Das Wochenthema ist der freien Fotografin sehr vertraut. "Die vielen Möglichkeiten in der heutigen Zeit überfordern uns oftmals. Ich bin keine chronische Zögererin, doch ab und an bereitet mir schon ein simpler Einkauf Kopfzerbrechen — wegen des riesigen Produktangebots im Supermarkt", sagt die Berlinerin.

FRANK SCHINSKI *3. Woche – Nicht sofort drauflosschaffen*

Frank Schinski ist nahe der polnischen Grenze aufgewachsen und machte eine Ausbildung als Maurer, ehe er zur Fotografie kam. "Nicht sofort drauflosschaffen, mir fällt das schwer", meint er. Nur beim Fotografieren sei das anders: "Da finde ich Ruhe und bin im Moment — meistens." Schinski gehört zum Berliner Fotografen-kollektiv Ostkreuz.

Die Textredakteurinnen **KATHRIN ALTHANS** und **HANNA LUCASSEN** stießen auf Wortschöpfungen wie "Sofortness" und "Sofortismus" — und merkten immer wieder, dass Tempo nicht zählt bei der Arbeit am Fastenkalender. Es braucht Zeit, Geduld und Sorgfalt, die passenden Texte für die sieben Wochen zu finden. Und: Manchmal kamen die besten Ideen in den Pausen.

Kathrin Althans ist Theologin und Journalistin und arbeitet als Redakteurin beim Hansischen Druck- und Verlagshaus. Hanna Lucassen ist freie Journalistin in Frankfurt am Main und schreibt unter anderem für das evangelische Magazin chrismon.

Gib der Seele einen Sonntag und dem Sonntag eine Seele.

PETER ROSEGGER, Schriftsteller

46 / Gottes Zeit feiern

KARSAMSTAG, 15. APRIL 2017

Gottes Zeit feiern
OSTERSONNTAG, 16. APRIL 2017

Ohr sein

Die ausgetretenen Wortwege
verlasse ich,
um einzutreten
in den Raum des Schweigens.
Warten will ich,
bis die Stille
das Laute überwächst
und ich ganz Ohr werde
für Deine Gegenwart.

ANTJE SABINE NAEGELI, Theologin und Therapeutin

Impressum

Herausgeber: Hansisches Druck- und Verlagshaus GmbH, Emil-von-Behring-Straße 3, 60439 Frankfurt am Main. Telefon: 069 / 580 98-247, Fax: 034206 / 652 08, E-Mail: info@7-wochen-ohne.de. Internet: www.7-wochen-ohne.de. Geschäftsführer von „7 Wochen Ohne": Arnd Brummer. Kuratorium: Regionalbischöfin Susanne Breit-Keßler (Vorsitzende), Claudia Fischer-Appelt, Dagmar Fulle, Henning Kiene, Martin Vorländer. Projektkoordination: Frauke Grothe. Textredaktion: Kathrin Althans, Hanna Lucassen, Art-Direktion: Dirk Artes. Bildredaktion: Dorothee Hörstgen, Lena Uphoff. Grafik: Lena Gerlach. Dokumentation und Schlussredaktion: Dr. Andrea Wicke. Assistenz: Marion Schwald. Lithographie: Hansisches Druck- und Verlagshaus GmbH (HDV). Druck: Těšínská tiskárna, Český Těšín, Czech Republic.

© 2016 by edition chrismon in der Evangelischen Verlagsanstalt GmbH, Leipzig

ISBN 978-3-96038-013-9
Bestellnummer: 238013

Text- und Fotonachweise

Titelfoto: Mike Schaefer/plainpicture

1. WOCHE
Fotos: Monika Höfler – www.monikahoefler.com, Texte: (1) Lutherbibel, revidiert 2017, © 2016 Deutsche Bibelgesellschaft, Stuttgart: Prediger 3,1–4 (2) Fulbert Steffensky © 2016 Hansisches Druck- und Verlagshaus GmbH, Frankfurt am Main (3) Kurt Tucholsky, Schnipsel, in: Die Weltbühne, 28. Jg., Nr. 25, 21. Juni 1932 (4) Manfred Hinrich, gefunden in www.aphorismen.de, abgerufen im August 2016 (5) Angelo Maria Ripellino, in: Luigi Nono, Intolleranza. Handlung in zwei Teilen nach einer Idee von Angelo Maria Ripellino. Deutsche Übertragung von Alfred Andersch. Ars Viva Verlag, Mainz 1962, S. 7 (6) Hanna Lucassen, Auf einmal war es ruhig. In: Frankfurter Rundschau vom 12.12.2007 (7) Ulla Hahn, So offen die Welt © 2004, Deutsche Verlags-Anstalt, München, in der Verlagsgruppe Random House GmbH

2. WOCHE
Fotos: Ina Schoenenburg – www.inaschoenenburg.de, Texte: (8) Lutherbibel, revidiert 2017, © 2016 Deutsche Bibelgesellschaft, Stuttgart: Mt 1,18–24 (9) Fulbert Steffensky © 2016 Hansisches Druck- und Verlagshaus GmbH, Frankfurt am Main (10) www.freudenwort.de, abgerufen im August 2016 (11) Michael Ende, Momo. Schulausgabe mit Materialien, Thienemann 2005, S. 36 (12) Frank Schumann (Hg.), Luther to go. Ein trefflich Wort von Martin Luther. Eulenspiegel Verlagsgruppe, Berlin 2016 (13) Andrea Nahles in: chrismon 2/2012 (14) Elazar Benyoëtz, Filigranit. Ein Buch aus Büchern. Steidl, Göttingen 1992

3. WOCHE
Fotos: Frank Schinski – www.frankschinski.de, Texte: (15) Lutherbibel, revidiert 2017, © 2016 Deutsche Bibelgesellschaft, Stuttgart: Lk 10,38–42 (16) Fulbert Steffensky © 2016 Hansisches Druck- und Verlagshaus GmbH, Frankfurt am Main (17) Matthias Brandt in: chrismon 6/2016 (18)

© Elke Heidenreich (19) Eugen Drewermann, Der offene Himmel. Meditationen zu Advent und Weihnachten © Patmos Verlag der Schwabenverlag AG, Ostfildern, 2011, www.verlagsgruppe-patmos.de (20) Peter Horst Neumann, Pfingsten in Babylon. Die Erfindung der Schere. Gedichte, 2. Auflage in einem Band, Rimbaud Verlag, Aachen 2005 (21) Arno Geiger, Der alte König in seinem Exil. Carl Hanser Verlag GmbH & Co. KG, München 2011, S. 187, mit freundlicher Genehmigung von Carl Hanser Verlag GmbH & Co. KG

4. WOCHE
Fotos: Norman Konrad – www.normankonrad.de, Texte: (22) Lutherbibel, revidiert 2017, © 2016 Deutsche Bibelgesellschaft, Stuttgart: Mt 20,16 (23) Fulbert Steffensky © 2016 Hansisches Druck- und Verlagshaus GmbH, Frankfurt am Main (24) Johann Peter Hebel, Schatzkästlein des Rheinländischen Hausfreundes; in: Emil Strass (Hg.), Poetische Werke (Tempel Klassiker). Vollmer, Wiesbaden o.J. (25) Heinz Summerer, zitiert nach: Engel passen auf dich auf. Von unseren himmlischen Begleitern. Coppenrath, Münster 2012 (26) zitiert nach Martin Buber, Die Erzählungen der Chassidim. Manesse Verlag Zürich 2014 (27) © Peter Glaser (28) www.citta-slow.de

5. WOCHE
Fotos: Verena Brüning – www.verenabruening.de, Texte: (29) Lutherbibel, revidiert 2017, © 2016 Deutsche Bibelgesellschaft, Stuttgart: Eph 4,26–32 (30) Fulbert Steffensky © 2016 Hansisches Druck- und Verlagshaus GmbH, Frankfurt am Main (31) © Erhard H. Bellermann, Dümmer for one, Books on demand, 2003 (32) Peter Wild (Hg.), Franz Fassbind, Apokryph, Gedichte (Werkausgabe 3), Walter Verlag, Olten 1989 (33) Anatole France, Der Fall Crainquebille, © Verlag Hans Carl, Nürnberg 1951 (34) © Margot Käßmann (35) www.facebook.com/evangelisch.de, gepostet am 27.4.2016

6. WOCHE
Fotos: Max Brunnert – www.maxbrunnert.de, Texte: (36) Lutherbibel, revidiert 2017, © 2016 Deutsche Bibelgesellschaft, Stuttgart: Lk 13,6–9 (37) Fulbert Steffensky © 2016 Hansisches Druck- und Verlagshaus GmbH, Frankfurt am Main (38) Dietrich Bonhoeffer, Berlin 1932–1933, DBW Band 12, S. 445 (39) Publik-Forum, Oberursel, Ausgabe 23/2015 (40) Hilde Domin, Nicht müde werden. Aus: dies., Gesammelte Gedichte. © S. Fischer Verlag GmbH, Frankfurt am Main 1987 (41) Fee, www.facebook.com/FeePoetrySlam (42) zitiert nach: Raphaëlle Giordano, Dein zweites Leben beginnt, wenn du verstehst: Du hast nur eins! Pendo Verlag in der Piper Verlag GmbH, München/Berlin

7. WOCHE
Fotos: Katharina Dubno – www.katharinadubno.de, Texte: (43) Lutherbibel, revidiert 2017, © 2016 Deutsche Bibelgesellschaft, Stuttgart: Gen 2,1–4 (44) Fulbert Steffensky © 2016 Hansisches Druck- und Verlagshaus GmbH, Frankfurt am Main (45) Antje Sabine Naegeli, „Die ausgetretenen Wortwege verlasse ich…", aus: Dies., Umarme mich, damit ich weitergehen kann. Gebete des Vertrauens © Verlag Herder GmbH, Freiburg i. Br. 2015, S. 41 (46) Marco Fechner (Hg.): Das Zitatenbuch, Marix Verlag, 7. Aufl., 2015 (47) Marie Luise Kaschnitz, Dein Schweigen – meine Stimme. Gedichte, Claassen, Berlin 1962 © Dr. Dieter Schnebel

NORMAN KONRAD *4. Woche – Nicht sofort drankommen*

Als der gebürtige Thüringer Norman Konrad von seinem Wochenthema erfuhr, fühlte er sich ertappt: Er ist oft ungeduldig und dachte, die Redaktion hätte den Tipp von seinem Berliner Bioladen-Verkäufer bekommen. Hinter der Kamera wartet er jedoch gerne, bis er das Bild, so wie er es sich vorstellt, im Kasten hat – am liebsten bunt und mit Humor.

VERENA BRÜNING *5. Woche – Nicht sofort lospoltern*

Dieses Wochenthema sollte sich jeder zu Herzen nehmen, meint Verena Brüning. Wenn sie Menschen porträtiert, versucht sie immer, die Welt aus deren Augen zu betrachten. Dass sie unterschiedlichste Menschen und Situationen kennenlernen darf, findet sie an ihrem Beruf besonders spannend. Wird es doch mal zu stressig, macht sie die Musik laut – oder fährt ins Grüne. Sie lebt in Berlin.

MAX BRUNNERT *6. Woche – Nicht sofort aufgeben*

„Seit ich im Alltag und in meinem Bildarchiv nach passenden Motiven zum Wochenthema gesucht habe, hängt an meinem Monitor ein Klebezettel ‚Nicht sofort aufgeben‘. Ich werde ihn erst einmal hängen lassen,“ sagt Max Brunnert, der in Düsseldorf lebt und am liebsten Menschen und Geschichten fotografiert.

KATHARINA DUBNO *7. Woche – Gottes Zeit feiern*

Katharina Dubno, geboren in Königshütte/Polen, studierte Fotografie in Mainz, reiste als Couchsurferin durch Osteuropa, lebte in England und wohnt heute im Rhein-Main-Gebiet. Um Bilder aus dem Leben zu finden, braucht sie vor allem eines: „Zeit, um den Menschen offen, ehrlich und zunächst ohne Kamera zu begegnen.“

FULBERT STEFFENSKY, *Jahrgang 1933, ist einer der bekanntesten theologischen Autoren im deutschsprachigen Raum und lebt in der Schweiz. Er legte die sieben Bibelstellen aus und schrieb uns seine Gedanken zum Thema Sofort: „Ich bin ein alter Mann, und wenn es die Weisheit des Alters gibt (ich glaube nicht sehr feste daran), dann ist es die Tatsache, dass mit dem Wörtchen „sofort“ nicht mehr viel auszurichten ist. Alles braucht viele Augenblicke: das Gehen, das Aufstehen, das Antworten, das Essen, das Lesen. Man reitet im Alter langsame Pferde. Ist es ein Verlust? Ja! Keiner soll mir das Alter schönreden! Aber es gibt Verluste mit Gewinnanteilen. Ich sehe nicht mehr so viele Orte wie früher, und ich ehre die wenigen mit neuer Bedächtigkeit. Ich lese wenig, aber ich bin weniger Richter als Hörer der Texte, die ich lese. Ich reagiere mit Verzögerung und bin meinen Augenblicken weniger ausgeliefert. Ich lerne die passiven Tugenden (es bleibt mir nichts anderes übrig): die Langsamkeit, die Geduld, den langen Blick auf die Dinge und die Vorgänge des Lebens. Ich lerne, mich einzufügen, und bin immer weniger Eroberer. Ich musste das Siegen verlernen.“*

Considering color

Traditionally artists have used drawings to explore their subjects. A monochrome medium was generally used—charcoal, graphite, or conté—and a finished painting developed from these initial studies. Now, however, the boundaries between drawing and painting are blurred. A wealth of colored drawing mediums open up whole new creative possibilities for indicating mood and atmosphere as well as helping to depict objects accurately.

As with all drawing, when you work in color you must look carefully and try to reproduce what you actually see, never making assumptions. Everything has color and tone that change according to the light: for example, the shadow side of an orange is a very different color to the lit side. Look carefully at shadows, they're never just gray or black but are darker tones of the surrounding colors. And colors have subtle biases: greens can be blue-green or yellow-green; blues can be gray-blue, green-blue, or purple-blue; reds may be orange-red or blue-red.

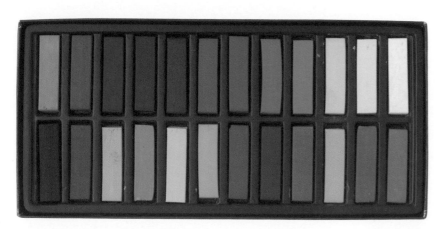

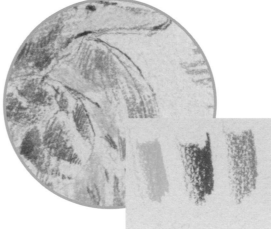

COLORED DRAWING MEDIUMS
Paint can be mixed and just a few colors can create endless shades and tones. Drawing mediums, however, rely on overlaid colors or optical mixes on the paper to achieve the right effect.

Convenient boxed sets of colored pencils, pastel pencils, and soft pastels give you a pre-selected range of the most useful colors, but there's no need to splash out on a huge set. Twenty-four colors will give you plenty of options. Too many colors can make selecting your palette difficult.

CHOOSING YOUR PALETTE
If you use too many colors in one drawing the result can be jumpy and visually unsettling. Working with a restricted palette produces a more harmonious image.

Look at your subject and identify the basic color families. In a landscape, for example, you may have both cool blue-greens and bright yellow-greens; the sky may be gray-blue or purple-blue. Look for these biases and select colors that best represent what you see. To create tonal variations, you can choose a light, medium, and dark version of each color.

THE WHEEL OF COLOR
There's no need to get too deeply into color theory, but it's worth being aware of the effects colors have on each other. Experiment a bit and you'll see that colors change their value depending on what you put them next to. A green next to a blue creates a quiet partnership. A green next to a red, however, immediately electrifies both colors—think of a poppy in a hedgerow.

A simple color wheel explains these relationships. Colors that are next to each other are called harmonious, while those that are opposite are complementary and if placed next to each other become more vibrant.

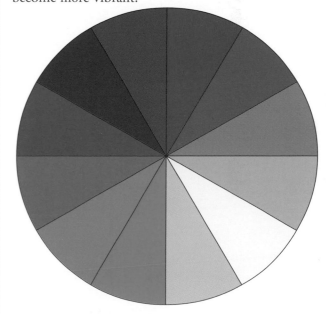

Practice juxtapositions of colors from the color wheel to see what effect they will have on each other in a drawing.

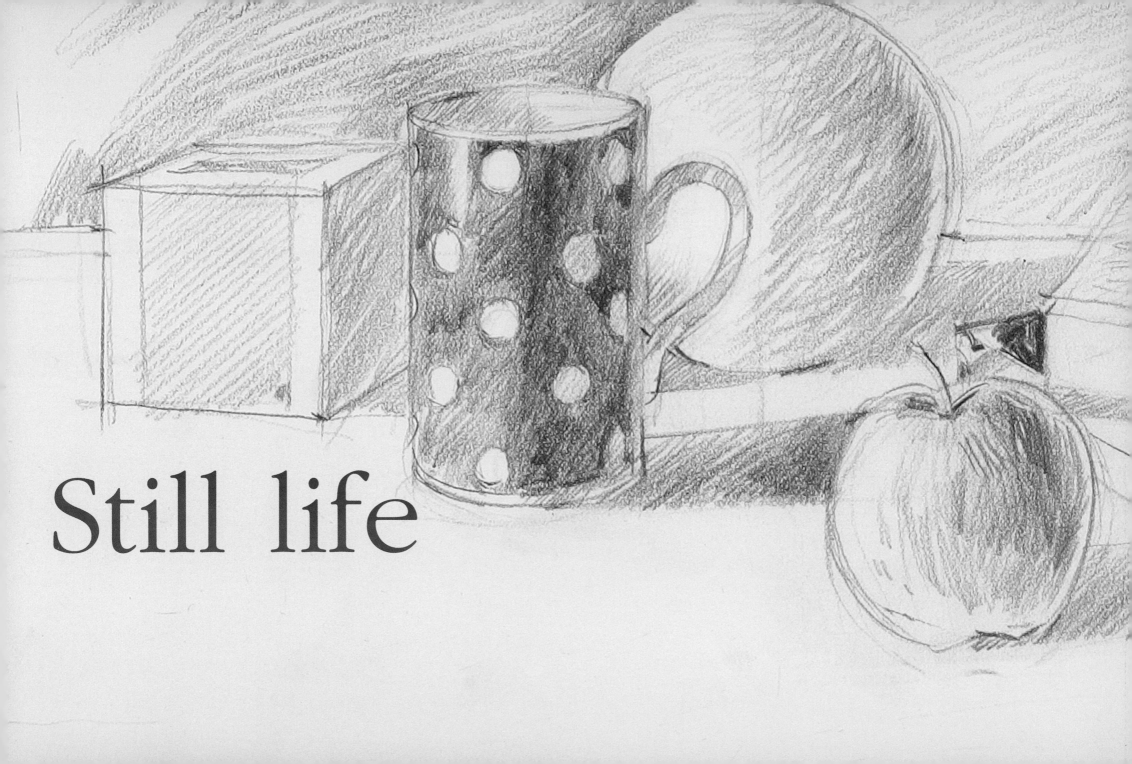

Still life

Drawing a still life

Still life—the drawing of inanimate objects—is the perfect vehicle for practicing your drawing skills and honing your powers of observation. A still life can be a study of a single intriguing object or a complex arrangement of several.

THE ADVANTAGES OF STILL-LIFE DRAWING

If you use still life as the subject of a drawing, you decide what to draw, how to arrange and light it, and what medium to use. You can experiment as much as you like and get in close to really study the chosen objects. You can also return to the same setup again and again to draw from different viewpoints and in different mediums. Notice the improvement as you get to know the subject better each time!

SELECTING YOUR SUBJECT

There are no rules as to what makes a still life—anything goes. You can compose your subject from a specially selected group of items or draw a found setup. Either approach will provide fascinating results.

For ready-made still-life subjects, just look around you. Use a viewfinder to isolate small areas around your home that might make interesting drawings. If necessary, reorganize things a little to make a pleasing composition.

Whatever inspires you to pick up pencil and paper will make a good subject. Look out for interesting shapes and textures, then get drawing!

Using a grid

If you are a new artist, the prospect of drawing a group of objects and getting their shapes and relative proportions right can be daunting. For the beginner, working with a grid provides a simple scaffold on which to construct a convincing drawing. It also helps train the eye to see things in relation to their surroundings and not in isolation. Experienced artists always use background clues to help map their subjects.

Try the exercise below a few times with different objects, then do the same thing with a simple group of two or three items. As your eye gets used to assessing shapes and their relation to one another, you will be able to translate what you see into lines on paper to create a convincing representation of your subject. Gradually, you will be accustomed to picking up clues from any setup and be able to use the information without needing a grid behind it.

USING BACKGROUND PATTERNS

Every still-life setup has some type of background, and you need to use whatever is there to help you draw accurately. There are plenty of ready-made grids that you can use as an attractive part of the composition. Place your objects on a checked or striped tablecloth, for example, and then use the pattern to help place the items precisely on the drawing paper. Or arrange your still life in front of a patterned curtain or roller shade. As your drawing progresses, keep checking the objects against the lines of this background pattern.

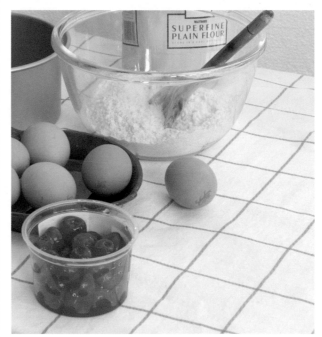

The tablecloth pattern provides a useful grid for accurately positioning objects within the drawing.

1 *Using a ruler and black pen, draw a grid of 2-in. (5-cm) squares on a sheet of paper that is big enough to provide a background for the still-life object. Using a 2B graphite pencil, draw another grid on your drawing paper; these squares can be smaller or larger depending on the size of the drawing.*

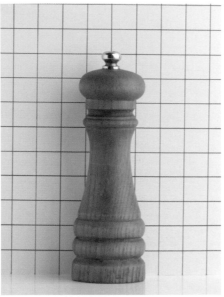

2 *Attach the first grid to a piece of cardboard and prop it up on the table so that the lines are precisely vertical and horizontal. Then place your subject on the table close to the grid. Try this exercise with a single object first and sit directly in front of it with your drawing board.*

3 *Closely observe how the object's shape sits within the background squares. Then use the 2B pencil to slowly fill in each section of the outline in the corresponding square on your drawing paper. Don't try to draw with a continuous line—use short marks for more control.*

Setting up a still life

When you decide to create a still life with a specially chosen group of objects, it is usually best to go for a linking theme rather than a totally random collection of items. You might choose things that have special significance for you or you may wish to create a kitchen theme. For visual interest, choose objects that vary in texture and shape, and don't overcrowd your setup with too many items.

Then decide on the setting. You can arrange everything on a simple tabletop or shelf, or on an interesting chair that then becomes part of the composition. Try using a viewfinder to help you decide on your final arrangement (see page 19) or consider making a triangular composition.

Keep moving the objects around until you are happy with the result. Notice how their relationship to each other changes as you move them, and observe the negative spaces between and around them. You will probably discover several arrangements that work well; just be sure that the final setup looks balanced.

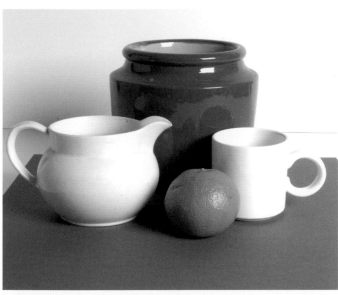

FOUR SIMPLE OBJECTS
Four simple household objects are enough to create an interesting still life. Notice the basic geometric shapes and the useful negative spaces created within and around the arrangement. The curved and straight lines make an intriguing pattern of abstract shapes, while the orange skin makes a visually interesting textural contrast to the smoothness of the ceramic objects.

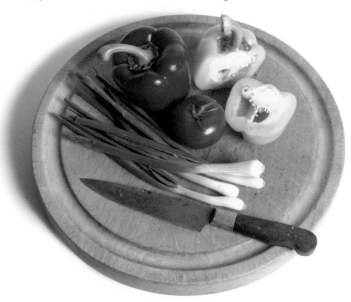

SALAD VEGETABLES
Looking down on a round chopping board provides a useful frame to help position the vegetables. The scallions and knife create strong diagonals, and the knife provides an interesting contrast with the softer, organic forms. The curve of the board is easy to plot if you relate it to the straight edges of your drawing paper—a viewfinder will help here (see page 19).

TRIANGULAR COMPOSITIONS
An imaginary triangle provides a useful frame as a starting point for your arrangement and can form the basis for a satisfying composition. Use it as a simple device to help you group your objects, not as a rigid and restricting format. The triangle can be set on its point or its base for different effects. It can be equilateral or have sides of different lengths.

Experiment and make quick thumbnail sketches (see below) as you try out alternative formats. Then use the triangle as a mental checkpoint to help you achieve a balanced but lively drawing.

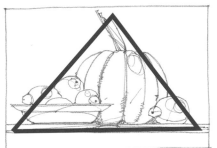

These objects sit on the base of an equilateral triangle. The eye travels effortlessly from object to object around the group.

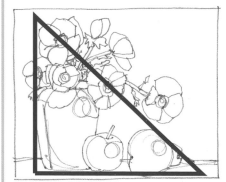

In this triangular composition the eye is drawn first to the flowers. The overhanging bloom carries the gaze to the apples at the base of the triangle and from there back to the vase.

Lighting and viewpoints

Lighting plays an important role in setting up a still life. You need a good light to see and understand forms, and strong, natural light from a window is ideal. However, the quality of daylight alters with the time of day, and the changing light will transform the appearance of your subject. So you will have to either complete your drawing before the light changes dramatically, or return to it the next day at the same time. Even then the light may vary.

For a constant and controllable light source, use a maneuverable desk lamp. You can manipulate artificial light to create strong areas of light and shade that add drama to a setup, and you can also use it to cast interesting shadows. Daylight bulbs create the most natural effects. Normal artificial light distorts color values in both subject and medium.

Move the lamp around your subject to test the effects as the light hits it from different angles. If your light source is behind the subject, a silhouette is created. Lit from the front, the subject is bathed in a general light. Neither of these light-source positions create the telling shadow areas that give clues to the forms. A strong side light, however, creates distinct areas of light and shade. If you render these accurately in your drawing, they will help you depict the three-dimensional forms convincingly. Shadows cast on the background from side lighting also add interest to the composition.

Notice how much more clearly you can see the shading and shadows in a black-and-white photo.

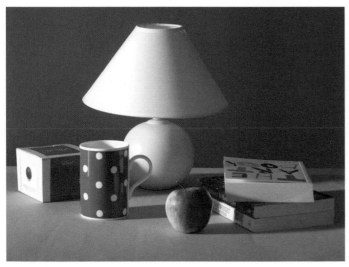

LOW VIEWPOINT
Look at your group from different angles and heights. From a low viewpoint objects are silhouetted against the background. Seen straight on, they become flat shapes, and the tops of objects virtually disappear.

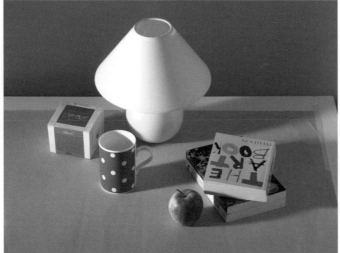

HIGH VIEWPOINT
Notice how the composition changes and becomes more or less pleasing as you change your eye level. From a high viewpoint objects are more spread out, so each is more clearly seen. Ellipses become wider at this level.

1 Household objects

simple shapes in graphite pencil

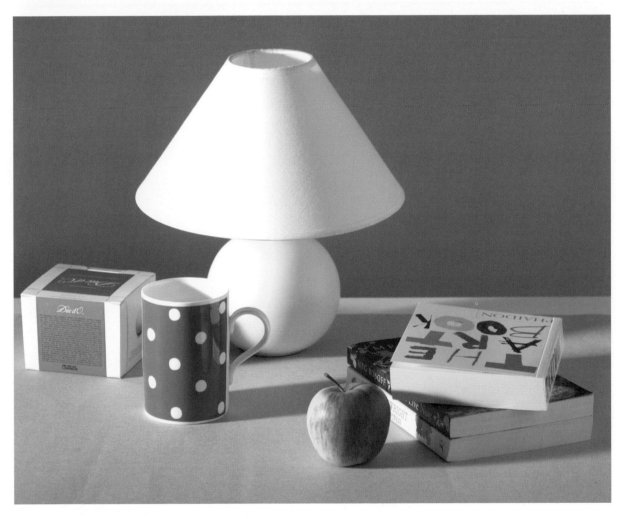

This first project will help you to recognize the underlying forms within a group of everyday objects. It is also an exercise in learning to observe, so that you put aside what you already know about an object and draw only what you see.

The items for this still life have been selected because the four basic shapes—the sphere, cylinder, cone, and cube—are easy to see. Being able to recognize the underlying geometric shapes will help you unlock your subject and make a more convincing drawing.

◀ *You'll find that all sorts of objects from around your home make ideal subjects for a simple still life.*

Using graphite pencils

Graphite pencils, sometimes misleadingly called lead pencils, were probably the first drawing tools you were introduced to as a child. They are easy to use and extremely versatile, producing marks that range from fine, pale gray lines to bold, dark areas of solid tone. This makes them suitable for all kinds of drawing, from finely detailed work to rapid, bold sketches.

Graphite pencils are graded from hard (H) to very hard (9H) and from soft (B) to very soft (9B), with HB in the center of the spectrum. The softest pencil, 9B, has a velvety black tone. The hardest, 9H, retains a sharp point to produce fine lines useful for detailed technical drawing. The softer pencils are more expressive and give a huge variety of linear and shading marks, so this range—from B to 9B—is popular with artists.

A single pencil can produce a range of tones, depending how much pressure you use. However, the darkest tone it can give is determined by the grade of the graphite—pressing down too hard won't make it any darker. You can exploit the capabilities of a single grade of pencil in one drawing, such as in the household objects still life in this chapter, or you can combine grades to create an even greater variety of marks and tones.

Artist's tip
Soft pencil smudges easily, so rest your hand on a clean sheet of paper to protect the drawing underneath. As you work around your drawing, lift the paper and reposition it—don't slide it.

SHARPENING A PENCIL

Avoid using a pencil sharpener. It tends to break the graphite and produce a short point that's so fine it cracks off or blunts at the slightest pressure. Instead, use a sharp craft knife or artist's scalpel and shave off the wooden outer shell to expose a longer area of graphite, then sharpen it gently to the kind of point you want. Twisting and turning the pencil as you draw helps maintain the tip.

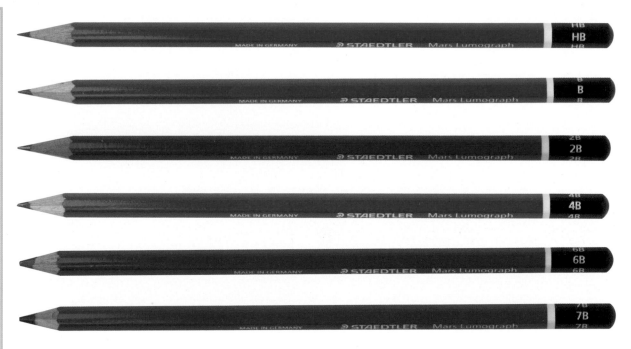

Choose pencils according to the effects you want to achieve, but avoid the hard ones because they have limited possibilities for the artist. Pencils are inexpensive, so choose several different grades and experiment to see how they perform. A good range of pencils to start with is B, 2B, 4B, and 7B.

Graphite pencil in practice

A single graphite pencil is often all you need to produce plenty of varied effects for an exciting and expressive drawing. Try it yourself with a soft pencil to see what it can do. A 7B graphite pencil was used for the strikingly different marks below. Try holding your pencil in different ways and applying varying degrees of pressure as you experiment. Use a sharp point, a blunt point, and the side of the exposed graphite to discover the pencil's versatility.

Crosshatched lines using light pressure

Shading using more pressure for darker areas

Graphite marks smudged for blended tone

HOLDING YOUR PENCIL

The way you hold your pencil influences the marks you are able to make. The closer to the tip you hold it, the more control you have—think of the way you hold a pencil when writing. The higher up the shaft you hold it, the more loosely and freely you can work.

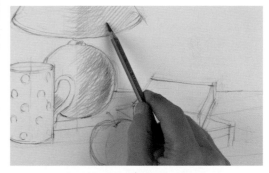

Hold the pencil far away from the point for light, loose sketching and shading.

Circular lines using point of pencil

Short linear marks using side of pencil

Stippling using point of blunt pencil

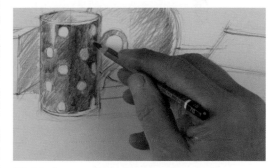

Hold the pencil close to the point when drawing precise detail and dark shading.

You will need
- Basic equipment (see page 8)
- Sheet of white hot-pressed (smooth) paper for final drawing
- Spare paper for exploratory sketches
- 7B pencil
- Conté pencil
- Putty eraser

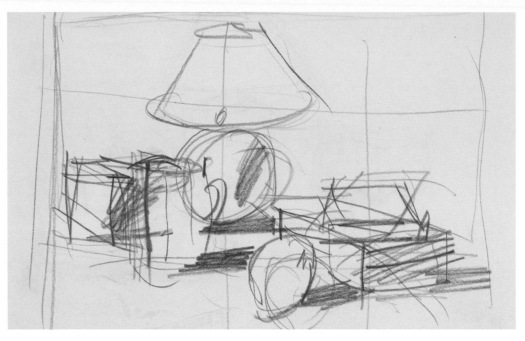

1 Begin by taking a spare sheet of paper and make a very quick sketch. This will give you confidence and stop you from getting caught up in details too soon. Concentrating on little details rather than the overall composition is a common problem for beginners.

Draw a rough grid of nine squares and then sketch in the objects, starting with the basic shapes. Notice that there is nothing dead center—the dominant lamp is placed on the left-hand vertical grid line, and the whole composition forms a triangle. Repeat this exercise as many times as you want. Every repetition will teach you something more.

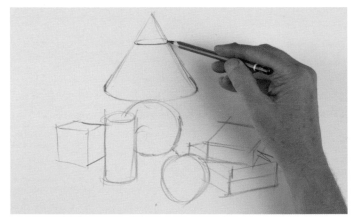

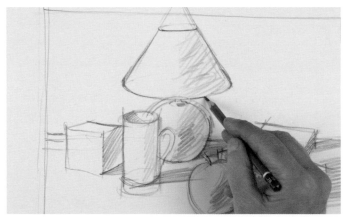

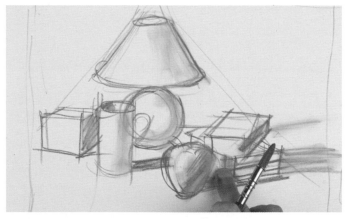

2 On another sheet of spare paper begin another, slightly more detailed sketch. Start by mapping out the underlying geometric shapes with the conté pencil. Using a 7B pencil, improve the basic shapes a little, adding lines and a few details to help define the objects more clearly.

3 Work more precisely to define the objects, noticing their positions and proportions in relation to each other. Look for the spaces between and around objects— the negative spaces (see page 16). Relate things to the edge of the tabletop and notice shadow areas. Draw in a rough frame to give yourself another point of reference.

4 Take another spare sheet of paper and, using the conté pencil, block in the shapes of the objects and their relative positions. Add some scribbled shading to make them look solid. Use your finger to smudge the marks and mold the forms. Make as many sketches as you wish, and keep them as guides for the final drawing.

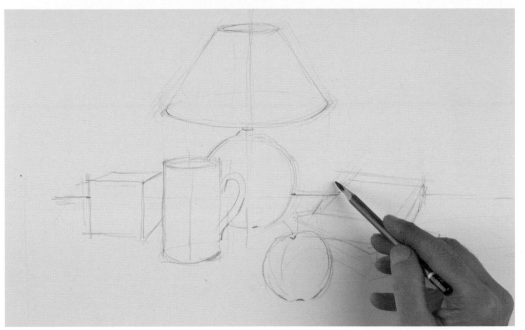

5 Now take a sheet of hot-pressed paper and a 7B pencil and begin to draw in the objects lightly, using your earlier sketches as a reference. Indicate the center line of the lamp to help you align the ellipses (see page 13) of the cone and the curve of the lamp base. Draw in the back line of the tabletop to help you position the items correctly.

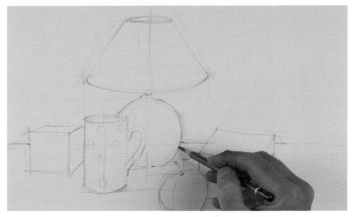

6 Check the negative spaces. For instance, draw the shape made between the books, the tabletop, and the lamp base. This will help you to angle the books properly. Plot the position of shadows by lightly sketching in their outlines. Erase and adjust things if necessary; nothing needs to be final yet.

Artist's tip
Turning your drawing upside down can quickly reveal any problems that need to be corrected. Discrepancies in the shapes of the ellipses, for example, will be more obvious when viewed from a different angle.

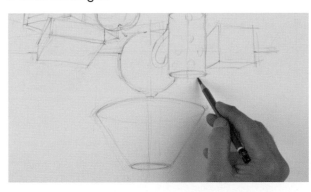

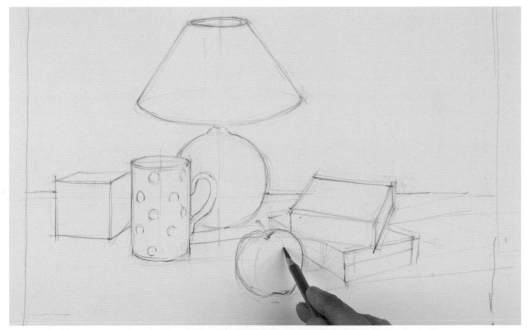

7 Draw in a rough frame around the picture so you can check the position of the objects against its lines. Begin to firm up some lines using a little more pressure on the pencil.

Keep assessing things as you add more detail, such as the spots on the mug. Notice that the spots on the mug are perfect circles when seen face-on, but as they continue farther around the sides, they become elliptical.

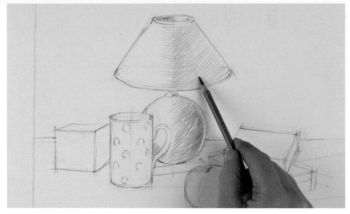

8 Indicate the shadow areas on the lamp base with light marks that curve to help describe its shape, adding some crosshatching (see page 29) to give a sense of the sphere. Use open marks rather than filling in. Treat the lamp shade in a similar way. Look at the shadow areas on the objects for any information they can provide.

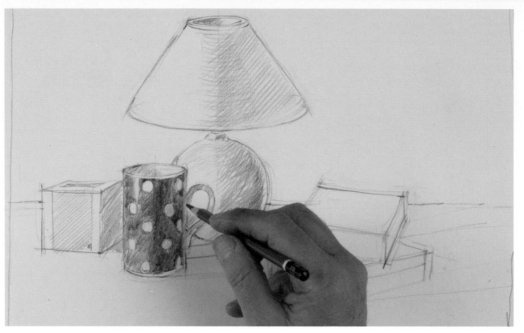

9 Add crosshatching to the apple to indicate shape and volume. Refine the mug handle, using the negative shape inside it to help you.

Look at the spots on the mug; some are white where the light falls on them, while others are gray because they are in shadow. Pick out the bright highlight on the mug by taking off some of your pencil marks with a putty eraser.

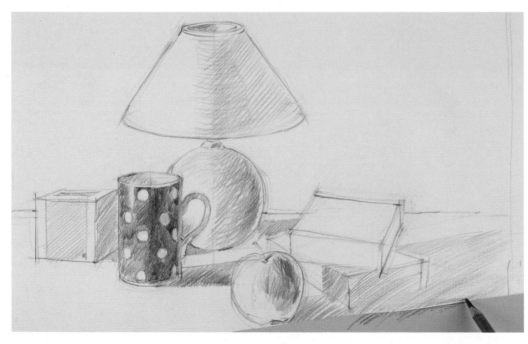

10 Now look at the shadows cast on the tabletop, noticing their shapes and directions—the shadow that travels up the spine of the book, for instance. Shade in these areas. You can use a spare piece of paper to mask off an area when shading to create a straight edge.

Up close
Curved surfaces become darker in tone as they turn farther away from the light. But if you look carefully, you will notice a small area of reflected light at the edge of the object as the surface disappears from view. You can see this light effect on the lamp base, apple, and mug. Include it to give an added sense of three dimensions. Take off pencil marks with a putty eraser, if necessary.

11 Add some dark tone to the book covers and work more into the apple. Try to make open marks that create a lively and expressive image. Too much solid tone can lead to a dull and lifeless effect.

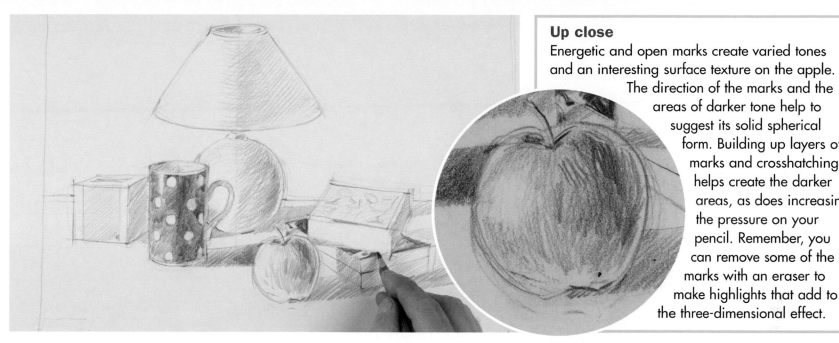

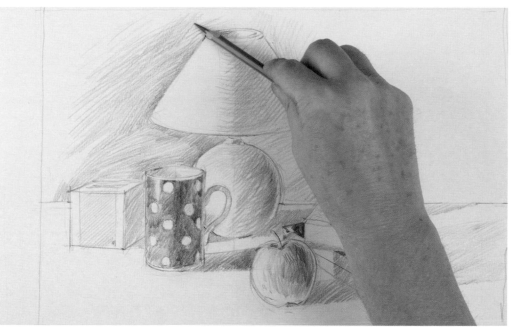

12 Shade in some of the background behind the still life using the side of the pencil to create loose, broad swathes of tone. Notice how this emphasizes the negative shapes around the objects and provides a strong tonal contrast that makes the objects stand out from the background.

Use crosshatching to build up the tone, working in random directions for textural interest.

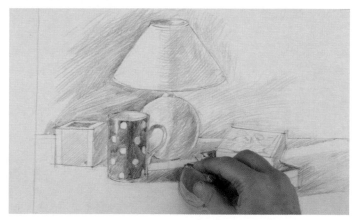

13 Sit back and assess your drawing, searching for any areas that need a little more attention, but be careful not to overwork things. Refine the shadows and reflections, deepening the tone on the left-hand side behind the box, mug, and lamp to bring them out more. Use your putty eraser to lift off the highlight on the apple.

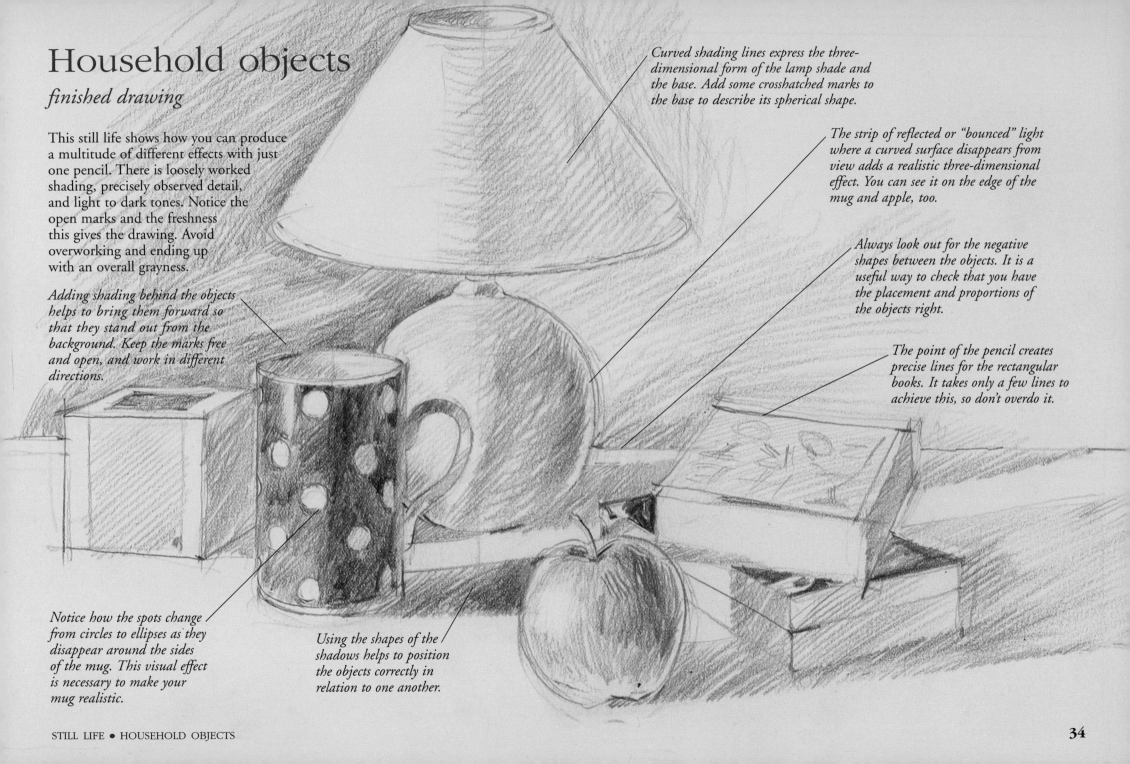

Household objects

finished drawing

This still life shows how you can produce a multitude of different effects with just one pencil. There is loosely worked shading, precisely observed detail, and light to dark tones. Notice the open marks and the freshness this gives the drawing. Avoid overworking and ending up with an overall grayness.

Adding shading behind the objects helps to bring them forward so that they stand out from the background. Keep the marks free and open, and work in different directions.

Curved shading lines express the three-dimensional form of the lamp shade and the base. Add some crosshatched marks to the base to describe its spherical shape.

The strip of reflected or "bounced" light where a curved surface disappears from view adds a realistic three-dimensional effect. You can see it on the edge of the mug and apple, too.

Always look out for the negative shapes between the objects. It is a useful way to check that you have the placement and proportions of the objects right.

The point of the pencil creates precise lines for the rectangular books. It takes only a few lines to achieve this, so don't overdo it.

Notice how the spots change from circles to ellipses as they disappear around the sides of the mug. This visual effect is necessary to make your mug realistic.

Using the shapes of the shadows helps to position the objects correctly in relation to one another.

Quick Review

This overview of the first project gives you a sense of how the drawing builds up from the first lightly drawn lines to the finished picture. Notice how the artist concentrates on the overall composition and relative sizes and positions of the objects before adding details.

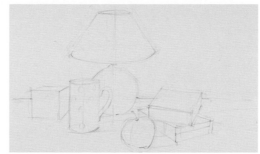

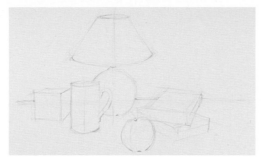

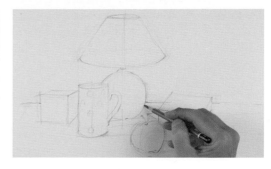

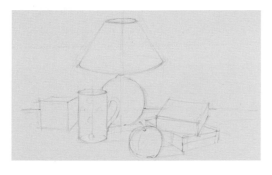

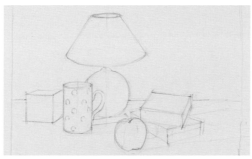

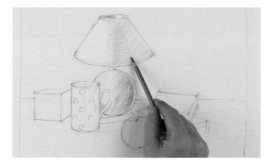

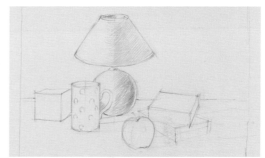

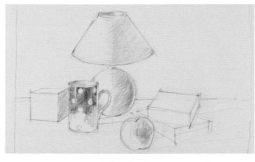

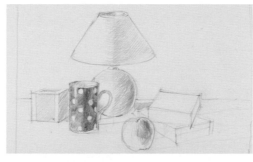

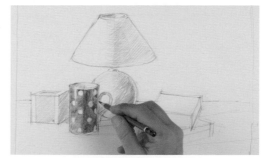

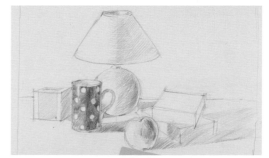

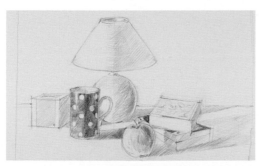

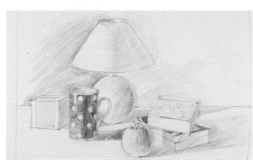

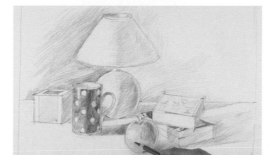

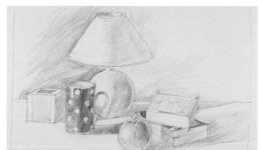

②Fruit
a charcoal study in light and shade

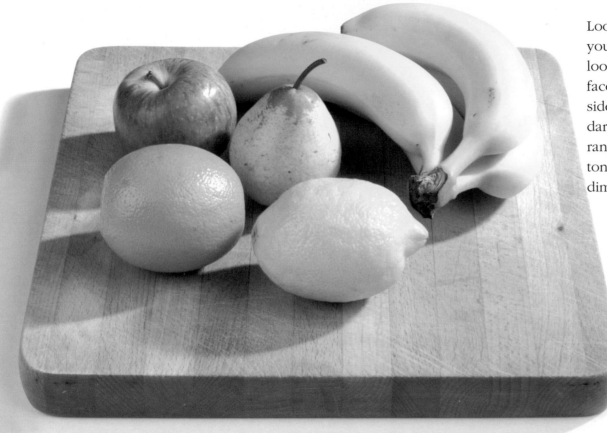

Looking at a subject in terms of light and shade will help you produce an accurate and realistic drawing. If you look closely at any object, you will see that the side that faces the light source has the lightest tone, while the side turned away from the light—the side in shadow—is darkest in tone. Between these lights and darks is a range of mid-tones. If you concentrate on drawing these tonal variations, you will achieve a convincing three-dimensional effect on your flat sheet of paper.

▼ *A black-and-white photograph will help you identify the areas of light and shade created by the shape of the fruit and to locate the lightest and darkest areas in the setup. Concentrate on representing these different tones and you will achieve a convincing three-dimensional look to your drawing.*

▲ *When you set up your own arrangement, light it strongly from the side so you have plenty of contrasting shadows and highlights. Natural light from a window may not be enough, so try an angled desk lamp to create a strong directional light.*

Using charcoal

Charcoal is a wonderful medium for line drawings, studies in light and shade, and for dramatic tonal effects. Made from charred wood—usually willow—it's inexpensive and easy to use. It's also great for beginners because it encourages a bold, spontaneous approach that keeps marks simple and fluid. You can mold forms with it, create highlights, and lift off mistakes with a putty eraser.

Charcoal is available as inexpensive natural sticks that are smooth and silky to use. These sticks vary in length and thickness and can be used to produce an exciting range of effects, from fine lines to bold areas and swathes of intense dark tone. Each size of stick offers different possibilities, so it's worth trying a few to get the feel of them. You can also experiment with charcoal made from different woods, as each kind creates different marks and tones.

The alternative to natural charcoal is compressed charcoal, which comes as straight sticks or pencils in hard, medium, and soft grades. These have a less velvety feel than natural charcoal sticks and are more limited in their variety of marks. However, they have the advantage of not crumbling or smudging so much, so hands and paper stay cleaner. They're less fragile, too.

Artist's tip
Charcoal smudges easily, so protect your drawing with a clean sheet of paper to rest your hand on. And when it's finished, spray it with fixative to prevent damage (see page 40).

SHARPENING CHARCOAL

Sharpen charcoal sticks and pencils carefully with a craft knife or rub them on an artist's fine sandpaper block. Be gentle with natural charcoal sticks; if you rub them too hard, they'll snap and crumble. Thin sticks are especially fragile.

Charcoal pencils are used for the fruit drawing project since they are more suitable for beginners. But if you find you like the medium, be sure to try out both the compressed charcoal sticks and the natural ones to discover the full range of effects.

Charcoal in practice

Use thin charcoal sticks for fine lines and linear shading effects, and thick sticks for large-scale drawings with bold lines and broad sweeps of tone. To lay down tone rapidly over a large area, use the side of a stick. For more precise, sharp touches, shape the charcoal to a point. Blend the charcoal marks for a soft effect—a finger does the job, but using a tissue is less messy. Experiment with your charcoal before using it on your first charcoal drawing.

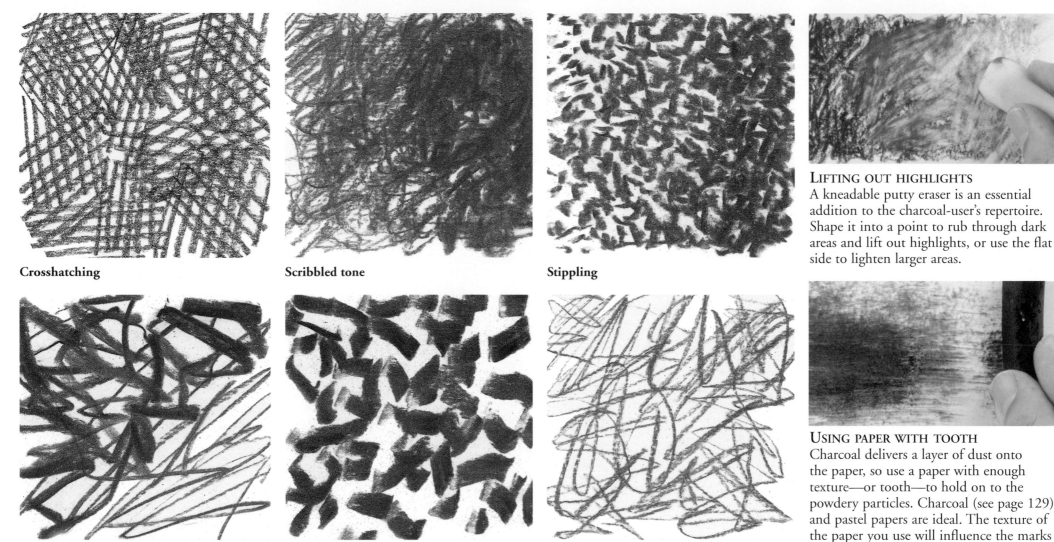

Crosshatching

Scribbled tone

Stippling

LIFTING OUT HIGHLIGHTS
A kneadable putty eraser is an essential addition to the charcoal-user's repertoire. Shape it into a point to rub through dark areas and lift out highlights, or use the flat side to lighten larger areas.

Thick and thin line

Short strokes

Delicate line

USING PAPER WITH TOOTH
Charcoal delivers a layer of dust onto the paper, so use a paper with enough texture—or tooth—to hold on to the powdery particles. Charcoal (see page 129) and pastel papers are ideal. The texture of the paper you use will influence the marks you make.

You will need

- Basic equipment (see page 8)
- Sheet of mid-gray pastel paper
- Charcoal pencils—hard, medium, and soft
- White pastel pencil—medium
- White chalk
- Spare sheet of paper for protecting drawing
- Craft knife or fine sandpaper block
- Fixative spray

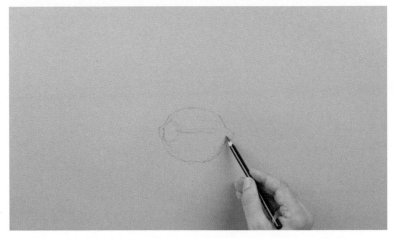

1 Map out the setup with the medium charcoal pencil. Use small marks to plot the position of the edge of the board and the pieces of fruit. Lightly sketch in the outline of the lemon at the center. Add a few lines to indicate the shadow areas, and draw some contour lines to indicate the shape and volume of the fruit.

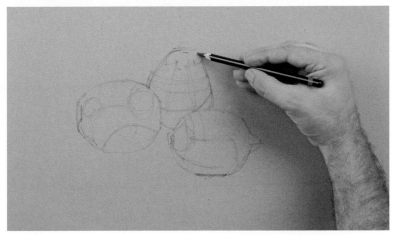

2 Sketch in the orange, assessing its position and size in relation to the lemon. Notice its smooth curves that contrast with the irregular shape of the lemon. Then move to the pear, studying its relative height and position. Check the shapes of the spaces between the fruit. Indicate the shadow areas and contours as before.

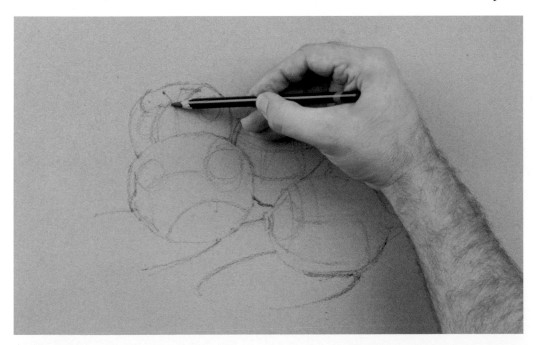

3 Draw the outlines of the shadows below the orange and lemon, then turn your attention to the apple. Keep sketching lightly and looking and assessing, relating each piece of fruit to the next. Notice how and where they meet, along with the shapes of the spaces between and around them.

If you don't feel happy with your drawing at this stage, turn back to the information on negative shapes (see page 16) and review that. On a separate piece of paper, try making a quick sketch just of the negative shapes around and between the fruit.

Artist's tip

Charcoal pencils lose their points quickly, and stopping to sharpen them when you are in the middle of a drawing can disturb your concentration. To avoid interrupting your flow, turn your pencil every so often as you work to maintain a good point. Alternatively, keep a piece of fine sandpaper or sanding block (see page 37) at hand and rub the point quickly on that to sharpen it. If you do sharpen your charcoal pencil with a craft knife, do it well away from your drawing so that charcoal dust doesn't fall on it.

Prop your drawing up and spray it from side to side. Two or three light sprays are better than one heavy one.

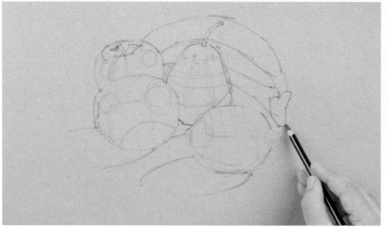

4 Now plot the curved shapes of the bananas. Notice the position of the joined stalks close to the lemon and check where the curves disappear behind the pear and the apple. A banana isn't a perfect cylinder, so add lines to indicate the facets of the skins where the tones change. Relate each curve to the next.

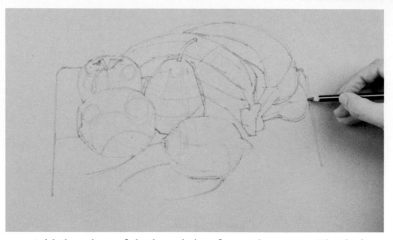

5 Add the edges of the board that frame the group. Check the angles of the lines and their distance from the fruit. Look at the negative shapes left between the edges of the board and the fruit. Notice where the back edge of the board disappears behind the bananas and emerges behind the apple.

6 When you have the subject mapped out and are happy with the position and proportion of all the elements, use a clean hand to stroke the paper gently. This will lift the marks slightly and remove any loose charcoal powder. Be careful not to rub so hard that you smudge your drawing.

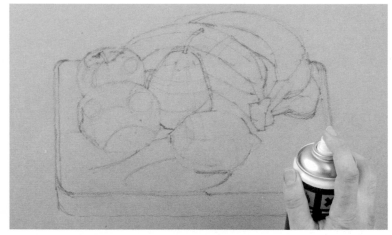

7 It is a good idea to spray your drawing with fixative at this stage so you don't lose these mapping lines. You can still work on top and change things later—these first lines will be covered as you build up your drawing. Notice how the artist is slowly building up the whole still life, not just concentrating on one area.

8 Now that everything is in the right place, you can start to pull out the three-dimensional forms of the fruit by adding the darker mid-tones. Add shade using the medium charcoal pencil lightly so you don't clog up the paper with too much pigment. Allow some of your marks to follow the contours of the fruit so you begin to describe their solid forms. Adjust the shapes if necessary and begin to firm up the outlines a little more strongly.

If you feel nervous about the more definite marks you are making, turn back to page 38 and look at the tips on mark-making with charcoal. Experiment on a spare piece of paper.

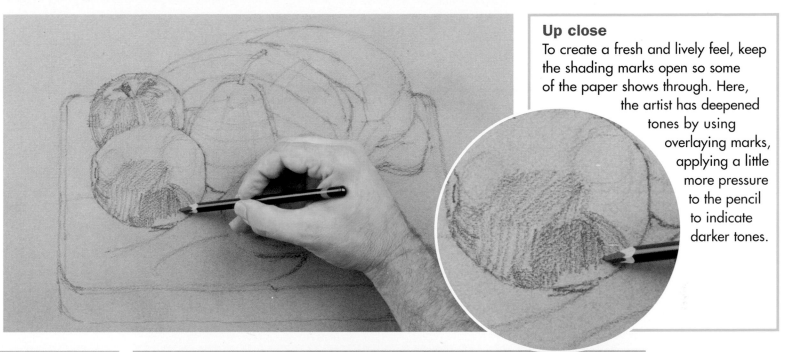

Up close
To create a fresh and lively feel, keep the shading marks open so some of the paper shows through. Here, the artist has deepened tones by using overlaying marks, applying a little more pressure to the pencil to indicate darker tones.

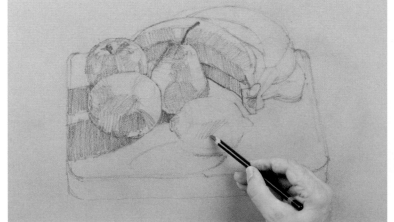

9 Continue shading in the mid-tones on the fruit using the direction of your shading to describe its contours. Firm up some of the outlines a little more and add the shadows on the board beneath the fruit. Fix your work again—charcoal rubs off easily, so don't lose what you've achieved so far.

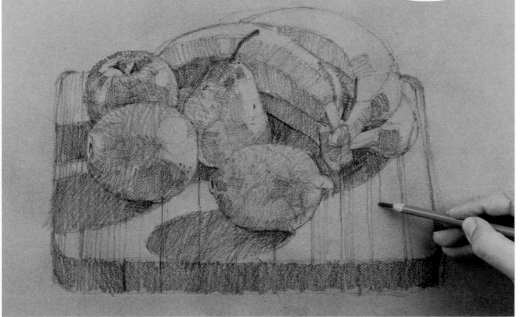

10 Change to the hard charcoal pencil. Darken the tones in deepest shadow and draw in more detail. Vary the directions of your strokes to help capture the texture of the citrus fruit. Keep working around the picture, adjusting the tonal values so they begin to read correctly. Draw in the lines on the board.

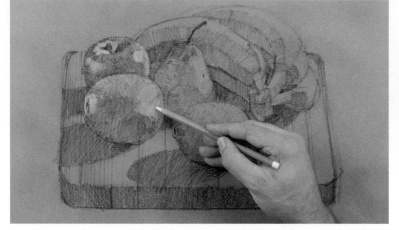

11 Fix the drawing again. Now use the medium white pastel pencil to start pulling out the lighter tones and highlights that add sparkle to the image. Work lightly at first and feel your way into the light tones using open scribbled marks, not solid areas of pigment.

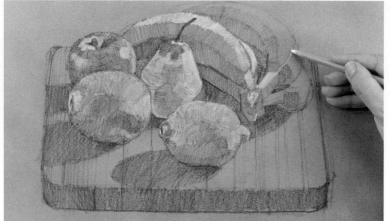

12 Keep moving around the drawing with your white pastel pencil, balancing, assessing, lightening, and molding the fruit into shape. If some of the shapes aren't quite right, you can adjust them as you go. Notice the exciting three-dimensional effect created by the light tones, bringing the image to life.

13 It is not possible to fix white pastel, so try to work with your hand off the paper or rest it on a spare sheet of clean paper. Lighten some of the tones a bit more, but still keep the marks open and free for a more realistic textural effect. Vary the direction of the marks to describe the rough skins of the lemon and orange. Reflect the smooth apple skin by working in one direction.

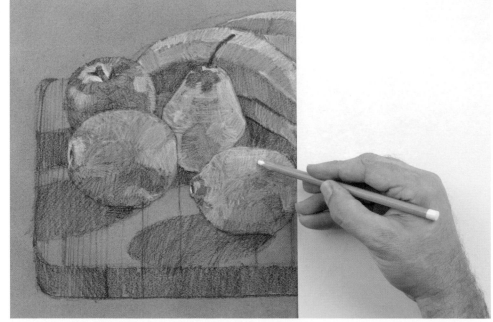

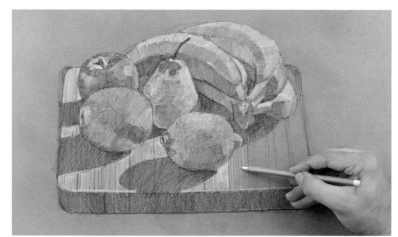

14 Add light tones to the board, still keeping the marks open for a lively texture. Highlight the front edge of the board with a heavier white pencil line. Then assess the tonal levels that you have achieved so far and move around the drawing, pulling out the light areas even more, if necessary.

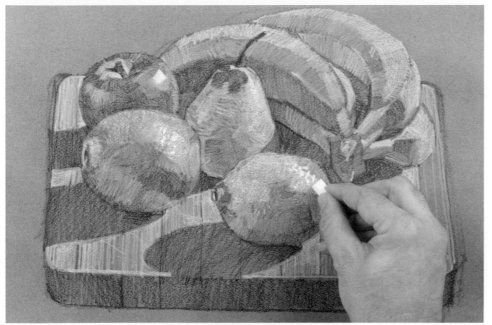

15 Use a piece of white chalk to add the brightest highlights. Work with the flat side of the chalk for smoother effects, such as on the pear skin. Use an easy pressure and glide it on. Then work with a sharp corner of the chalk for a stippled effect to get the texture of the citrus fruit skins. Don't lean too hard on the chalk or it will crumble and make messy marks.

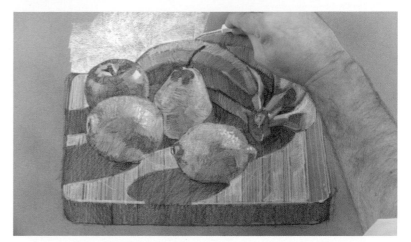

16 Use the flat side of the chalk and press hard around the upper edge of the image to make a firm line; then drag the chalk upward to create a background tone. Vary the pressure as you drag the chalk away so you create interesting tonal effects. Make sure your hand doesn't rub over the drawing and smudge it.

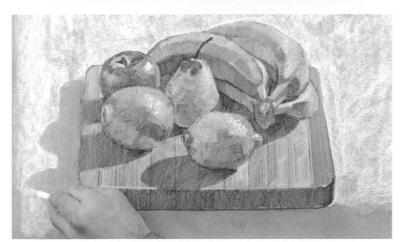

17 Scrub in the background with the flat side of the chalk, working in different directions to create a varied and open texture. Take the chalk marks around the shape of the shadow on the left side and bottom edge of the board. This cleverly reserves the mid-tone of the paper as the shadow area.

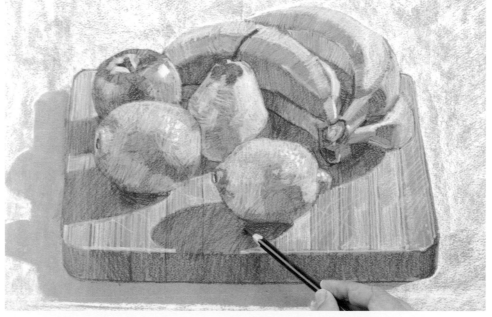

18 Assess your drawing and adjust some of the light tones and highlights, if necessary. Then add some finishing touches to complete your study. Use your soft charcoal pencil to draw into the image a little and add dark marks here and there—on the banana stems, the apple and pear stalks, and in the deepest shadow areas. These will add final touches of detail to bring your drawing to life.

Fruit

finished drawing

Leave your drawing for a few days, then come back and reassess it. Enjoy all the things that you feel work well. Take note of anything you believe you could improve the next time around.

Varying the direction of the marks on each side of the banana skin is a simple device to convey the shape of the fruit.

Using the flat side of the chalk and varying the pressure creates an interesting background and lets the texture of the paper show through.

Putting highlights where the light catches the fruit is easy and adds sparkle and convincing realism to your drawing.

Stippling the highlights with the sharp end of the white chalk conveys the dimpled texture of the orange skin.

Adding detail to the banana stalks and darkening some of the lines on the shadow sides of the fruit helps to bring the drawing to life and enhances the three-dimensional effect.

Keeping the shading marks open and loose and working them in different directions helps to capture the roughness of the lemon skin.

Take the white chalk around the shape of the shadow so the mid-tone of the paper serves for the shadow.

Quick Review

An overview of this project shows how the artist built up charcoal and white pastel to create a study in light and shade. You may want to try a still life of fruit—or of just one piece of fruit—using pencil before trying charcoal. Go at your own pace and have fun!

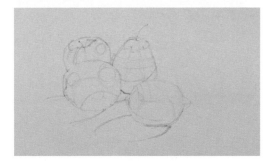
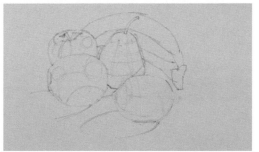
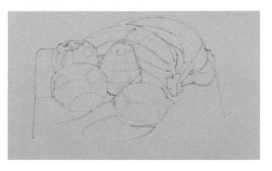

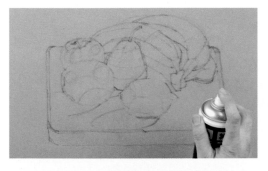
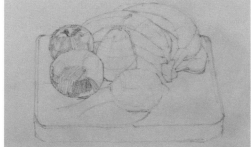
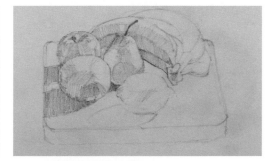
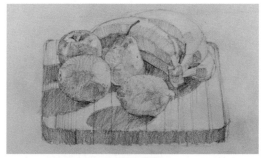

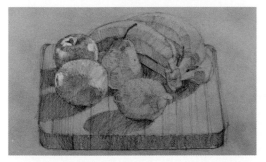
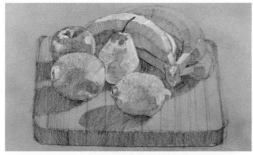
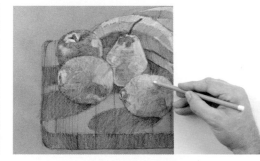
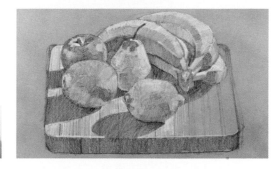

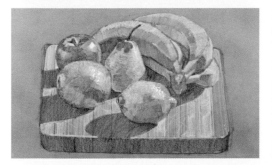
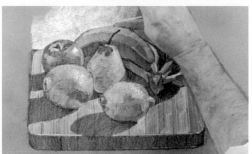
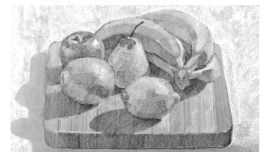
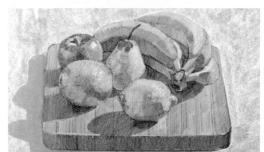

3 Kitchen objects
everyday objects in pastel pencil

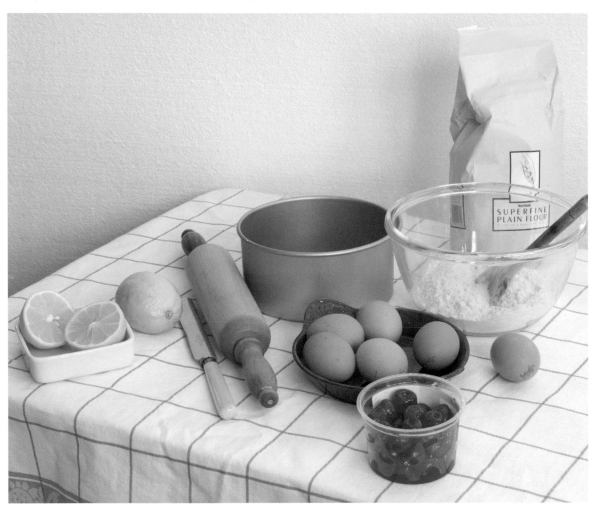

You don't have to look far to find a collection of objects for an interesting still life. For this project, the artist has selected a group of baking items. If you create your own setup, choose objects with varied shapes and surface textures to make an interesting study. The artist put the items on a squared cloth to help position the individual elements. She also worked in natural light, which is softer and allows more tonal variations for a color study.

Next the artist drew in blocks of color and tone rather than treating the subject as a line drawing with added color. She worked very lightly and loosely at first, looking at the group as a whole and continually balancing and adjusting colors and tones across the image. If you haven't worked this way before, you will find it makes your drawing excitingly loose and expressive.

◀ *Take time to arrange your selected items into an interesting pattern of shapes and textures.*

Using pastel pencils

Pastels come in several forms, including pencils and soft and hard sticks. They are all richly pigmented and offer an enormous range of vibrant colors and tones that create fresh and lively drawings with lots of textural interest.

Pastel pencils are a little harder than soft pastel sticks and feel slightly scratchy on the paper.

However, they have the same intensity of color and are versatile and expressive. They are hard enough to produce sensitive and detailed linear work, but at the same time soft enough to create gently shaded effects. Use them to add detail to drawings made with broader, soft pastels, or to add whispers of color to graphite pencil drawings.

CHOOSING THE RIGHT PAPER

Pastel papers have a textured surface so that the particles of color can cling to them. They are available in a wide range of colors and tones that enhance the effects of the medium. The background paper often shows through open pastel marks, so choose a paper color that either provides a contrast to your drawing or complements the tones you've used. It can provide the background if left largely empty—in a portrait, say—or work as a color in its own right within the subject.

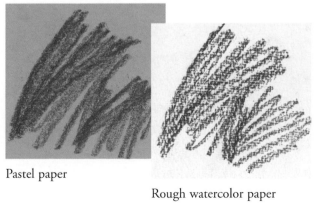

Pastel paper

Rough watercolor paper

The texture of the paper affects the look of the pastel marks.

When trying out pastel pencils, select a few different colors to experiment with. Gradually add to your collection as you need new colors for planned drawings. Sharpen pastel pencils with a craft knife to expose the colored core—it's fragile, so be careful. Rub the tip on fine sandpaper to create and maintain a point.

Pastel pencils in practice

Hold the pastel pencil high up the shaft for sweeping gestures and loose marks, and closer to the point for more control over fine, linear marks. A sharp point creates precise details and sensitive shading. A rounded tip makes bold marks and broad swathes of color. You can blend colors together, lay one color over another, or create optical mixes. One note of warning: Don't use too many colors or you'll end up with an unattractive shade of mud!

Long marks using side of pencil

Scribble using point of pencil

Broken color

BLENDED COLOR
Color blending mixes colors on the paper surface, as opposed to optical mixing, where two colors are scribbled together. In this case, red on the right and yellow on the left are blended with a finger or tissue to create orange in the center.

Controlled hatching

Optical mixing

Varied line using point and side of pencil

BLENDED TONE
To create subtle tonal gradations, make progressively lighter marks with a pastel pencil, then blend them with a finger or tissue. You can smudge the powder farther across the paper to make the lightest whisper of tone.

You will need

- Basic equipment (see page 8)
- Sheet of mid-gray pastel paper
- Pastel pencils: white, light ochre, pale lemon, terra-cotta, vermilion, leaf green, cool mid-gray, light blue-gray, light umber, Van Dyke brown, sky blue
- Putty eraser

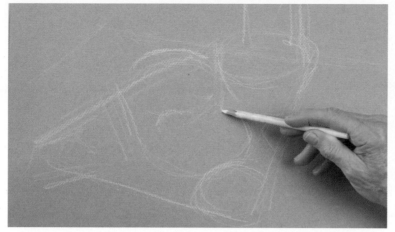

1 Look carefully at the setup. Observe the effect that the light has on the objects and notice the negative shapes between and around them. Using a white pastel pencil, sketch in the outline of the triangle created by the arrangement and lightly plot the positions and relative sizes of the objects within the triangle.

2 Using light ochre, pale lemon, and terra-cotta pastel pencils, softly shade in the areas of brown and yellow tone, then indicate the cherries with a vermilion pencil. Sketch lightly with the pencils to keep things loose. At this stage nothing is definite—you are simply feeling your way into the subject.

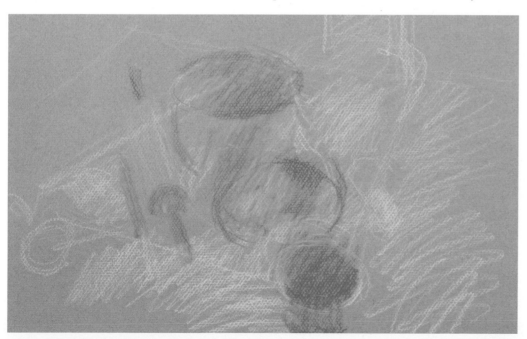

3 Firm up the shape of the cake pan with terra-cotta, then tone it down with a light haze of lemon yellow over the top. Roughly indicate the eggs. Evaluate your drawing and adjust things, if necessary. Add the rolling pin and use cool mid-gray to create the shadow it casts on the side of the cake pan and to indicate the knife blade.

Enjoy the loose, sketchy feel of your drawing. Don't be tempted to work on the details yet. Continue concentrating on the overall pattern and shape of the objects in the still life.

Artist's tip

A rolling pin is a long cylindrical shape. However, here you are looking at it from one end, so the shape appears to change. This effect is called foreshortening. Observe how the rolling pin looks shorter, and draw what you see, not what you think you know!

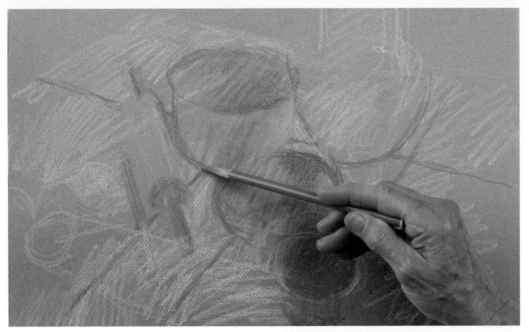

4 Broadly scribble in the white background of the tablecloth, then draw in a few of the lines on the cloth using the cool mid-gray pencil. There's no need to draw them all; use just a few as a guide to help you check and adjust things.

5 The lines on the cloth provide useful information. All your marks are still very light, so if things are in the wrong place, you can lift them off easily with a putty eraser and shuffle them around a bit so they settle in properly. The lemon and the bowl have been adjusted and the spoon added.

Up close

Look carefully at the outer surface of the cake pan as it curves away from the light source and is thrown into shadow. Notice how this shadow is not just gray but includes areas of "bounced color" that have been reflected from the nearby objects. Including information such as this will help bring your drawing to life.

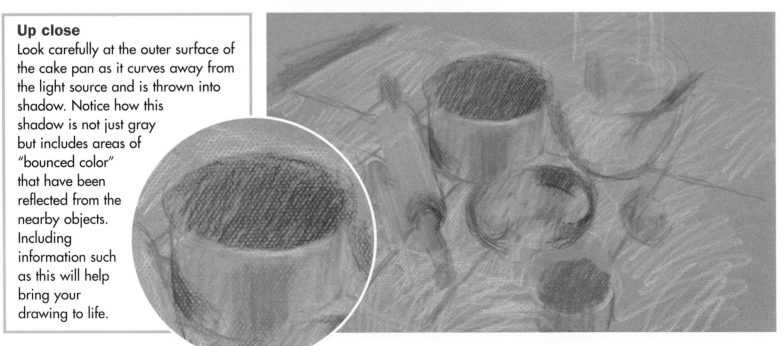

6 Use terra-cotta and light umber to darken the tone inside the cake pan and help describe its form. Keep working over the whole drawing, adjusting the relationships between the objects and establishing their tonal values. The overall tone seemed a bit too warm, so a little leaf green has been added to cool things down, especially on the flour bag and the lemon.

Working in this way helps you understand that objects won't look realistic if you draw them in one solid color. Light, shadow, and texture make different parts of an object appear in various shades.

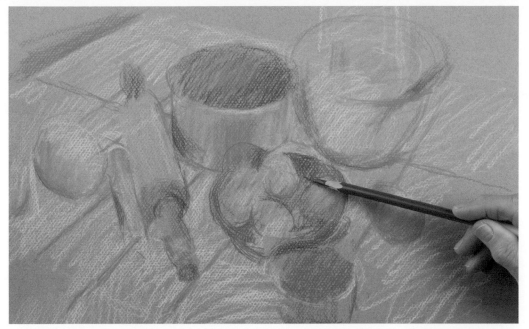

7 Now that everything is more or less in place, start adding more definition to the shapes. Use Van Dyke brown and terra-cotta to firm up the cake pan and egg bowl. Add more emphasis to the negative shapes between the eggs. You should now be drawing in the deeper tones across the whole image.

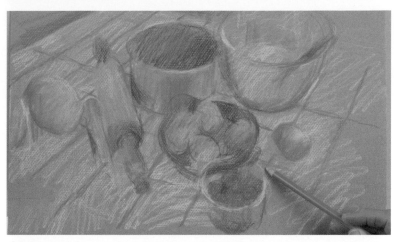

8 Use white on the top edges of the cherry pot and glass bowl, and pale lemon on the edge of the pan to add some highlights. Then fill in the remaining lines on the cloth and adjust the existing ones, if necessary. Use the sky-blue pencil to strengthen the lines and add a cooler note.

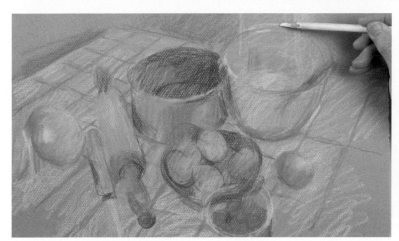

9 Check the ellipses (see page 13) and adjust them if necessary, using appropriate colors to make them convincing. Add a bit more definition to the eggs. Work into the knife handle. You can still change things—pastel allows for unlimited tries.

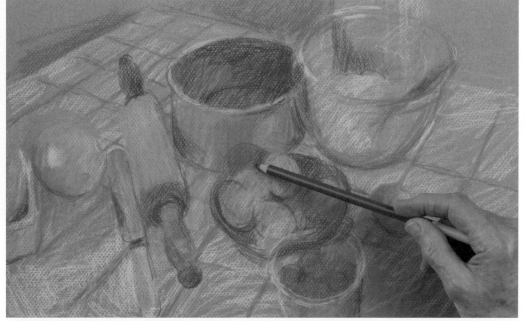

10 Stand back from your work from time to time to evaluate it. Once you are happy that the image conveys the idea of three-dimensional forms, it's safe to go into more detail. It's up to you how far you take things, but don't overwork your drawing or it may become lifeless.

Up close
The label on the flour is distorted by the glass bowl. Suggest the label with an area of pale gray that helps it to recede behind the bowl and contrasts with the white of the flour. Don't attempt to add every detail.

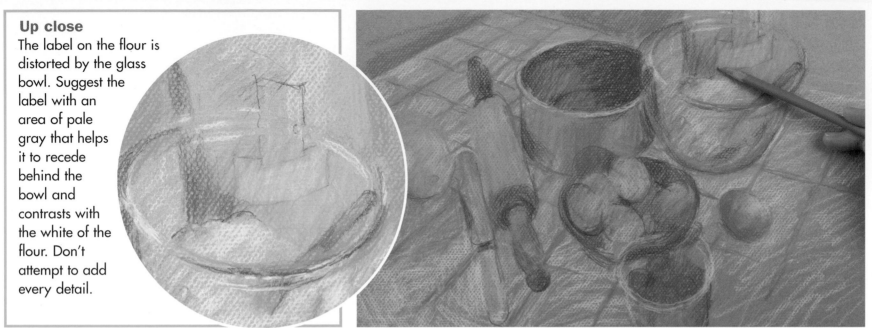

11 Darken the tone inside the cake pan with more Van Dyke brown, and sharpen up the highlight on the edge with white and pale lemon. This gives a crisp effect that conveys the nature of the pan. Work up the handles of the rolling pin and use the cool mid-gray to suggest the label on the flour bag.

12 Add some brown, white, and gray to mold the shape of the eggs a bit more. Stipple white on the lemon skin to describe its texture. Lift the image with more highlights—on the knife blade, the cherry pot and cherries, and the bowl rim. Slightly lighten the tablecloth in the foreground. Strengthen the dark tones where necessary to add depth, and add more definition to some of the outlines.

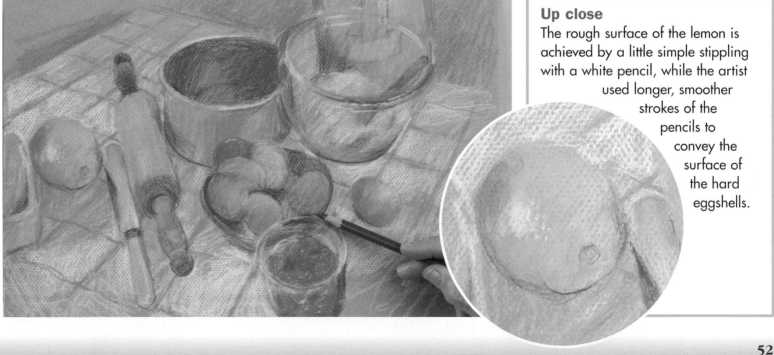

Up close
The rough surface of the lemon is achieved by a little simple stippling with a white pencil, while the artist used longer, smoother strokes of the pencils to convey the surface of the hard eggshells.

Kitchen objects

finished drawing

Pastel pencils let you mold the objects to create a realistic effect. Notice not just the different colors, but their varying tones as well. Try to imitate these, and don't simply darken all shadow areas to the same gray tone.

Shadows are never just gray. The shiny surface of the pan, for instance, reflects areas of color from nearby objects.

With pastel pencils you can color mix on the page with fresh, open marks that let the layers of color show through. Terra-cotta, light umber, and Van Dyke brown are used to achieve the variations of tone inside the cake pan.

Adding bright highlights brings the drawing to life. On the rim of the glass bowl they're white, but the metal of the cake pan creates highlights with a yellow tinge.

The textured surface of the paper creates interesting patterns that break up areas of flat color and add character to the drawing.

Notice how foreshortened the rolling pin appears when viewed from one end. Draw it exactly as you see it, checking it against the surrounding objects as you work.

Adding definition to the darkest areas makes the objects stand out from the flat surface of the paper, increasing the three-dimensional effect.

Make use of the squared pattern on the tablecloth as a grid to help you get the positions and relative proportions of the objects right. Notice how the lines fan out in perspective toward the bottom of the picture.

QUICK REVIEW

A review of the progress of this project shows how the final image was created by carefully building up the different colors. The picture began with a simple outline. After that, areas of color were blocked in to define the shapes of the objects.

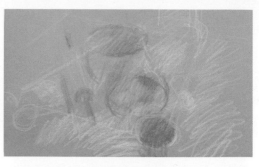

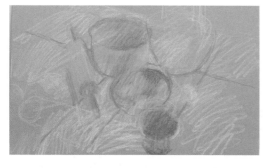
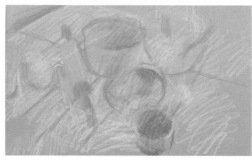
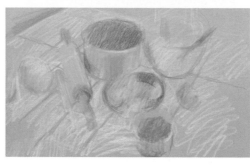
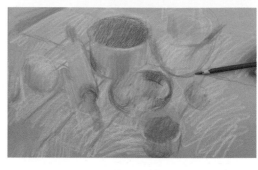

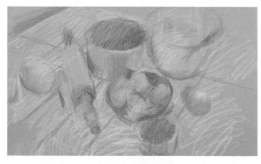
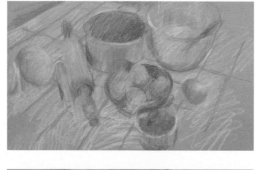
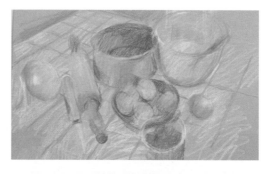
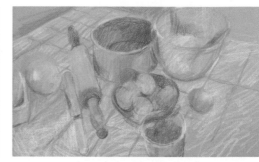

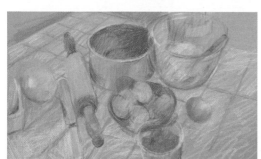
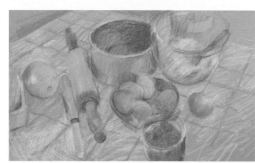
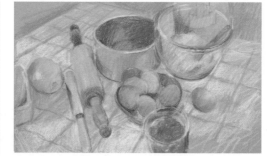
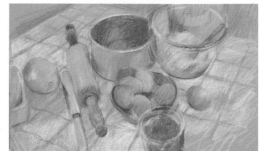

Flowers
and trees

Drawing flowers and trees

Flowers and trees in all their spectacular variety are endlessly popular subjects for beginners and experienced artists alike. Both may appear in a drawing as part of a wider scene—a garden vista or a landscape. But they each make infinitely challenging and rewarding subjects in their own right, with the advantage that they provide something interesting to draw at all times of the year.

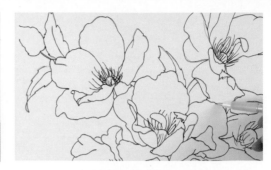

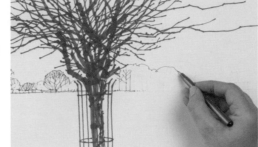

FLOWERS AND TREES IN COMPOSITIONS

Floral arrangements are a favorite form of still life with many artists. From humble, small wildflowers to exotic cultivated species, there's no shortage of inspiration. You can choose to draw a bouquet of flowers or an intimate study of a single bloom.

Trees are as enormously varied and fascinating as flowers and present their own challenge to the artist. Many landscape scenes are likely to include trees that form an important balancing element within the composition.

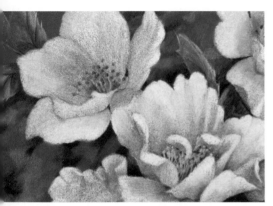

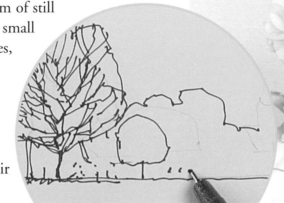

RENDERING SUBJECTS CONVINCINGLY

Even if they appear in a minor role rather than as the major focus of a drawing, flowers and trees need to be depicted convincingly. It's worthwhile devoting some time to studying them in detail to understand their forms.

At first glance they can seem complex. However, if you use the basic-shape approach explained in the introduction to analyze the forms, you will be able to render them successfully, whether in detail close up or in shorthand at a distance.

Understanding flower shapes

Like any other forms, the complexities of flower shapes can be unlocked with the basic-shape approach (see pages 12–15). Whether you choose to draw a corner of a summer garden in full bloom with the varied flowers loosely represented, or a more detailed study of a few cut blooms in a vase, you'll need to understand their forms in order to draw them realistically.

The best way is to start by looking for the underlying geometric shapes and sketch these in first. Then you can start to add the details.

Try drawing these three well-known flowers in your sketchbook, following the guidelines provided. Look closely at other flowers and you'll be able to identify their basic shapes in the same way.

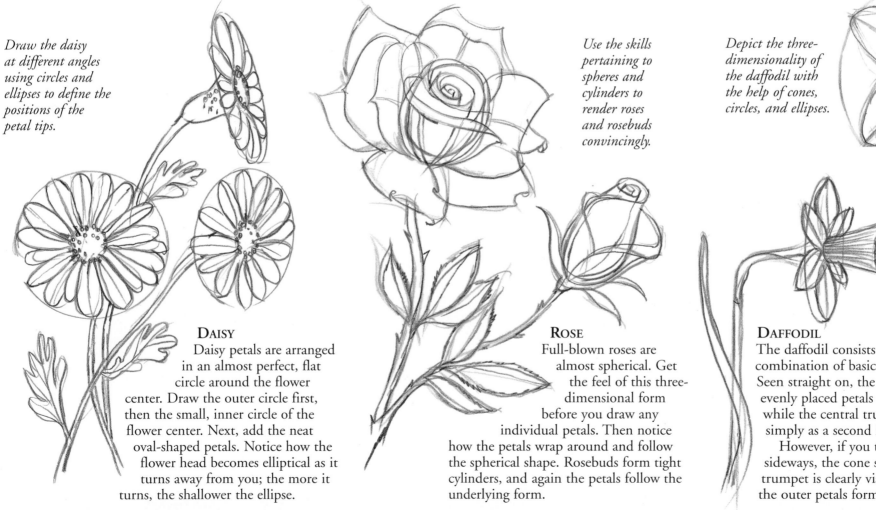

Draw the daisy at different angles using circles and ellipses to define the positions of the petal tips.

Use the skills pertaining to spheres and cylinders to render roses and rosebuds convincingly.

Depict the three-dimensionality of the daffodil with the help of cones, circles, and ellipses.

DAISY
Daisy petals are arranged in an almost perfect, flat circle around the flower center. Draw the outer circle first, then the small, inner circle of the flower center. Next, add the neat oval-shaped petals. Notice how the flower head becomes elliptical as it turns away from you; the more it turns, the shallower the ellipse.

ROSE
Full-blown roses are almost spherical. Get the feel of this three-dimensional form before you draw any individual petals. Then notice how the petals wrap around and follow the spherical shape. Rosebuds form tight cylinders, and again the petals follow the underlying form.

DAFFODIL
The daffodil consists of a combination of basic geometric shapes. Seen straight on, the outer ring of evenly placed petals forms a circle, while the central trumpet is seen simply as a second inner circle.

However, if you turn the flower sideways, the cone shape of the trumpet is clearly visible, while the outer petals form an ellipse.

Understanding tree shapes

The sheer size of trees and the complex network of branches and foliage can make them intimidating to draw. But as with flowers, help is at hand if you concentrate on looking for the simple basic structure and don't become distracted by too much detail. First, remember that trees are three-dimensional forms; see them "in the round," not as flat shapes against a backdrop. Then consider the structure and pattern of growth. A tree has a central trunk from which the branches radiate. The foliage fills out this underlying skeleton to give each species its recognizable overall shape.

Before you attempt any detail, sketch in the underlying geometric forms. After this you can add more specific information to indicate the species.

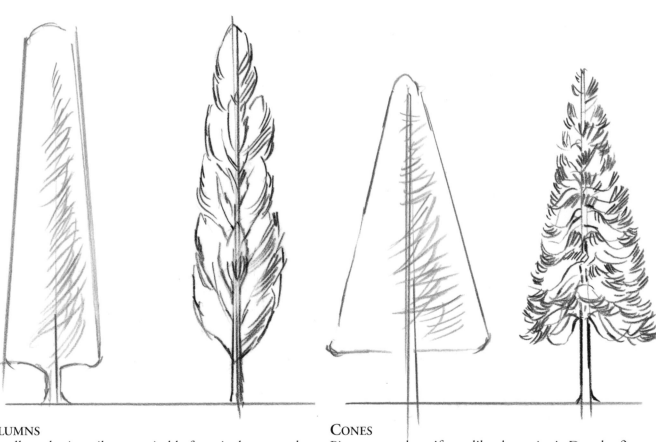

SPHERES AND DOMES
Deciduous trees such as sycamore and beech form domed umbrella shapes, with branches that radiate out from the central trunk. Oaks are almost spherical in form.

COLUMNS
The tall poplar is easily recognizable from its long, neatly tapering shape. The branches point upward from the trunk and become shorter as they approach the top, which gives this tree a distinctive columnar shape.

CONES
Pine trees and conifers—like the majestic Douglas fir—form distinct, symmetrical cone shapes. The branches radiate outward at right angles from the tall, straight trunk, decreasing in length toward the top of the tree.

CYLINDERS
The tall elm is basically cylindrical in form. Although the branches radiate out from the central trunk, the spread of the canopy is narrow, which gives it a slim silhouette. The foliage forms distinct clumps on the branches.

Trees in winter and summer

To get to know tree shapes, make sure you draw them in both the winter and summer seasons. Without its summer foliage the structure of a tree and its growth patterns is clearly visible. Studying and sketching the trunk-and-branch skeleton will help you draw the three-dimensional shape of the tree when it's in full leaf in summer.

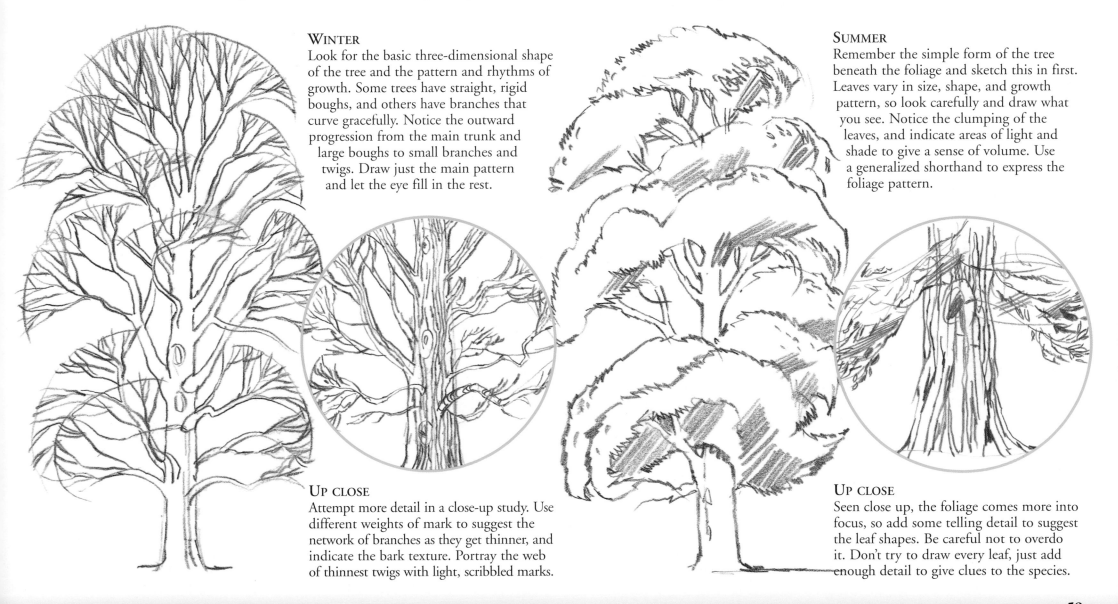

WINTER
Look for the basic three-dimensional shape of the tree and the pattern and rhythms of growth. Some trees have straight, rigid boughs, and others have branches that curve gracefully. Notice the outward progression from the main trunk and large boughs to small branches and twigs. Draw just the main pattern and let the eye fill in the rest.

UP CLOSE
Attempt more detail in a close-up study. Use different weights of mark to suggest the network of branches as they get thinner, and indicate the bark texture. Portray the web of thinnest twigs with light, scribbled marks.

SUMMER
Remember the simple form of the tree beneath the foliage and sketch this in first. Leaves vary in size, shape, and growth pattern, so look carefully and draw what you see. Notice the clumping of the leaves, and indicate areas of light and shade to give a sense of volume. Use a generalized shorthand to express the foliage pattern.

UP CLOSE
Seen close up, the foliage comes more into focus, so add some telling detail to suggest the leaf shapes. Be careful not to overdo it. Don't try to draw every leaf, just add enough detail to give clues to the species.

1 Winter tree
a study of a tree in felt pen

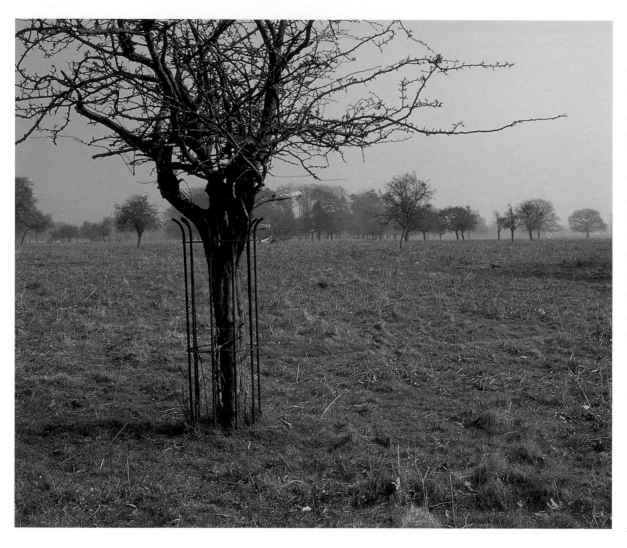

A leafless tree may seem like a challenge to draw. Where do you begin when faced with a tangle of bare branches? The answer is to be selective. You don't need to draw every branch. Just a few expressive lines can be enough to suggest the complexity of the whole tree. If you go into too much detail, you risk losing sight of the basic character and form of the tree. As always, look for the underlying form and the pattern of growth. Notice that the tree in the foreground is a very different shape compared to those in the distance.

◀ *The artist has chosen to draw a tree with bare, tangled branches that create a distinctive pattern against the winter sky. He has also been selective in what part of the tree he has chosen to draw—he did not include the whole tree but has cropped out the tops of the branches to add more drama to the finished picture. The tree has a metal guard around it to protect it from deer.*

Using markers and pens

The array of felt tips, marker pens, ballpoints, roller balls, technical drawing pens, and fine-liners on the market is positively bewildering. However, they can all make a contribution to your drawing repertoire and are worth looking at.

ART MARKERS AND FELT TIPS

These are available in extensive ranges of color and tip sizes. Use fine points for linear details and optical color mixing. Thick, rounded tips give broad washes of color and bold lines. Chisel-shaped tips produce a variety of line widths according to the part of the tip used. Some markers are water-based for creating wash effects as well as line. The possibilities are endless, and you can employ several marker types in one drawing.

Scribbled line

Thin and thick line

Stippling

Short strokes

Each pen gives a fixed width of line that limits its possibilities, but they come in a variety of sizes and colors so you can combine several in one drawing to create emphasis and variation. Pens lend themselves perfectly to linear techniques for creating tone and texture—hatching, crosshatching, stippling, and scribbling—and can produce energetic images. Carry one or two with your sketchbook for rapid notetaking and quick impressions. They dry rapidly, don't leak, and are clean to use. Don't discard old pens; dried-out tips make interesting marks!

Artist's tip
Marks made with these pens can't be erased. The only way to correct mistakes is to adjust the shapes with overlaid marks. Work lightly at first and firm up the drawing when the subject is established on the page. Don't use abrasive means to lift marks; this roughens the surface of the paper, and working on roughened paper creates spreading ink marks and fuzzy lines.

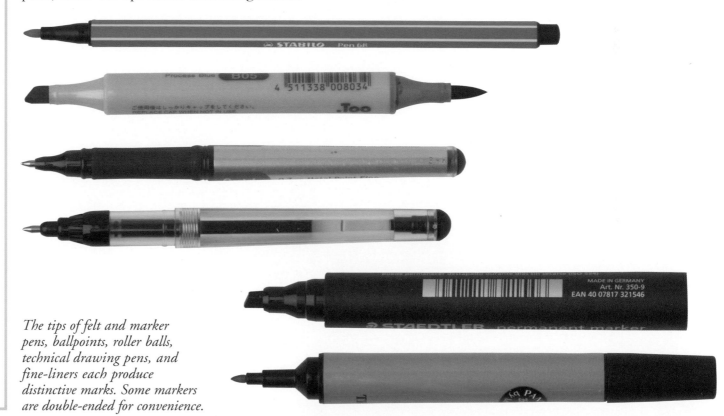

The tips of felt and marker pens, ballpoints, roller balls, technical drawing pens, and fine-liners each produce distinctive marks. Some markers are double-ended for convenience.

Ballpoints and roller balls

These are primarily writing tools. The tips don't deteriorate, and the ink flows freely to produce a constant smooth line. The range of tip sizes creates different widths of line that you can exploit for added interest in your drawing. Build tone with expressive overlaid marks and adjust shapes by adding more lines. Some ballpoints are water-soluble, so you can soften selected lines with a moistened finger or a brush.

Technical pens and fine-liners

As their name suggests, these are designed for draftsmen to produce precise and accurate drawings and design work. They deliver smooth, consistent lines that offer no variation, so the result can be a bit mechanical. However, for the artist they are useful for adding a different weight of line to a drawing, perhaps to suggest distance, and to add fine details to a bolder drawing, as in the winter tree study (see page 67).

Scribbled line

Crosshatched tone

Crosshatched tone using two tip sizes

Scribble softened with wet finger

Circular scribble

Short open strokes

Short textural strokes

Directional scribble

You will need

- Basic equipment (see page 8)
- Sheet of smooth drawing paper
- HB pencil
- Black marker pen with ³⁄₁₆-in. (5-mm)-wide chiseled tip
- Black fine-line felt pen
- Putty eraser

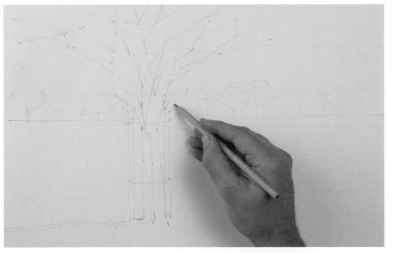

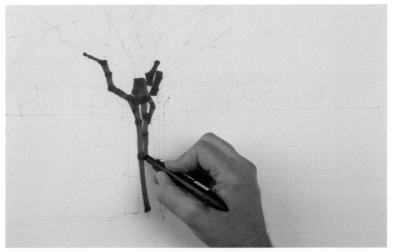

1 Use the HB pencil to lightly map out the subject. Ignore detail and concentrate on the strong elements in the scene. Draw in the position of the foreground tree and indicate the main boughs. Sketch out the trees in the distance.

2 Now use the broad side of the chisel-tipped marker pen to start drawing in the trunk and larger branches. As you draw, pause at intervals without lifting the pen to make a darker mark on the paper that adds texture to the trunk.

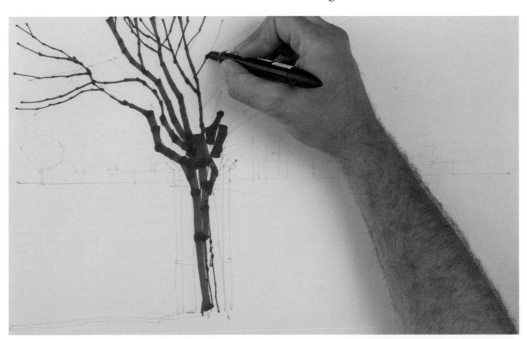

3 Turn the pen and use a sharp edge to add finer lines for the thinner branches. Pause as you draw your lines as before. The darker marks made by moving the pen in this way cleverly suggest the joints and knots in the branches. Experiment with this technique on a spare piece of paper if you are not used to working with a marker pen.

Artist's tip

Use a paper with a smooth or "hot-pressed" surface that won't absorb the ink. A more absorbent paper works like blotting paper and soaks up some of the ink so that the felt pen marks are less crisp and lack intensity.

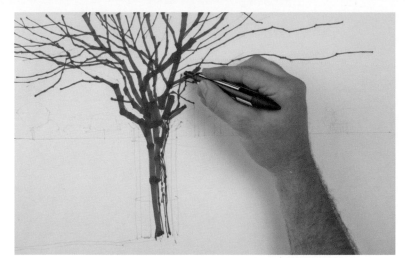

4 Continue adding to the tangle of branches that form the canopy of the tree. Be selective and don't attempt to draw every branch—edit what you see as you begin to build up expressive marks that suggest the nature of the leafless tree.

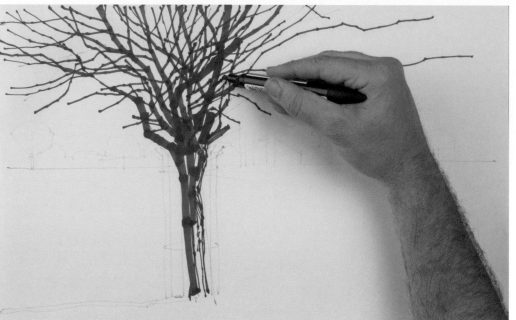

5 Hold your pen loosely and twist and turn it as you work so you use different edges of the pen to vary the thickness of the line. Cross over some of your earlier marks to create a sense of depth as you continue to build up the network of branches.

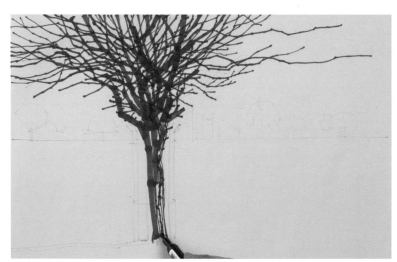

6 Add marks to increase the density of the branches. Use light pressure, letting the pen do the work. Add small strokes for the short twiggy ends. Turn the pen to add finer lines to the trunk, keeping them open to suggest the lighter side of the tree.

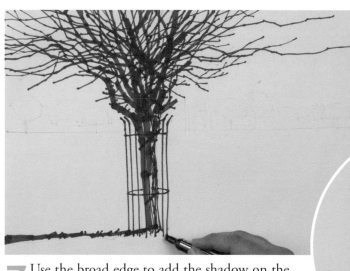

7 Use the broad edge to add the shadow on the ground, twisting the pen to use the thinner edge to suggest blades of grass. Then use the pointed corner of the pen to draw the railings around the tree.

Up close
Fully exploit the versatility of your pen and use it to create long, smooth lines for the metal railings around the tree, or short staccato marks to suggest blades of grass. The broad side of the tip creates interesting textures and suggests the shadow beneath the tree in a single sweep.

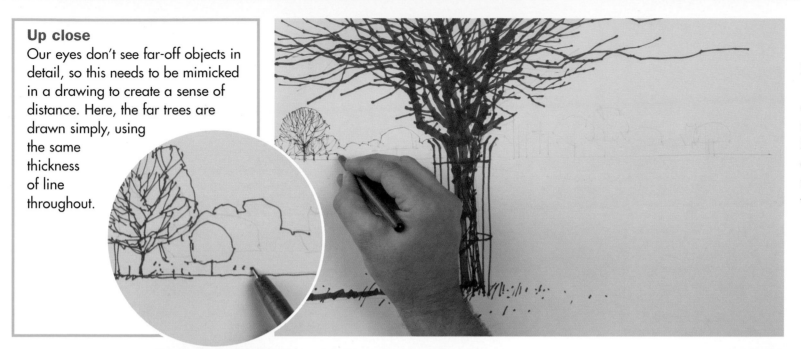

8 At this stage, stand back and assess your drawing. Add a few more twiggy lines if necessary, but don't overdo it.

Then turn to your fine-line pen to start drawing the distant trees. Again, hold the pen loosely and use a light, smooth line to indicate the outer edge of the tree canopies. Add a few branches to the nearer trees and thicken up the trunks slightly with more lines.

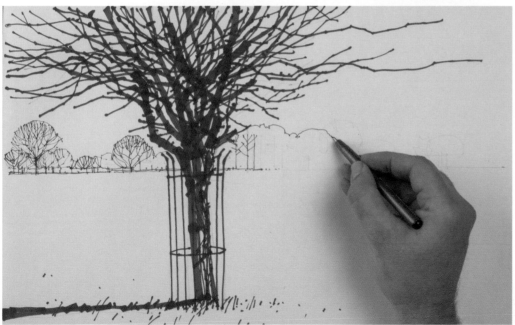

9 Continue working across the line of distant trees, adding a few horizontal lines for the ground. Indicate the farthest trees in outline only—in reality, a mistiness on the distant horizon makes it hard to pick out details. Suggest just a few of the branches on the closer trees—the eye will fill in the rest.

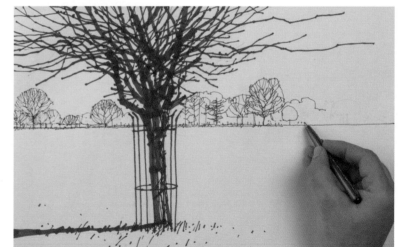

10 As you continue drawing the distant part of the scene, notice the different types of trees and their varied and characteristic silhouettes and hint at these in your drawing. Anchor them to the ground with more horizontal lines.

11 Complete the distant line of trees. Then turn your attention back to the main tree and use the fine-line pen to draw in some twigs. This will add more texture to your drawing and a density to the mesh of the tree's canopy. Use short lines and brisk strokes to indicate the fine, brittle twigs. Look at the way they grow out of the thicker branches and try to capture the pattern of their growth. Vary their length, since foreshortening will make some twigs appear shorter than others. If they are all drawn the same length, your tree will look two-dimensional.

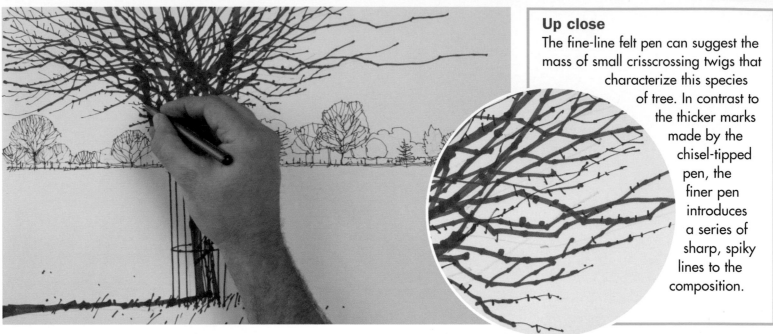

Up close
The fine-line felt pen can suggest the mass of small crisscrossing twigs that characterize this species of tree. In contrast to the thicker marks made by the chisel-tipped pen, the finer pen introduces a series of sharp, spiky lines to the composition.

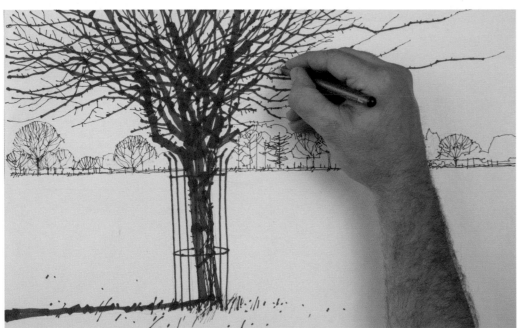

12 As you draw each twig, leave the pen on the paper for a second at the end of each line. This finishes each twig with a small dot that suggests the little nodules you find at the ends of bare twigs where flower and leaf buds appear in spring.

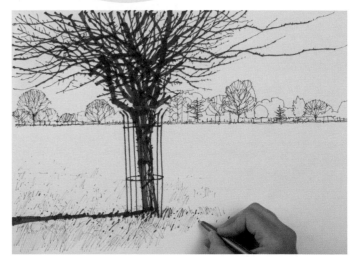

13 Still using the fine-line pen, add a variety of quick scribbles and dashes beneath the tree to suggest the grass in the foreground. Remember, you are creating an impression, not drawing in detail.

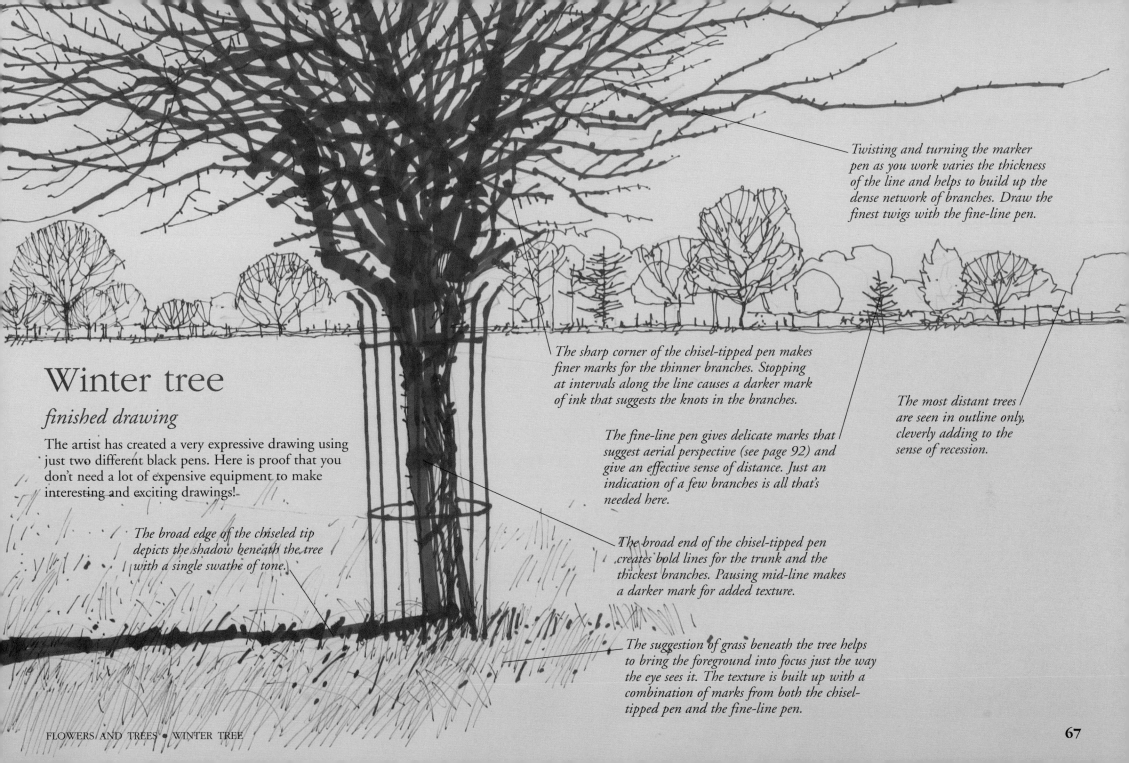

Twisting and turning the marker pen as you work varies the thickness of the line and helps to build up the dense network of branches. Draw the finest twigs with the fine-line pen.

The sharp corner of the chisel-tipped pen makes finer marks for the thinner branches. Stopping at intervals along the line causes a darker mark of ink that suggests the knots in the branches.

The most distant trees are seen in outline only, cleverly adding to the sense of recession.

The fine-line pen gives delicate marks that suggest aerial perspective (see page 92) and give an effective sense of distance. Just an indication of a few branches is all that's needed here.

Winter tree

finished drawing

The artist has created a very expressive drawing using just two different black pens. Here is proof that you don't need a lot of expensive equipment to make interesting and exciting drawings!

The broad edge of the chiseled tip depicts the shadow beneath the tree with a single swathe of tone.

The broad end of the chisel-tipped pen creates bold lines for the trunk and the thickest branches. Pausing mid-line makes a darker mark for added texture.

The suggestion of grass beneath the tree helps to bring the foreground into focus just the way the eye sees it. The texture is built up with a combination of marks from both the chisel-tipped pen and the fine-line pen.

QUICK REVIEW

After the initial underdrawing in pencil, the artist drew the thickest lines before moving on to the medium-sized marks. His manipulation of the chisel-tipped pen allowed for a variety of different marks. He then switched to a finer pen to add the finer lines.

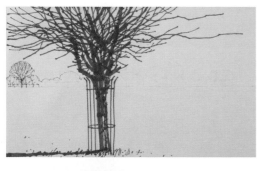 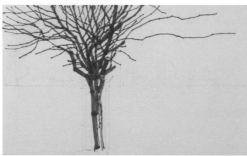 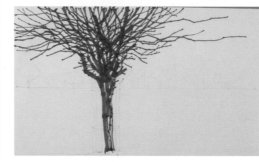 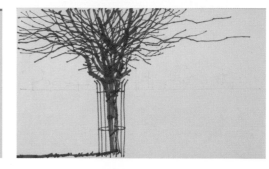

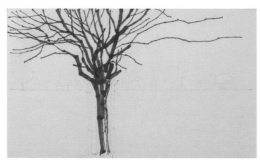 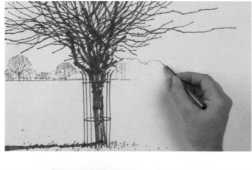 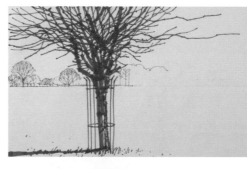 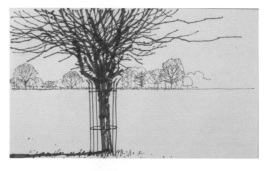

② Four roses
a flower drawing in colored pencil

Flowers are an endless source of inspiration for the artist. Before photography, artists drew or painted plants in great detail so that botanists had a record from which to study. Even with today's easy-to-use cameras, an intimate floral study is still a rewarding subject to tackle. By drawing flowers, you get a chance to hone your powers of observation.

You may decide to make a study of a single bloom, or you might opt for the slightly more ambitious approach and put together a pleasing composition of several separate flowerheads. This artist chose to work on dark paper for a dramatic end result. If you think flower drawings lack impact, you are in for a pleasant surprise!

◀ *Don't expect to find the perfect arrangement growing in your garden. The artist working on this project photographed different roses at various times and put her photographs together to create a well-balanced and interesting study.*

Using colored pencils

Most of us first used colored pencils when we scribbled in coloring books as children. Take another look at them and you'll quickly discover that they are a versatile and expressive medium for the artist. Colored pencils are inexpensive and clean and easy to use, but more than this, you can use them to produce anything from vigorous and expressive sketches to delicately detailed and carefully shaded drawings. Use them for linear work or combine colors in a number of ways to produce lively shaded and textural effects.

There are many different makes of colored pencil, and most are available in a wide range of colors. Some are hard and maintain a point to give precise lines. Others are softer and produce bold lines and areas of solid color.

Artist's tip

You can buy colored pencils in sets or singly. Take advice from your art store, and take your time testing them before you buy. Decide which shape you prefer, round or hexagonal, and whether a harder or softer type best suits your purposes. The colors in a small set are all you need to give you plenty of scope for mixing and blending a host of tones and shades.

CHOOSING THE RIGHT PAPER

You can use almost any type of paper for colored pencil. Smooth paper is fine for line drawings and lightly shaded effects. A textured paper will create interesting broken-color effects. And for layering colors you'll need a pastel paper with tooth.

As for paper color, neutral tones are suitable for any colored pencil work, while strong colors can be allowed to show through open hatched tones to add an extra dimension. Dark tones can provide a powerful contrast to enhance the image. For example, in the roses drawing, the dark paper emphasizes the paleness of the flowers (see page 77).

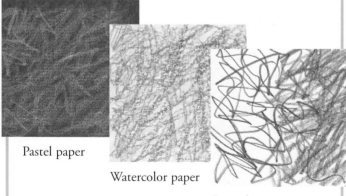

Pastel paper

Watercolor paper

Smooth paper

The look of the pencil marks is affected by the paper surface.

The shape of pencil you choose can influence the way you draw. Round ones turn easily as you work, which is good for varied, free-flowing lines and looser drawing. Hexagonal ones are more stable to grip for fine details and lines. Try both to see which you prefer.

Colored pencils in practice

Colored pencils produce lines that range from very fine and controlled to bold and expressive. The sharpness of the point gives endless variations. You can use them to create areas of solid color, or use open techniques for broken color effects and optical mixes. Before you start the roses drawing, get to know the capabilities of colored pencils by playing with them on different kinds of paper and enjoy the huge variety of effects you can achieve.

Mixed-color crosshatching

Mixed-color scribble

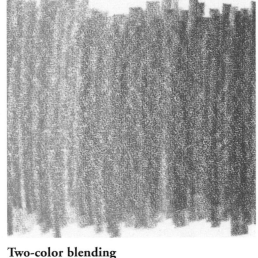

Two-color blending

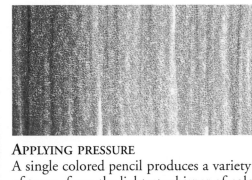

APPLYING PRESSURE

A single colored pencil produces a variety of tones, from the lightest whisper of color through to a deep intense shade. Very light pressure creates a pale tone, more pressure makes a mid-tone, and firm pressure a dark tone.

Impressed lines scribbled over with pencil

Broken color mixing

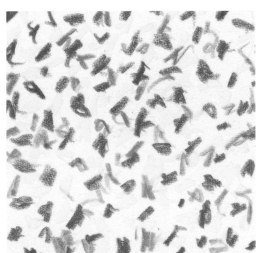

Optical color mixing

CREATING HIGHLIGHTS

You can't completely erase colored pencil marks, especially if they are made with too much pressure, so add successive layers lightly until you have the depth of color and tone you want. Then you can work into the color gently with a plastic eraser to remove some of the pigment and burnish out highlight areas.

You will need

- Basic equipment (see page 8)
- Sheet of lightweight white paper
- HB pencil
- White chalk
- Sheet of dark blue pastel paper
- Red ballpoint pen
- Colored pencils: Chinese white, cadmium yellow, orange, vermilion, light violet, spectrum blue, kingfisher blue, leaf green, emerald green, indigo, lemon yellow
- Putty eraser

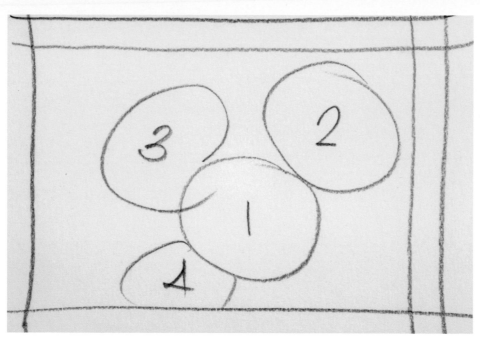

1 For this project, the artist used four different photographs to create her composition. If you want to work like this, number each photograph and make a quick sketch to position each flower. Number the sketch and the photos to avoid any confusion. This artist has decided that the rose numbered 1 is to be the main focus of the composition and has placed it in the middle, slightly off center.

To give more guidance for the less experienced, the artist has also used a technique that transfers an initial drawing on inexpensive lightweight paper to the dark blue pastel paper used for the final drawing. So beginners can do several drawings on white paper before choosing the one they want to transfer.

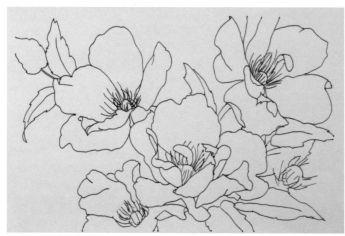

2 Make a line drawing of the roses on lightweight white paper using an HB pencil. (This line drawing has been traced over in pen so that it shows clearly.) Doing an initial drawing on spare paper means you can erase any mistakes without damaging the surface of the pastel paper.

3 Turn the line drawing over and use the side of the chalk stick to cover the back of the lightweight paper with white chalk. Attach the drawn design to your pastel paper chalk side down using low-tack masking tape.

Draw over your lines so they are imprinted in white chalk on the dark pastel paper. Use a strong-colored ballpoint pen so you can see where you have traced. Check that the transferred lines are visible—if not, lift the lightweight paper carefully and add more chalk.

4 When your drawing is safely transferred, attach the dark blue pastel paper to your drawing board with masking tape. Stick the strips of tape so they make a frame around the paper. This gives you an edge to frame your composition and also enables you to turn your drawing around if you want to work in another direction to avoid smudging.

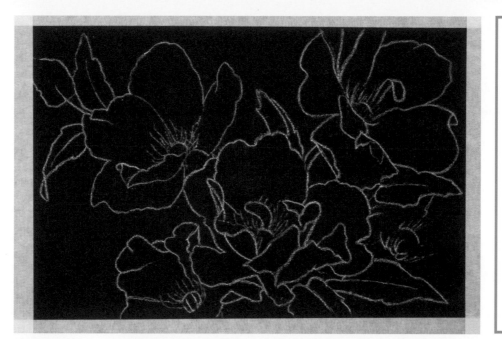

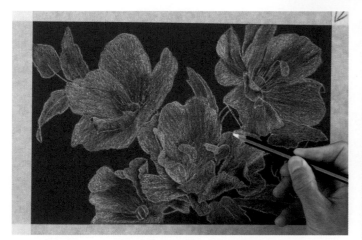

5 Begin to lay down some color in the lightest areas using light, even strokes of the pencil to create a foundation that you can build on later. Block in the leaves with leaf green, then use Chinese white to establish the brightest parts of the petals.

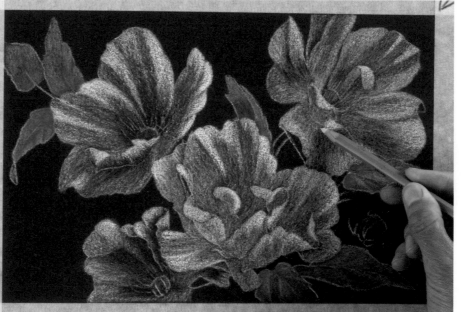

6 The light is coming from the right in this composition. Note the parts of the petals that face the light source, and continue using Chinese white to strengthen these areas of brightest tone. Use a dusting of cadmium yellow to warm the centers of the flowers and to pick out lighter tones on the leaves.

7 Continue using cadmium yellow to layer more color toward the center of the flowers. Deepen the inner areas further with a little orange, feathering it out into the yellow so the colors blend with no hard edges. Continue adding layers of yellow and white to deepen the tones, working up each petal in the same way.

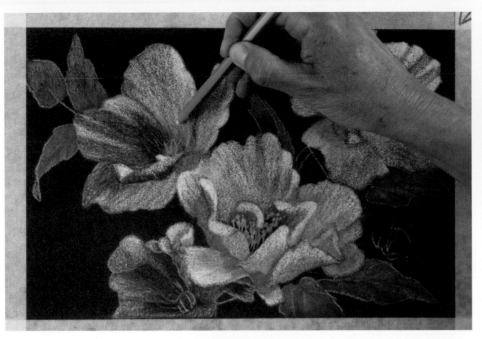

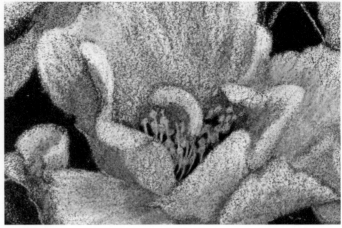

8 Add the detail of the stamens at the center of the flower. Begin by drawing them in with Chinese white. Then add some orange and vermilion to deepen their tone. Darken some of the tips, too.

Up close
To create a strong tonal contrast known as "counterchange," darker colors were used to deepen the background in the areas around the lightest edges of the petals and the rose stem. Here it helps to emphasize the flowers and gives a sense of depth to the drawing.

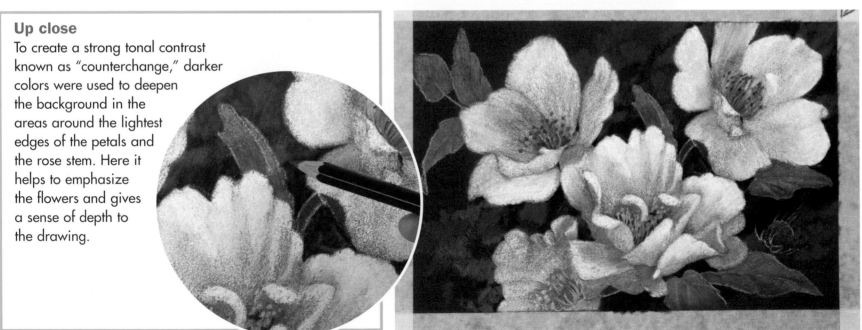

9 Now add some color to the background with a mixture of light violet, spectrum blue, kingfisher blue, leaf green, and emerald green. Vary the direction of your strokes to build up tone and texture behind the flowers. Blend the colors together and then add more layers to deepen the intensity of the effect.

10 Work around the stem of the top right-hand rose with some indigo. Use emerald and leaf green in the areas between the flowers to indicate leaves, picking out highlights with the lemon yellow. Don't go into too much detail on these leaves, or the contrast between the petals and the background will be lost and the flowers will not stand out as much as they should.

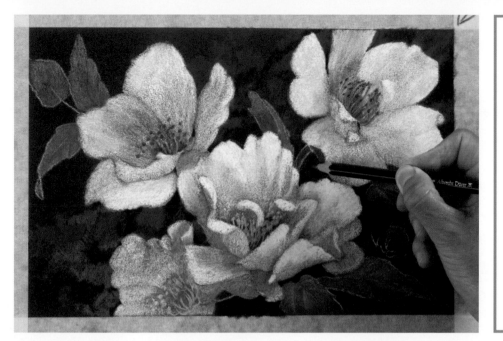

Artist's tip
To keep the composition of this picture tight and to draw the eye to the focal flower in the group of blooms, the artist has made sure that the area around that flower includes both the lightest and the darkest tones of the colors used.

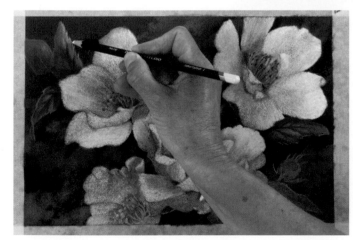

11 Use lemon yellow to add a base tone to the dead flowerhead at bottom right. Pick out the highlights on the leaves with the same color, then deepen the veining with emerald and indigo.

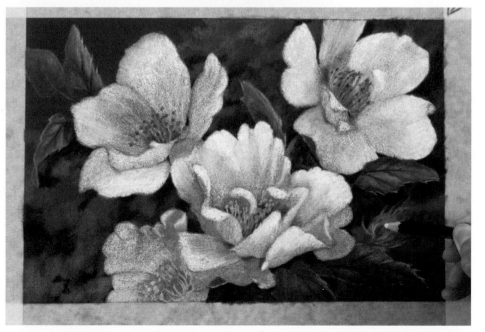

12 Add more detail to the dead rose head. Use more lemon yellow, then darken the tone with orange. Lighten the sepals and stamens with Chinese white and more lemon yellow, then deepen the tips with vermilion. Finally, stand back and assess your work to identify any areas that need adjustment.

Four roses

finished drawing

Colored pencils can be used in different ways. Here the color is built up slowly using almost no pressure. This means there are no visible individual pencil marks on the petals, just a subtle gradation of tone that perfectly imitates the smooth, waxy petals of the flowers.

Sharpened pencils add accurate details such as the stamens. The color between the stamens helps to show the detail.

Lightly applied layers of cadmium yellow and Chinese white build up the tones of the delicate rose petals. A final dusting of yellow darkens the color toward the center of the flowers.

Orange deepens the center of the flowers still more. The colors are carefully blended into each other so there are no hard lines.

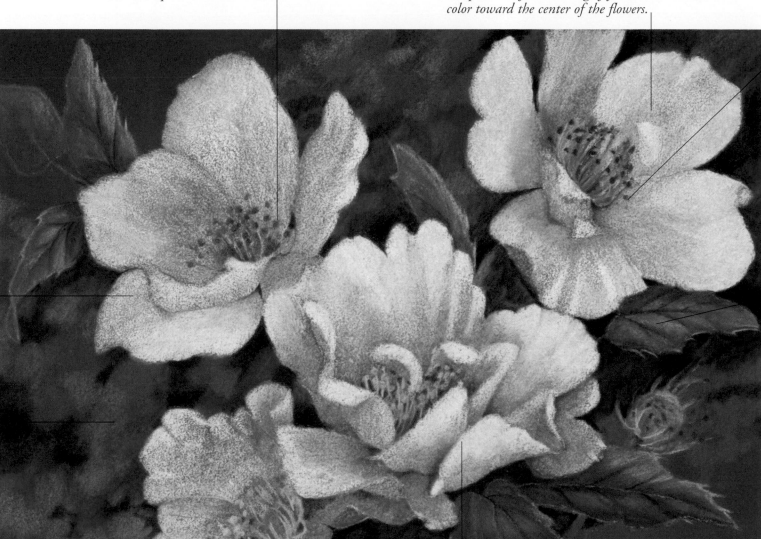

The fine surface texture of the paper breaks up the pigment from the pencils very slightly so that the colors aren't flat and dull.

Violet and yellow are "complementary" colors— they play off each other to add visual excitement, and the touches of violet in the background serve to emphasize the pale yellows of the petals.

The leaves need subtle handling as well. Overlaid colors do the trick here, too; then the veins are drawn and the highlights added. The edges of the leaves are highlighted in lemon yellow in a final finishing touch.

Extra white is layered in the lightest areas where the light glances off the petals.

QUICK REVIEW

A review of the progress of this project shows how the final image was created by carefully building up the different colors. The picture began with a simple line drawing. After that, areas of color were blocked in to define the shapes of the flowers.

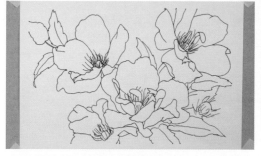

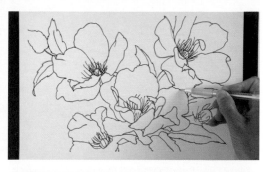

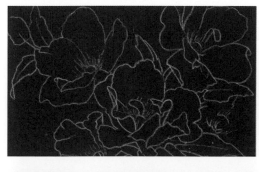

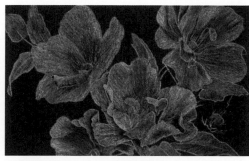

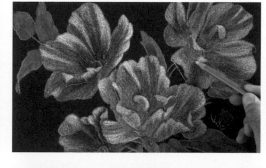

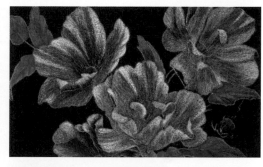

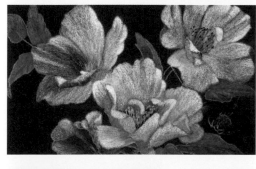

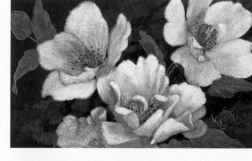

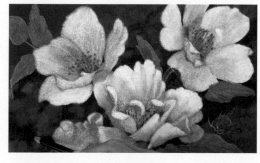

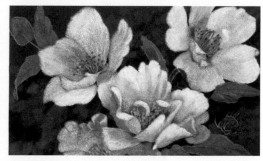

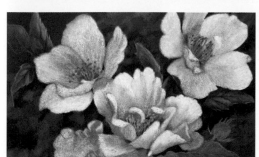

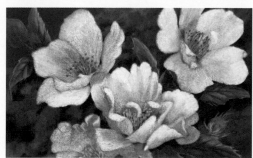

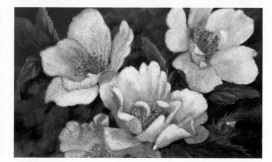

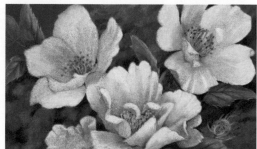

③ Summer display
a vase of flowers drawn in pastel sticks

A vase of flowers is a favorite choice for many artists. This may seem quite a complex subject to tackle when you're a beginner, but you can achieve pleasing results if you follow some basic guidelines.

Keep in mind the underlying forms in each flower. This will help you understand what you see. Take note of the negative spaces, too—they are a useful aid as you map out the subject. Explore the rhythm and movement within the arrangement and the overall shape that it makes, and reflect these in your drawing.

◀ *The soft colors of mauve sweet peas and apricot-pink cobea flowers are in perfect harmony with the gray-green of the foliage.*

Using soft pastel sticks

Pastel sticks are soft, smooth, and give wonderfully quick results. You can cover broad areas rapidly with swathes of color, mix and blend endless tones and colors on the page, and incorporate line work,

CHOOSING THE RIGHT PAPER

As with other soft mediums, it's essential to use a paper with tooth to retain the powdery pigment. Use the sticks lightly so the paper texture is visible through the color, adding visual interest. Work more heavily or add more layers to fill the surface and create areas of unbroken color.

Use a toned paper to enhance your drawing. White paper makes it harder to judge color values and can create a distracting speckled effect through soft pastel marks. However, you can put this to good use if it adds to the mood of the subject. Try watercolor papers to see the effect of the texture on the pastel marks.

White paper

Blue paper

Black paper

Notice the effect the colored-paper background has on the intensity of the colored pastel strokes.

too. Small wonder that the technique of drawing with soft pastels is often called "pastel painting." Moreover, pastel sticks are easy to use and kind and forgiving for the beginner.

The key to success is not to overwork pastels. Too much mixing and blending leads to a dull and lifeless image. Try them out, use a light touch, exploit their possibilities, and enjoy their versatility. Use them on their own or to add exciting touches of color and texture to pencil or pen drawings.

Soft pastels are available in sticks of different sizes and many vibrant and inspiring colors. They vary in softness, so ask your art store for advice and try a few single ones first before you invest in a boxed set. Shown on top of the box of pastels is a torchon. This is a tube of paper rolled to a point. You can use it to blend pastel colors on a drawing, but many artists prefer to use a finger or a tissue instead.

Soft pastel sticks in practice

The side of a pastel stick makes varied marks. You can cover broad areas quickly with swathes of intense color, and create varied tonal effects or mixed colors with simple blending or optical techniques. Their softness makes them unsuitable for very fine details, but you can incorporate line work into your drawing with the blunt tip. For more delicate lines, shave the tip of the pastel sticks to a point with a craft knife or sharpen on sandpaper.

Long marks using side of stick

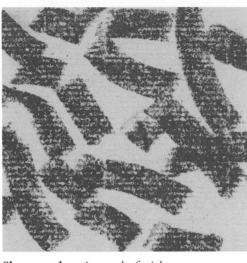

Short marks using end of stick

Scribble using a sharpened stick

Thick and thin lines made by turning stick

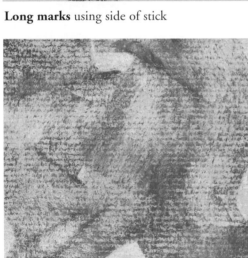

Mixed colors using side of stick

Mixed colors using end of stick

Blended colors using side of stick

Keeping things clean

Pastels are messy. Keep a clean, damp cloth at hand so you can wipe your hands frequently to avoid transferring unwanted smudges to your drawing.

Protect the drawing with a clean sheet of paper on which to lean your hand. And preserve the finished drawing with fixative spray—a light mist is enough; too much might affect the colors.

You will need

- Basic equipment (see page 8)
- Sheet of pearl-gray pastel paper
- White pastel pencil—medium
- Soft pastel sticks: white, pale apricot, pale lime green, apple green, earth green, fir green, crimson pink, cyclamen pink, dark warm purple, cobalt blue, light blue, pale blue-violet
- Putty eraser

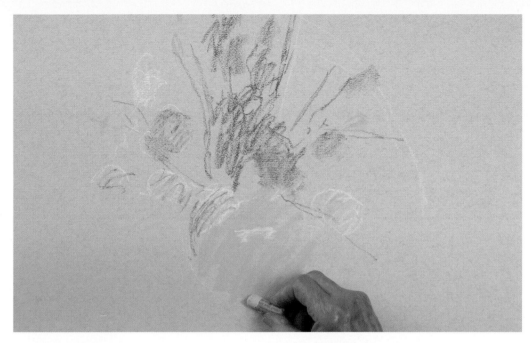

1 Using white pastel, lightly map out the overall position and shape of the arrangement. Use your mid-green tone to indicate leaf groups and the main stems. Sketch in the blooms in appropriate colors. Block in the general shape of the vase with light blue and add the highlight. Work very loosely with no attempt at detail, and be prepared for things to change as your drawing develops.

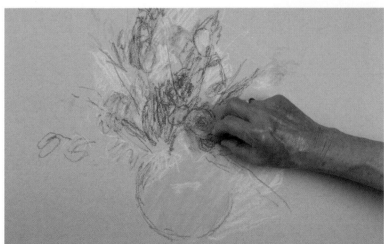

2 Use the negative shapes between the flowers and foliage as a visual guide, and use the vase as a reference point to plot the position of each element. Develop the central area with some of your darker tones as you begin to work your way into the subject.

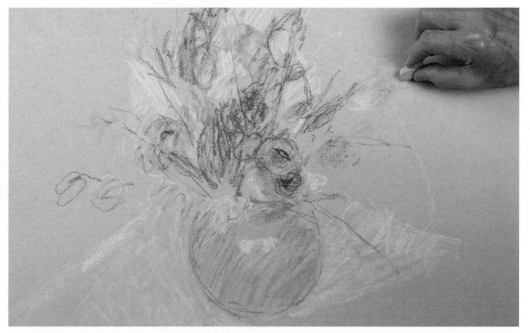

3 Add some areas of neutral color to the background. This will help the stronger colors stand out. Roughly block in the tablecloth to act as a guide when building up the composition. Don't worry if any of your earlier marks need to be changed. Use the putty eraser to lift color off.

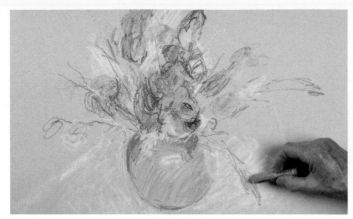

4 Strengthen the shadow side of the vase with cobalt blue and check the positions of the flowers in relation to its strong shape. Block in the lighter green areas of foliage with apple green, and soften the color with a mist of white over the top.

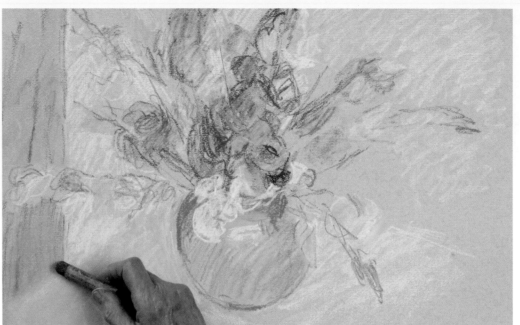

5 Begin to add firmer marks to delineate some of the flower and leaf forms once they are in place. Notice the intensity of some of the colors and the depths of tone that occur across the image.

Use the stronger tones in your palette to imitate these. Sketch in some background to help you check the accuracy of your drawing.

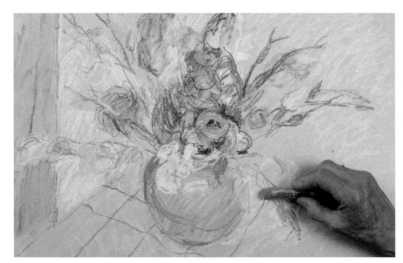

6 Continue adding the deeper tones. Using the cobalt blue, draw in a few of the lines on the tablecloth. These lines give the vase a sense of place and help you check the relative positions of the flowers.

7 Begin to work up areas of detail across the image. Color mix on the page, laying one light layer on top of another. Lighten some of the negative shapes between the leaves to create lively contrasts.

Up close
If you look at your setup carefully, you may see some areas of reflected color. Here there is a patch of pink reflected onto the tablecloth beneath the vase and a bright edge of yellow around the base. Include these for a livelier finished picture.

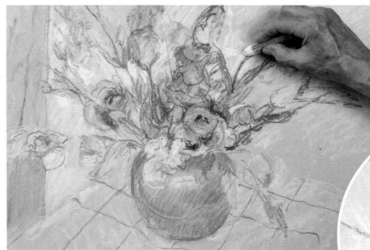

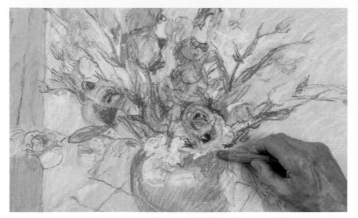

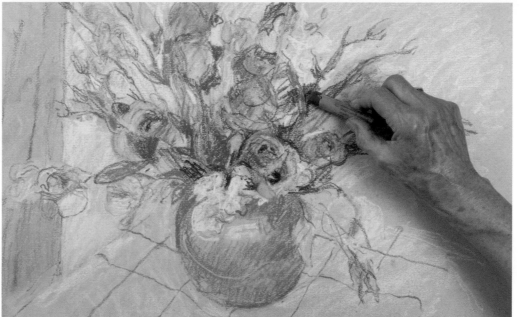

9 Add detail to the flower stems with the fir green. Use the sharp edge of the pastel to make linear marks; create broader swathes of color with the side of the stick. Note the differences between the stems of the different plants. Keep the drawing open and allow the paper to show through in places.

8 Search out the darkest areas of foliage and use the earth green to deepen the tone of these areas where they occur behind the pale flowers. Creating contrasts of color and tone in this way will bring the blooms forward and help your drawing look three-dimensional.

Up close
Soft pastel is not the medium for drawing in precise details. A loose suggestion of what you observe will convey enough information while creating an exciting drawing. In this case, the viewer is certain as to the shape and form of these blooms, yet the artist has used minimal detail.

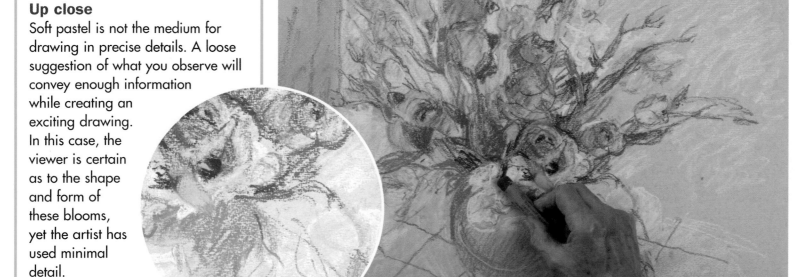

10 Pastel allows you to work over your drawing so that you can add anything you've missed. Look at the setup and add in any details that you've left out so far. You can be more emphatic and committed now because you know everything is in the right place. Add a little more emphasis here and there to liven up the image, but don't overdo.

Finally, sit back and assess your drawing. Check the balance of tones and detail across the picture. Make sure you haven't worked into one area too much at the expense of another. Looking through half-closed eyes can often reveal imbalances.

Summer display
finished drawing

Soft pastels are a wonderful medium for this subject. You can work loosely and freely to create a lively and expressive image that conveys the essential nature of the flowers.

Broad strokes of color hint at the shapes of the flowers, while contrasting linear marks indicate the stems and leaves and bring them more sharply into focus.

A few quick lines with a sharp edge of the pastel stick are enough to suggest the petals wrapped around each other in bud.

The neutral, muted tones in the background make the more vibrant colors of the flower arrangement and the vase stand out.

The darkest green tones make the foliage recede and bring forward the central blooms.

Nothing is dominant, but small areas of emphasis, such as the speck of orange in the flower's center, keep your eye moving across the picture.

The squared pattern of the cloth provides a contrast with the curving rhythms of the stems and flowers.

The unexpected orange reflection beneath the vase attracts the eye.

QUICK REVIEW

Note how drawing with pastel is different from making a line drawing with pencil or charcoal. The artist has built up the drawing by layering areas of color rather than outlining the shapes and filling them in. The composition is also interesting. For extra impact, the ends of some of the flowers continue outside the picture area.

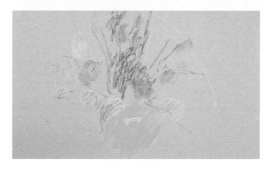
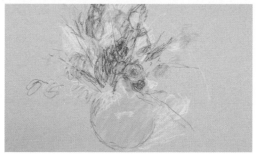
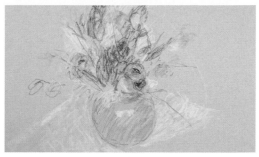

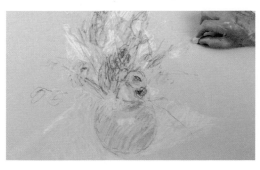
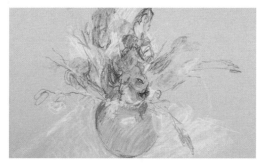
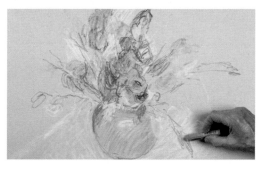
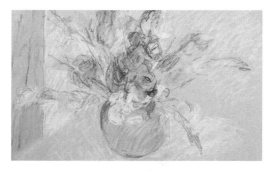

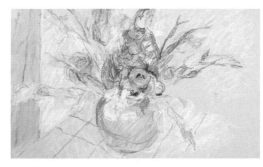
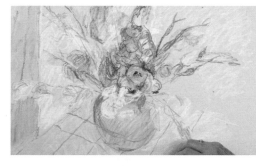
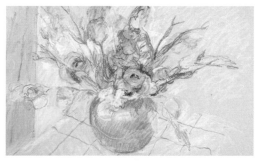
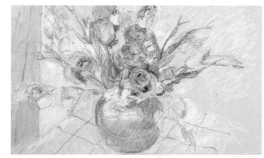

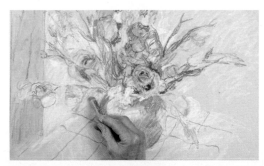
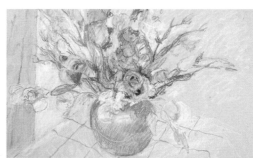
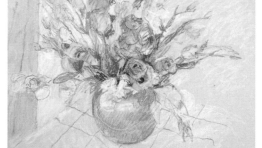

Landscape

Drawing landscapes

Landscape is a varied theme for artists. It isn't confined to wide vistas of open countryside but includes absolutely any outdoor scene. An intimate garden view, a street scene, a portrait of a single house, a close-up study of a rock pool, or even a drawing of a window box is as much landscape as a breathtaking mountain scene.

WORKING OUTDOORS OR INDOORS

You can work from photographs, but don't rely on your camera. Part of the fun of landscape drawing is working in the field. When you are on location, you experience firsthand the weather, the light, and the atmosphere. And drawing is not just an activity for a warm summer day—winter conditions reveal a familiar scene in a very different mood. If the weather gets really bad, turn your car into a mobile studio or use your sketches and photographs to finish the drawing at home.

DEPICTING THE MOOD

Landscape drawing enables you to study the sky in all its varied aspects. The sky is the source of light and weather and dictates the mood of the subject. Just as a landscape changes with the season, so it changes with the weather. A scene that looks dramatic and forbidding under

a stormy sky looks open and benign on a sunny day. The sky is an important feature in any landscape drawing, regardless of how much you include in your composition. Observe it, marvel at it, and draw it at every opportunity.

Remember, you are in charge of the finished image. Be selective and edit out any feature of the landscape that detracts from the composition. That way, your drawing reflects your personal experience of the scene before you.

Composing a landscape

When you draw a landscape, it's essential to be selective. Artistic license allows you to manipulate what you see in the interests of a pleasing picture. Carefully choose what to include, leaving out any elements that are unsightly or disturb the composition. Then frame or crop the view to create an exciting image.

It can be hard to know how to approach a huge landscape. Rather than plunge straight in and attempt to draw the whole scene, you can resolve this problem with the help of a viewfinder (see page 19). First decide what aspect of the scene appeals to you. You may be excited by the cloud effects, say, or the play of light and shade on trees and buildings. With this in mind, scan the scene through your viewfinder—a pair of L-shaped brackets is ideal—and see what possibilities it has to offer. You can do this effectively whether you are working from a photograph or drawing on the spot.

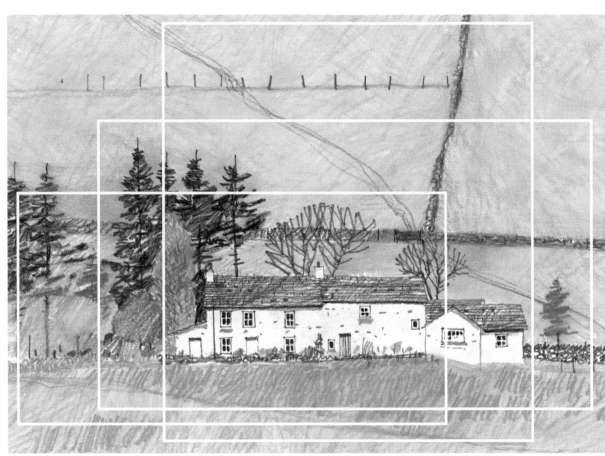

Seen in its entirety, the countryside this scene was taken from seemed pleasant but rather bland, with no discernible focal point. Once the selected fragments were isolated and cropped, interesting compositions emerged.

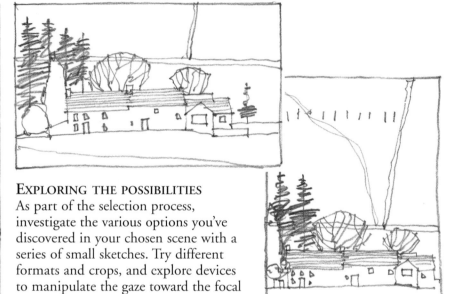

EXPLORING THE POSSIBILITIES

As part of the selection process, investigate the various options you've discovered in your chosen scene with a series of small sketches. Try different formats and crops, and explore devices to manipulate the gaze toward the focal point—for example, a winding road, a fence, a line of trees, or echoed colors.

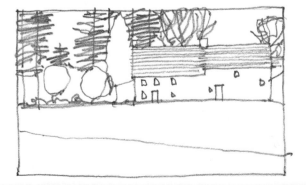

Positioning the horizon

The horizon in a landscape drawing divides the scene in two. It's an important element in the composition of an outdoor drawing and has a powerful effect on the general mood of the overall scene, so you need to give it some thought when you plan your landscape.

A centrally placed horizon can create a mundane composition that's hard to handle effectively. A common solution is to place the horizon roughly one third from the top or bottom of the picture area (see page 18). This creates a far more exciting and dynamic effect than a central horizon.

Of course, the position of the horizon dictates how much sky you include. The sky is the source of light and changes with the weather, so it influences the appearance of a landscape. Consider the atmosphere you want to convey—a large expanse of turbulent cloud will create a moody sense of drama, while a small strip of tranquil blue sky will have a benign and peaceful effect.

Before deciding on your horizon position, make a few quick sketches to experiment with it in different positions. Then use the one that creates the effect you want to achieve.

 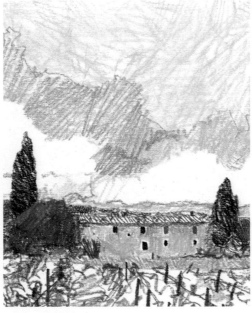 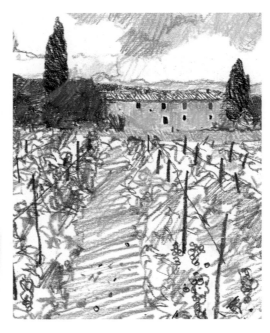 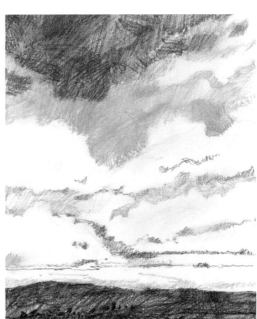

CENTRAL HORIZON
A central horizon in a landscape drawing gives equal emphasis to land and sky. This can result in a dull composition, with little opportunity to exploit the drama in a scene. In this case, nothing draws the viewer's eye around the image and the attention instead is confined to the center of the scene.

LOW HORIZON
With a low horizon the large expanse of sky can be exploited for maximum dramatic effect. Cloud formations and weather conditions and their effects on the landscape become more apparent, and the result is open and spacious. Notice the impact this drawing has compared to the one to its left.

HIGH HORIZON
With only a small strip of sky visible in a high horizon, the mood of the scene depends on the composition of the land area in the foreground. The vines and grapes in the drawing above create visual interest. The off-center path cuts a swathe into the middle distance, but there the eye is abruptly halted.

UNDERSTANDING CLOUDS
Use your sketchbook when you're out and about to record varied skies and cloud effects. They'll help you practice your observation and drawing skills and provide useful reference for later drawings. Depict their shadow side to give them a sense of volume and three-dimensionality.

Working in the field

Drawing outdoors is a stimulating experience, and the more you do it, the more confident you'll get. A camera will record a scene effectively, but it will not capture the subtle nuances of light or the atmosphere. So it's a good idea to at least start your landscape study on the spot.

If you haven't drawn in public before and want to be as discreet and invisible as possible, keep it simple and take just a small sketchbook and a few pencils. However, for a full-blown landscape drawing session in the field, take the equipment suggested in the box at right.

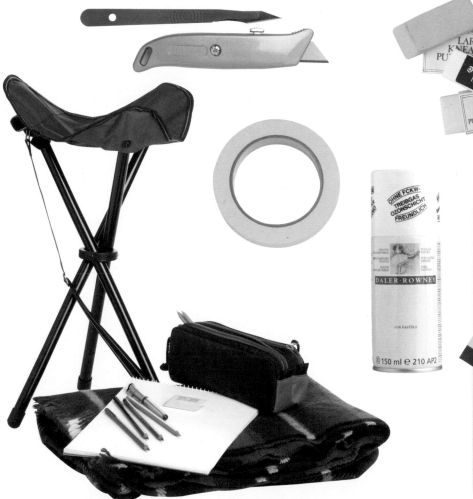

EQUIPMENT

First of all, be sure to equip yourself properly. This is for pleasure, not an endurance test, so make sure you'll be comfortable, dry, and warm! You may plan to sit on a park bench or at a café table, or you may find yourself sitting in the corner of a damp field.

Take a waterproof blanket to sit on, and if you're not happy sitting on the ground, try a lightweight folding stool. If you become seriously addicted to outdoor drawing, consider investing in a folding sketching easel. And take some refreshment—a hungry, thirsty artist is not a happy artist.

For your drawing equipment you'll need a strong bag that's roomy enough to hold everything. After that it's largely a matter of personal choice. Here's a suggested checklist:

- A hardback drawing pad or sketchbook, or a small drawing board with sheets of paper.

- Binder clips to secure your drawing paper and prevent it from flapping in the breeze.

- Nonsmudge drawing tools—a selection of graphite pencils, fiber-tipped or ballpoint pens, and colored pencils—and a pencil case to keep them in.

- An eraser for eliminating errors and creating highlights.

- A craft knife or artist's scalpel to sharpen pencils, safely housed inside its safety cover.

- A small bottle of fixative spray to protect soft pencil drawings.

- A roll of masking tape—this has many uses, so never be without one.

① Mountain scene
understanding aerial perspective

A hilly landscape can provide the ideal opportunity to study the effects of aerial perspective. The hills become less distinct as they recede into the distance, and the atmospheric conditions obscure detail and affect the colors that you can see. In this project the house in the foreground has been drawn in sharp focus, while the valley and far hills have been suggested in a more generalized way to create a sense of distance.

The artist chose pastel pencils in order to create both soft shaded effects and sharp details. He used light, open marks to build up layers of pigment, allowing one color to show through the next, leaving the viewer's eye to do some of the mixing.

For this drawing, the artist drew from a photograph, first tracing it to plot the main points onto his paper (see "Artist's tip," page 93). Working this way can instill a lot of confidence while providing very impressive and realistic results.

The high horizon leaves only a small area of sky visible, so the viewer's attention is concentrated on the landscape. ▶

Aerial perspective

You will notice that when you look at a landscape, the farther away things are, the less distinct they become, while closer scenery is in sharp focus. This isn't due to poor eyesight. It's the effect the atmosphere has on the light, which causes colors to change and details to be obscured. This effect is known as "aerial perspective."

Look again at a landscape. Notice how colors appear bluer toward the horizon and there's less contrast between light and dark. There is also less definition; details are lost in the distance, and everything appears muted and soft. If you try to imitate these effects in your landscape drawing, you'll create a real and believable sense of recession and space.

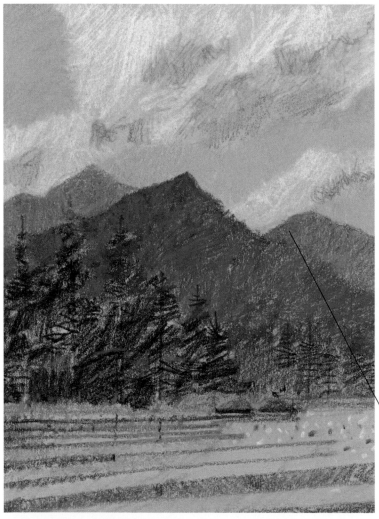

PASTEL PENCIL
For a colored drawing medium, such as pastel or colored pencil, describe the effect of aerial perspective with colors that are bluer and softer toward the horizon and use generalized hints of texture.

To advance the foreground, fill it with warmer colors, greater tonal and color contrasts, and sharper details that attract the eye.

Drawing the hills at the back with soft blues makes them appear distant.

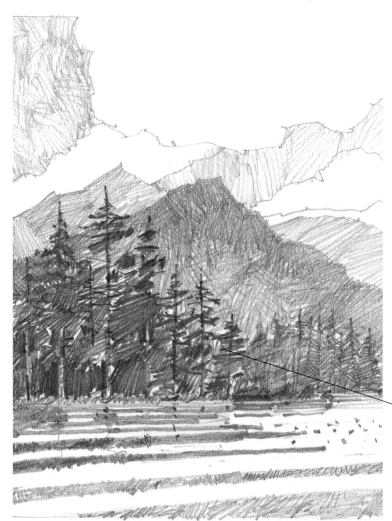

GRAPHITE PENCIL
If you are working in a monochrome or single-color medium, such as charcoal or graphite pencil, imitate aerial perspective by using paler tones, lighter lines, and less detail in the distance.

To bring the foreground into focus, use more precise details, emphatic textures, and stronger contrasts in tone.

The strong, bold lines of the trees make them appear closer than the lightly drawn hills in the distance.

You will need

- Basic equipment (see page 8)
- Tracing paper
- Graphite paper
- HB pencil
- Sheet of blue-gray pastel paper
- Pastel pencils: white, light ochre, dark sepia, light green, earth green, olive green, light ultramarine blue, cobalt blue, purple, black
- Putty eraser

Artist's tip

If you are drawing from a photograph, you can use a tracing to help plot the main points onto your paper. Start by enlarging the photo to the size you want your drawing. Then use tracing paper and trace over the main features. Place a sheet of graphite paper facedown on your pastel paper and lay the tracing paper on top. Secure both with small pieces of low-tack masking tape and then draw over the lines again with an HB pencil to transfer them.

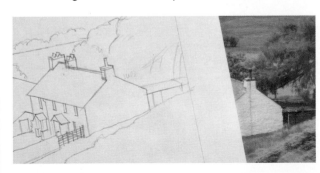

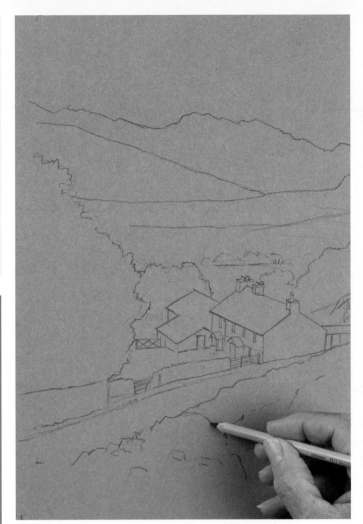

1 Trace your photograph and transfer the main features of the landscape onto your pastel paper. This creates an underdrawing of the scene that will give you confidence when you start to add color. Start to go over your transferred lines with a pastel pencil. The artist has used a dark line that shows up well here, but in reality you can use a lighter tone that will blend into your drawing.

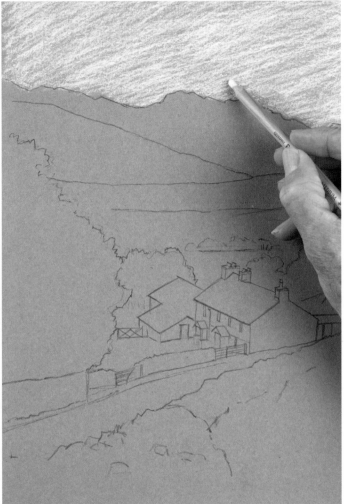

2 Stand back and assess your sketch. Make any adjustments you feel necessary. Keep the photograph propped up in front of you for continual reference. Then take the white pastel pencil and hold it loosely, well away from the tip. Scribble lightly over the entire sky area, layering the marks in a diagonal direction and creating an open texture so some of the paper shows through.

3 Overlay more layers of white in those areas of the sky where there are clouds. This will create a stronger tone. Keep the marks free and open to maintain the soft, fluffy cloud texture. Avoid coloring in solid areas of white, which will make your sky dull and unrealistic.

4 Stroke light ultramarine blue onto the areas of sky between the clouds, still working in a diagonal direction. This color is very vivid, so tone it down a bit by adding some white over the top. Notice the way the sky pales toward the far horizon and lighten this area a little.

5 Even on a sunny day, skies are never just blue and white. Look carefully and detect the varied colors that are caused by weather conditions, time of day, and aerial perspective. A little purple is added to the underside of the clouds to hint at their three-dimensional forms.

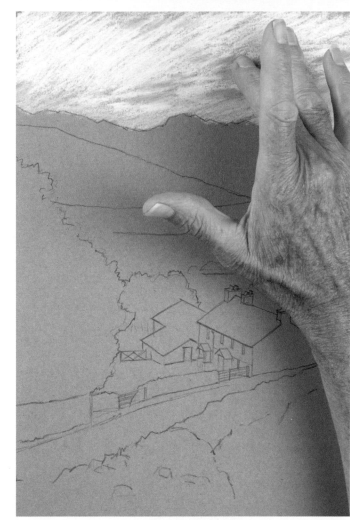

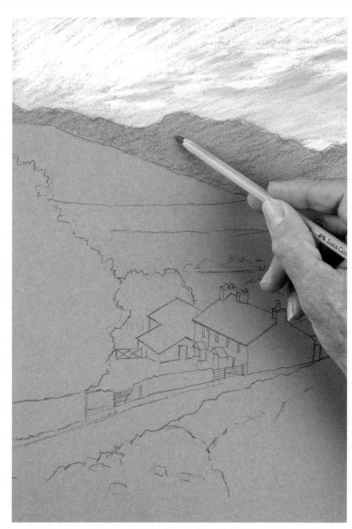

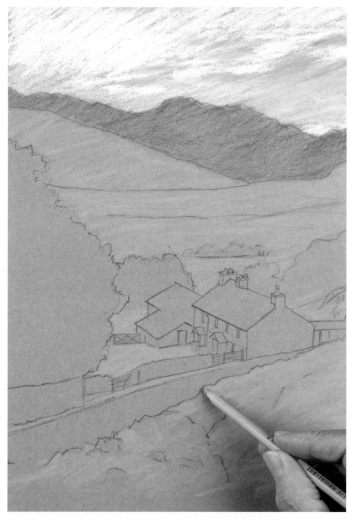

6 In order to capture the softness of the clouds and to help convey their shapes, smudge the purple marks to blend in the color a little. You can use a tissue to do this, but a clean finger does the job just as well. Now turn your attention to the distant hills. To the eye they seem to be purplish in color.

7 To capture this effect, begin by blocking them in lightly with a scribble of cobalt blue. Make diagonal marks, following the slope of the hills. Using light ochre, gently stroke over the top of the cobalt blue. Then add some purple, especially on the very tops of the far hills. Keep your marks open and light.

8 Use the light green to lay a base color over the next range of hills and into the foreground. Keep your marks loose, leaving plenty of paper showing through. If you clog up the paper with too much pigment at this stage, you won't be able to build up on it later.

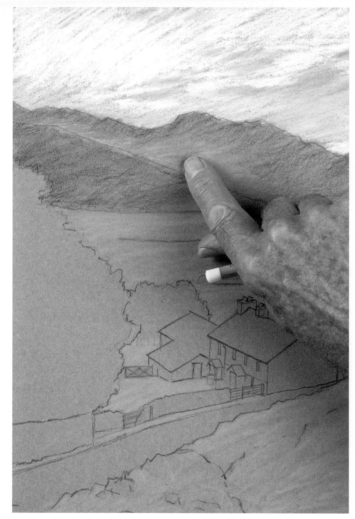

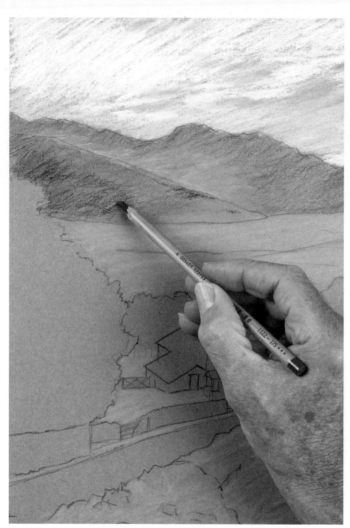

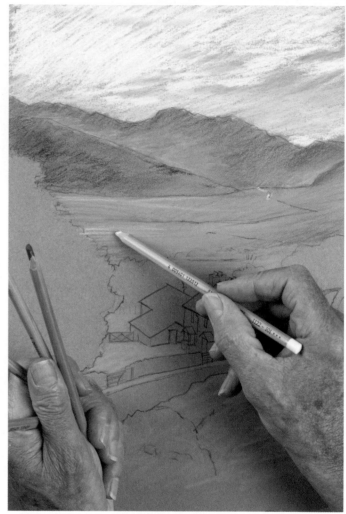

9 Add dark sepia sparingly to the hills in the middle distance, softening the marks with your finger. Add a little white to the farthest hills, just where they disappear behind the middle-distance hills; blend with your finger. Remember to keep things open for textural interest; don't fill any areas with solid color.

10 Use the black pastel pencil to plot the shadow areas in the middle distance. Work very lightly and smudge it a little to soften and blend the black marks into the color beneath. If you look carefully at shadows, you will see they are never just black. They reflect the colors of things around them.

11 Begin working up the middle distance, using light ultramarine, cobalt, light ochre, and olive green. Look at the scene to detect the varying colors and tones and then layer the colors lightly over each other. Avoid putting too much pressure on the pastel pencils or the paper surface will become clogged with pigment.

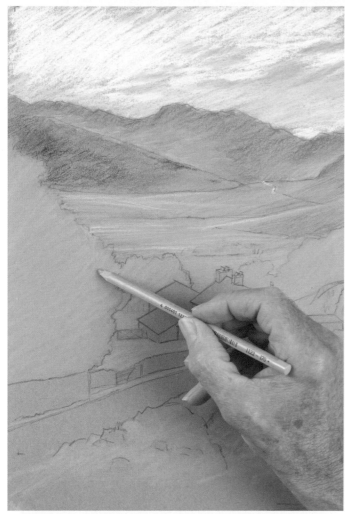

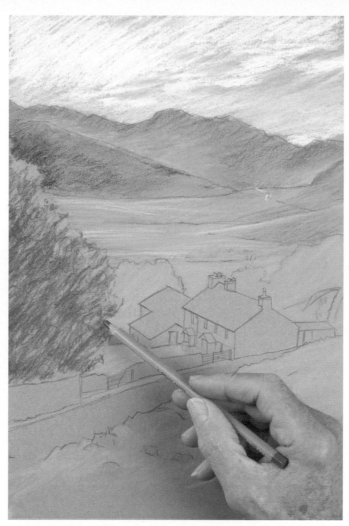

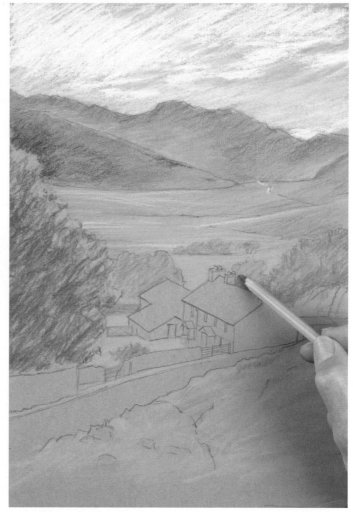

12 Add the light green as a base note for the large tree on the left of the picture. Then scribble over the tree with the same color, applying a little more pressure on the pastel pencil. Vary the direction of your marks to suggest the texture of the leaves and keep them open so the underlayer of light green shows through.

13 Then scribble over the tree with dark sepia, letting your marks express the density of the foliage. Work more into some areas to deepen the tone and add textural variety. Used this way, one pencil can create a range of tones. If you are worried about smudging your drawing, work with a spare sheet of paper under your hand.

14 Use cobalt blue on top of the light green base tone to bring out those trees seen in the middle distance, behind the house. Then work into them with olive green and more cobalt, increasing the pressure on the pencils to darken the tones.

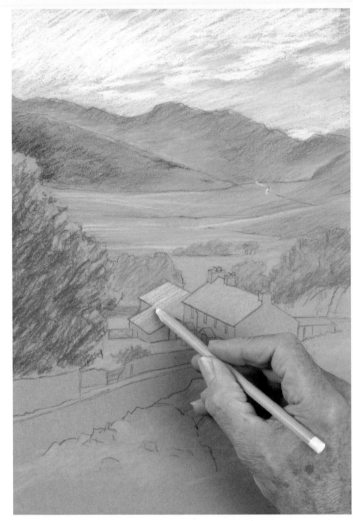

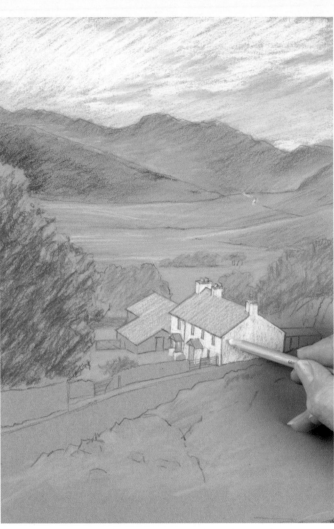

17 Use white to lighten the grass and the lane. Add a layer of light ochre to the lane, then more white and finally a little light ultramarine. Blend it with your finger to suggest the smooth surface of the road. Work into the wall with dark sepia, then add detail to the foreground slope with the same color.

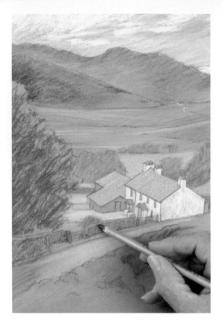

Artist's tip

Whatever you are drawing, you can use artistic license and edit out anything you don't like in the scene. The artist has decided to omit the receptacle in front of the stone wall because it adds nothing to the scene.

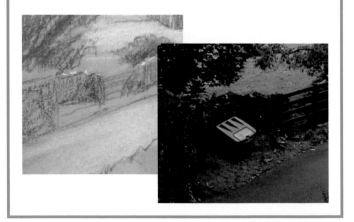

15 Now turn your attention to the house. It is in the foreground and can be seen in great detail, so be sure to reflect this level of detail in your drawing. Use light ochre on the roof, then lighten the tone with a little white. Add lines to suggest the shingles.

16 With the white pastel pencil, make marks in different directions on the walls and chimney to express the texture of a weathered surface. Create tonal variations by varying the pressure on the pencil. This will make the walls look much more convincing and interesting than coloring them a thick, solid white.

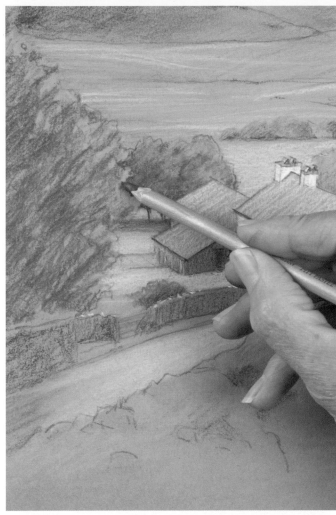

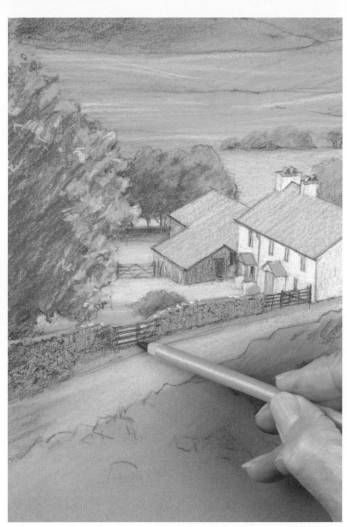

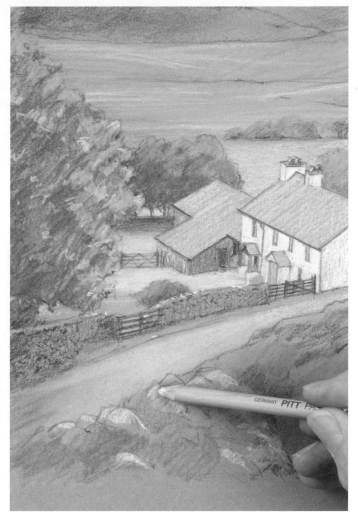

18 Work around the foreground area, adding details to bring it into focus. Draw again into the front of the house and the barn and darken the hedge behind the house, adding a highlight to the top of the wall. Use black sparingly to deepen tones. In this drawing it's used on top of other colors so it mixes to create the right tone.

19 Add flecks of white to the light side of the large tree. These will pick up pigment from the colors underneath and create lively highlights. Add definition to the gate, the grass border, and the stone wall. Add just enough detail to suggest structure and texture. Sit back frequently and assess the effect.

20 Add detail to the right-hand tree with dark and light touches as before. Scribble light ochre in different directions on the foreground slope and use dark sepia for the rocky outcrops. Add some highlights where the light hits the rocks. For the grass use blue, light ochre, and green tones, but don't try to draw every blade of grass.

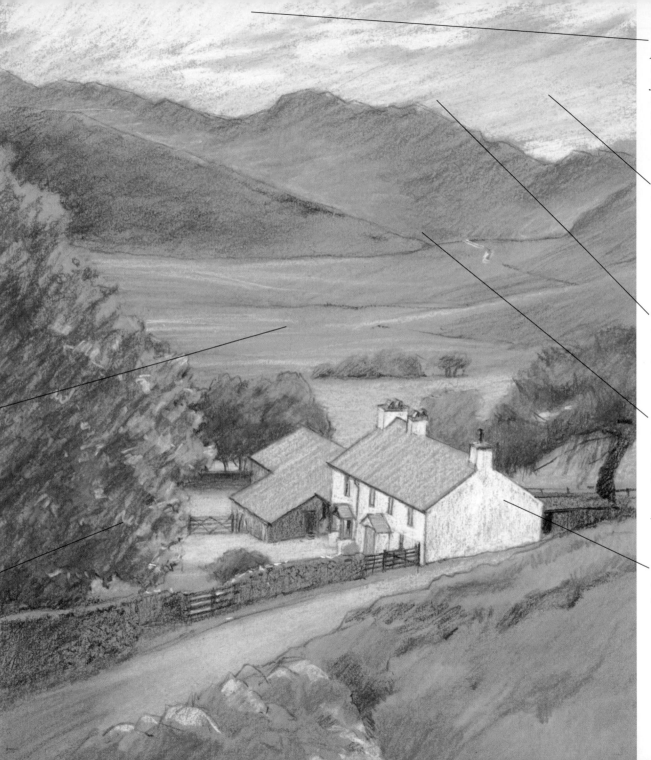

Mountain scene
finished drawing

Pastel pencils are perfect for a wide-ranging landscape. They allow you to make softly shaded areas fading into the distance and sharp linear details that bring the foreground into focus. Overlaid layers of color build up just the right tones throughout the picture and create a realistic sense of recession.

The greens of the valley lighten and brighten as they come closer. Layers of color laid on with open marks build up interesting tonal variations.

The closest tree is seen in more detail than the trees in the middle distance, which are just vague silhouettes. Layers of scribbled marks are a kind of shorthand that suggests the texture and density of the foliage.

The diagonal direction of pencil marks creates the sense of the sky as a canopy that reaches forward out of the painting and over the head of the viewer. Remember, the sky isn't a flat backdrop.

Clouds are three-dimensional and never just gray or white. A little purple hints at the underside of the cloud that faces away from the light.

Notice that the sky lightens subtly toward the horizon. Imitating this effect adds to the sense of an endless overhead arch.

With distance, colors cool and become bluer, and detail is obscured. Soft layers of overlaid color imitate this effect and create a realistic sense of recession. This effect is known as aerial perspective.

The cottage is the focal point of the picture. Its brightness and detail attract the eye and maintain the viewer's interest.

QUICK REVIEW

An overview of this project shows how the artist used areas of different tone and color to build up the scene. Working from a traced photograph has produced a detailed, realistic, and pleasing result. This style of drawing is good for evoking a very real memory of a place you have visited.

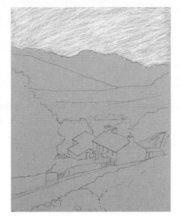 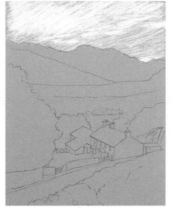 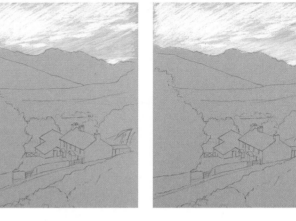

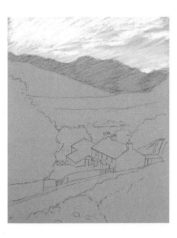 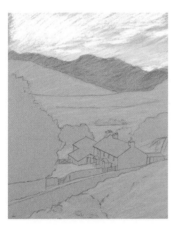 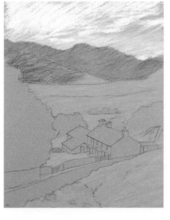 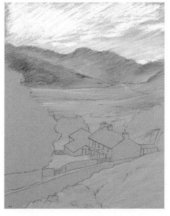 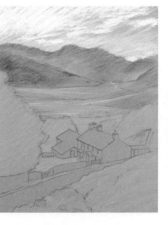 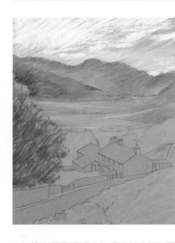

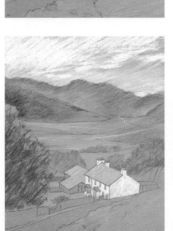 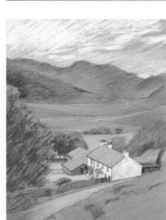 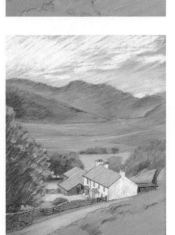

②Avenue of trees
a study in single-point perspective

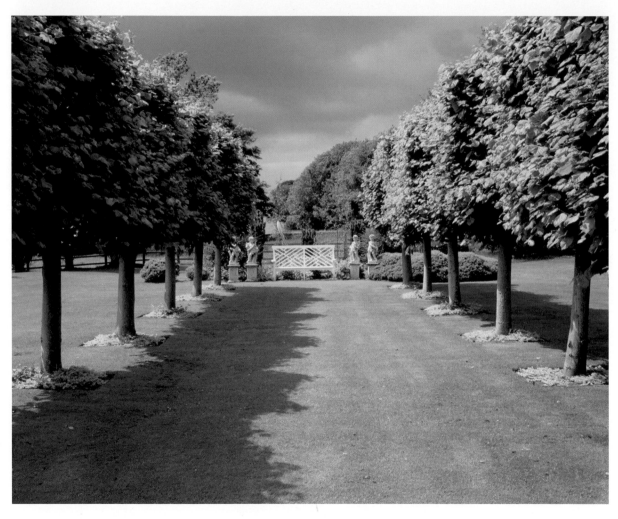

This view of an avenue of trees provides the perfect scene for studying the rules of single-point perspective. All the trees have been planted the same distance apart and in two parallel rows; therefore, the trees on either side reduce in size equally as they recede toward the same center point. That spot is the vanishing point, directly in front of the camera.

Plot a few basic construction lines (see next page) before you begin drawing and you'll have no difficulty producing an image with a convincing sense of recession and distance.

◀ *Formal gardens are often laid out with avenues of trees that are designed to lead the eye to some focal point of interest—ideal for a perspective drawing.*

Single-point perspective

You will be familiar with the visual effect that distance has on objects. Things of the same size appear smaller as they get farther away, and parallel horizontal lines appear to converge as they recede.

Linear perspective is a simple system that enables you to mimic these effects in your drawing and create the optical illusion of three-dimensional form. To draw anything in perspective, you must first establish the horizon line, an imaginary horizontal line that runs across the subject at your eye level (even if you can't actually see the horizon). Your eye level depends on how tall you are and whether you are sitting or standing, but it's always straight in front of your eyes. In single-point perspective there is one vanishing point at the center of vision on the horizon line at which all the receding parallel lines in the subject appear to converge.

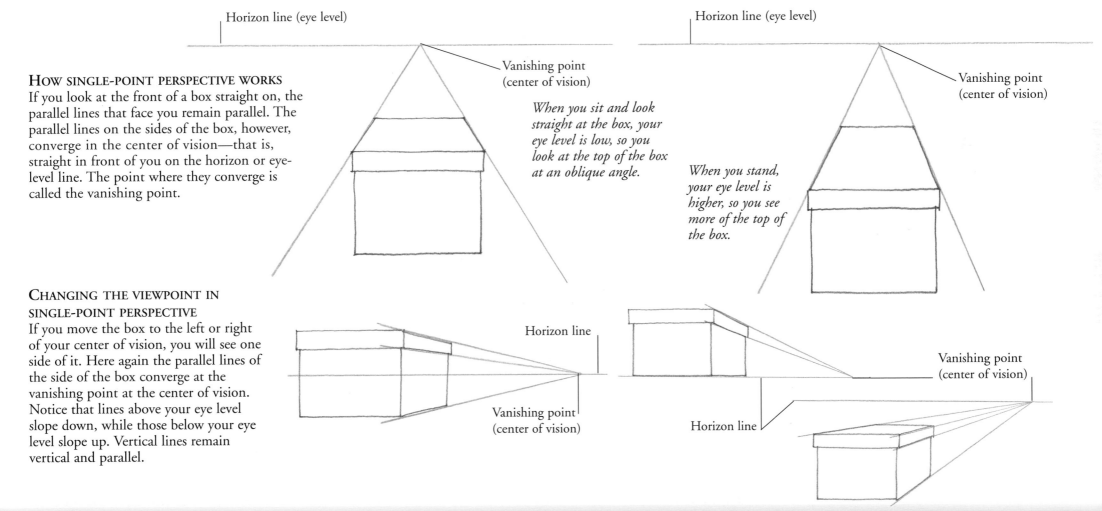

Horizon line (eye level)

Vanishing point (center of vision)

Horizon line (eye level)

Vanishing point (center of vision)

HOW SINGLE-POINT PERSPECTIVE WORKS
If you look at the front of a box straight on, the parallel lines that face you remain parallel. The parallel lines on the sides of the box, however, converge in the center of vision—that is, straight in front of you on the horizon or eye-level line. The point where they converge is called the vanishing point.

When you sit and look straight at the box, your eye level is low, so you look at the top of the box at an oblique angle.

When you stand, your eye level is higher, so you see more of the top of the box.

CHANGING THE VIEWPOINT IN SINGLE-POINT PERSPECTIVE
If you move the box to the left or right of your center of vision, you will see one side of it. Here again the parallel lines of the side of the box converge at the vanishing point at the center of vision. Notice that lines above your eye level slope down, while those below your eye level slope up. Vertical lines remain vertical and parallel.

Horizon line

Vanishing point (center of vision)

Vanishing point (center of vision)

Horizon line

Single-point perspective in practice

In the drawing of the avenue of trees the artist's viewpoint is squarely centered in front of the tree-lined avenue so the center of vision and the vanishing point are just above the middle of the seat. This means that the parallel lines of the trees fan out in perspective equally on both sides of the avenue.

Notice that as the trees recede, the gap between them seems to diminish. This is another effect of perspective. In the same way, a row of street lamps or a line of pillars will appear closer together the farther away they are. Once you observe this effect you will notice it in many different places. Try to capture it in your sketchbook.

Artist's tip ◀
To find the angles of the converging lines, hold your pencil out in front of you so it matches the angle of each line in turn (see page 17). Then lay the pencil against your drawing at the same angle as a guide for drawing the perspective lines.

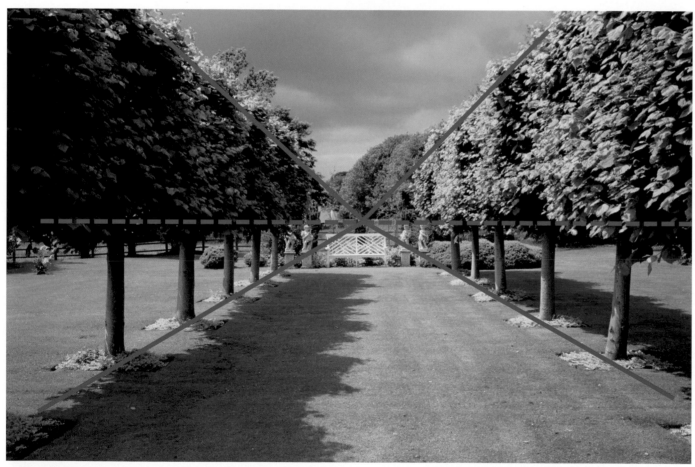

Photograph of the tree avenue, with superimposed eye-level line (horizon), vanishing point, and perspective lines.

MOVING THE CENTER OF VISION

If the artist moves to the right so his center of vision is at the right-hand end of the bench, the vanishing point also moves. Then the right-hand line of trees is seen at a more oblique angle and the perspective lines fan out more steeply on that side.

At the same time, the trees on the left are seen at a shallow angle and the perspective lines become less acute, too.

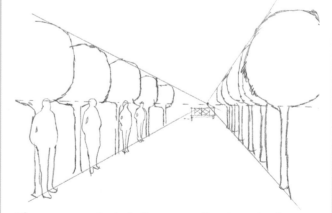

If you want to include figures receding into the distance, draw the nearest figure, then draw converging lines from it to the vanishing point. You can then plot distant figures in correct proportion to the closest figure.

You will need

- Basic equipment (see page 8)
- Sheet of smooth drawing paper
- Pencils—2B, 6B, 7B
- Ruler or straightedge (optional)
- Putty eraser

1 Draw a horizontal line to indicate eye level, just above the top of the bench (see page 104). Mark the vanishing point at the center of this horizontal line.

Draw in the perspective lines that indicate the tops of the trees so that they meet at the vanishing point. Repeat with perspective lines that run along the bottoms of the tree trunks. Do this freehand or with a ruler if you prefer, and measure the angles with your pencil or a measuring device (see pages 17 and 112). Use a 7B pencil and make light marks that can easily be erased (the lines are emphasized here so they show up well). Then begin to map in the bench and trees.

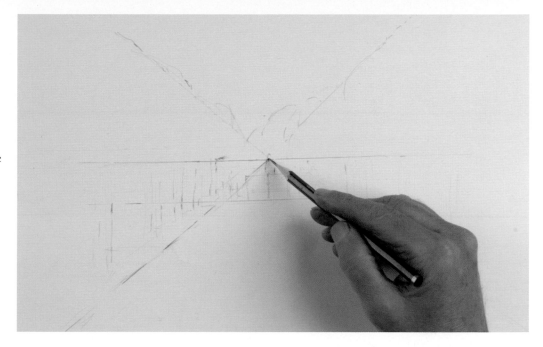

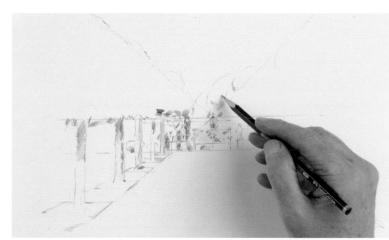

2 Use the 2B pencil to draw into the garden seat and the statues a little. Plot the left-hand line of tree trunks, looking at the negative spaces between them to help you. Begin to add some of the dark tones to start indicating the tree shapes.

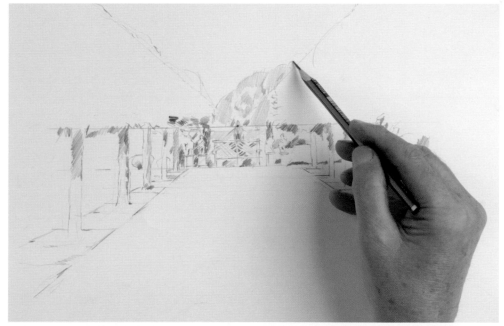

3 Aerial perspective (see page 92) means the eye can't see distant details, so use light marks to hint at the area behind the seat. On the right-hand line of trees, line the trunks up with the left-hand trees, holding your pencil horizontally to check their positions. Follow the perspective lines through to keep things in the right place.

4 Change to a 6B pencil and begin to indicate the dark areas of foliage on the left-hand trees. The sides of these trees that face the viewer are mostly in shadow—the only light areas are at the top where the sunlight hits them. Use marks that follow the direction of growth for a lifelike texture, and hint at only a few individual leaves, letting the eye fill in the rest. If you attempt to draw in every leaf, your drawing will look dull and flat.

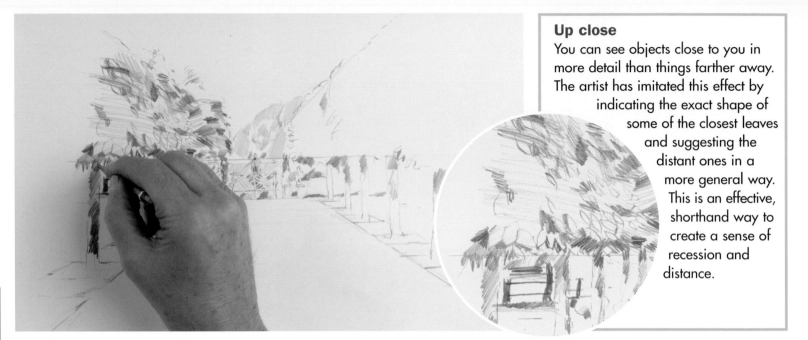

Up close

You can see objects close to you in more detail than things farther away. The artist has imitated this effect by indicating the exact shape of some of the closest leaves and suggesting the distant ones in a more general way. This is an effective, shorthand way to create a sense of recession and distance.

5 Add a little more definition to the trunks and to the trees beyond. Continue to work on the foliage, adding extra texture and detail. Hold the pencil loosely and add the shadows beneath the trees, using soft horizontal marks followed by a little hatching. Notice how the shadows recede along perspective lines.

6 Hold the 6B pencil right at the end and use it very softly to indicate the sky tone, stroking on the tone with broad, light sweeps. Then shade in the distant trees the same way. You will be surprised what interesting variations of tone and texture you can achieve with just three pencils.

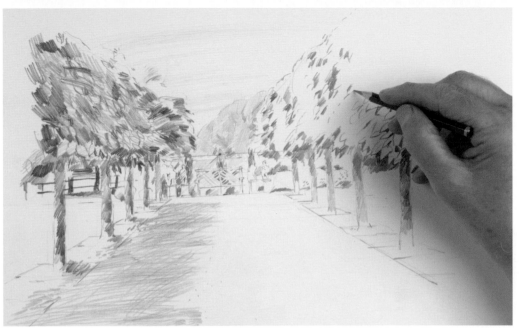

7 Turn your attention now to the right-hand row of trees and, still using the 6B pencil, add more tone to the trunks. Then pick out the darker foliage—the sides of the trees that face the viewer catch the light, so there are only small dark areas. The strong sunlight makes everything sharper to the eye, so add more definition to the dark tones and draw the nearest foliage accurately. Vary the pressure on the pencil to create dark and light tones.

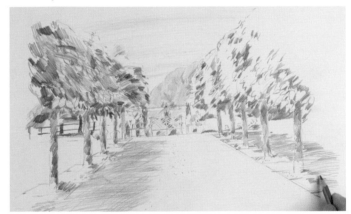

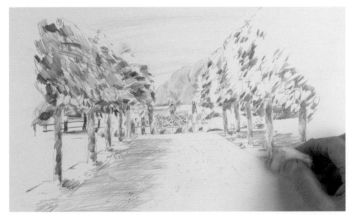

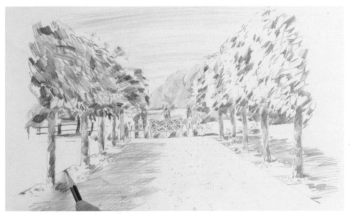

8 Define each tree canopy, looking for their shapes within the general mass of foliage and lightly indicating the tops of the trees. Add the shadows on the ground with loose horizontal strokes and stipple with the tip of the pencil to suggest a little grass texture. Change to your 2B pencil to add some accurate detail to the seat.

9 Notice how the mown lines on the grass follow the perspective, and lightly indicate these. Break up the shadows on the left a little, lifting them off with a putty eraser to lighten and vary the tone and texture slightly. If your construction lines are too visible, you can use the eraser to carefully remove them.

10 Now sit back and assess your drawing. Add a few final details, such as a little more stippling in the foreground and beneath the trees to suggest blades of grass. Darken the sky tone a little above the trees to portray it extending overhead. Stroke the eraser over the sky gently to blend the marks a little.

Avenue of trees
finished drawing

The artist used graphite pencils and varied the texture and tone of his marks to create a sense of recession. The white of the paper serves for the areas in bright sunlight, and the pencils create the range of mid- and dark tones.

The vanishing point is in the center of the scene, and the avenue of trees leads the eye directly to it. Beyond the focal point the distant trees are indicated with lightly shaded marks.

These trees are in full sun, so the white paper serves as the lightest tone. Loose sketchy marks suggest distance, while small areas of shadow indicate the leaf groupings. Individual leaves can be seen clearly in the foreground.

These trees are mostly in shadow. Groups of scribbled marks of varying tonal intensity give a lively texture. This hints at the clumps of foliage that make up the tree canopy.

Look at the negative spaces between the tree trunks to help you position them accurately.

A few individual leaves are shown on the closest trees but not in the distance.

Adding detail to the central feature of the scene draws the eye.

Some lightly stippled marks give texture to the grass. Soft horizontal and diagonal marks indicate the shadows cast by the trees.

The soft 6B pencil provides a variety of tones and marks that suggest the rough surface of the tree trunks.

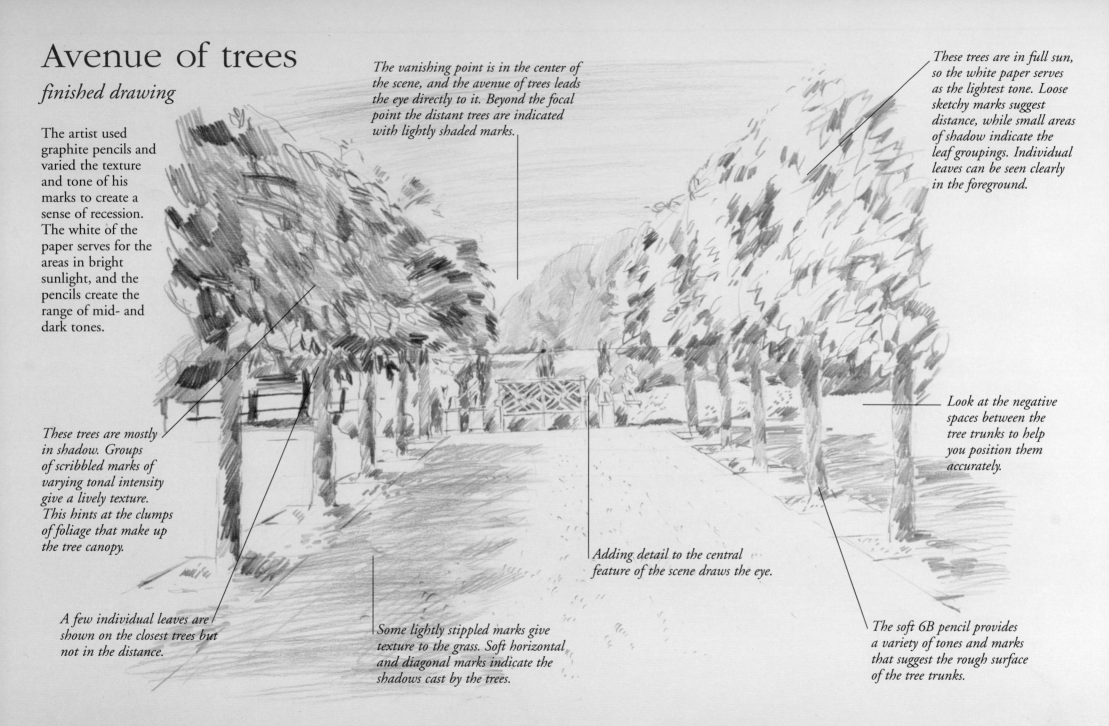

Quick Review

Using three different pencils, the artist has drawn the scene in terms of light, dark, and mid-tones. He has used the white of the paper for the lightest tones. Combining tonal gradations with the principles of single-point perspective creates a strong sense of three dimensions on a flat piece of paper.

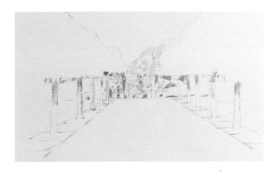
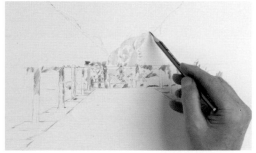
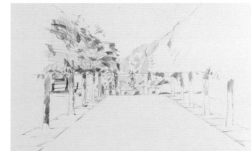
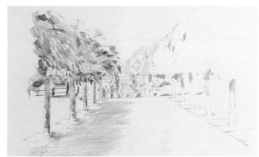

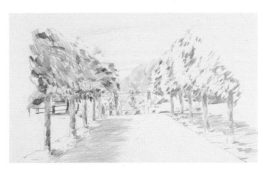
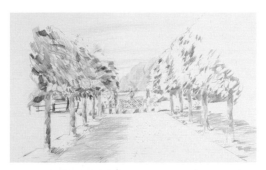
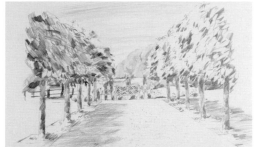
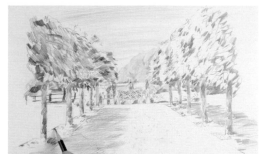

③ Victorian house

a study in two-point perspective

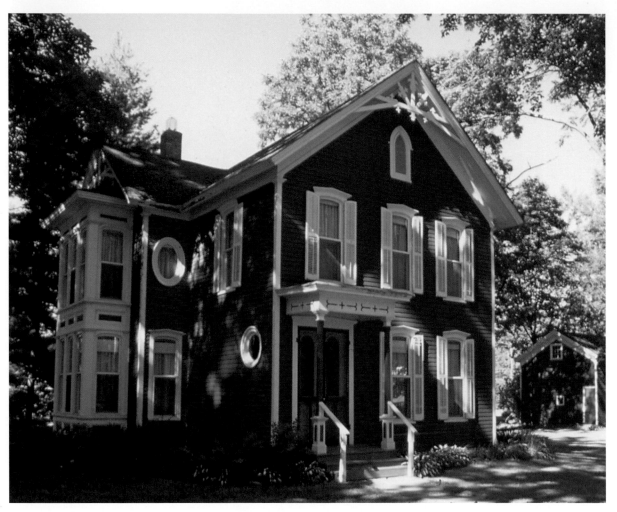

A drawing of your house or any other significant building makes a great memento. If you are drawing your own home, then this is a subject you can revisit as often as you like. If you are drawing a building you've spotted while traveling, you may want to take a photograph you can work from later.

If you decide to sit outside to draw, bear in mind that you may take more than one session to complete your study. You need to make sure the light is similar on each occasion. Different times of day and changing weather conditions can make things look very different.

◀ *Often the most interesting view of a house is not from straight in front. Looking at a building from one corner reveals two sides.*

Two-point perspective

The rules of one-point perspective come into play when you look at a building straight on—the parallel converging lines of the side of the building meet at a single vanishing point that coincides with your center of vision on the horizon line (see page 103).

However, drawing a building from one corner can often make a more interesting composition than drawing it straight on. Notice how when you look at it from one corner, you will see two sides of the building, not just one. The parallel lines on both sides converge as they get farther away. To mimic this in your drawing, you'll need to employ two-point perspective.

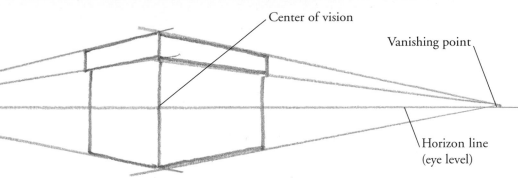

Center of vision

Vanishing point

Horizon line
(eye level)

1 *Look at a box with the center of one corner directly in front of you at eye level. From this viewpoint your center of vision will be in the center of that corner. The parallel lines of the sides converge at two different vanishing points on the horizon line (your eye level), one at each side of the box. These vanishing points are an equal distance away from your center of vision.*

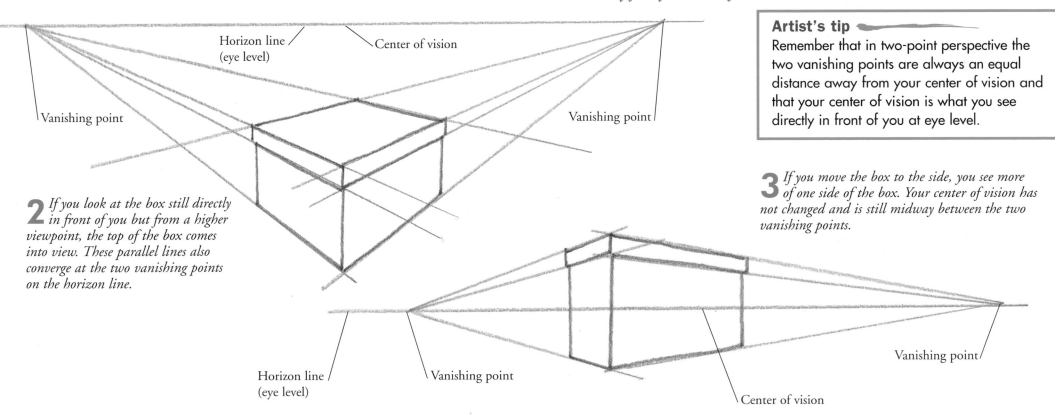

Horizon line
(eye level)

Center of vision

Vanishing point

Vanishing point

2 *If you look at the box still directly in front of you but from a higher viewpoint, the top of the box comes into view. These parallel lines also converge at the two vanishing points on the horizon line.*

Horizon line
(eye level)

Vanishing point

> **Artist's tip**
> Remember that in two-point perspective the two vanishing points are always an equal distance away from your center of vision and that your center of vision is what you see directly in front of you at eye level.

3 *If you move the box to the side, you see more of one side of the box. Your center of vision has not changed and is still midway between the two vanishing points.*

Vanishing point

Center of vision

Two-point perspective in practice

The Victorian House colored-pencil study was drawn from one corner, so the artist had to employ two-point perspective to produce a solid and convincing drawing. Two sides of the building are in view, and each side has its own set of converging lines that meet at two separate vanishing points, one on each side of the building. Both these vanishing points are on the same horizon line (eye level), but

neither of them is at the artist's center of vision. Notice that the top and bottom of the windows line up on parallel converging lines, too.

Sometimes, as in this case, the vanishing points may be way outside your final picture area, so you may have to imagine the vanishing points and estimate the angles. Better still, measure the angles for accuracy.

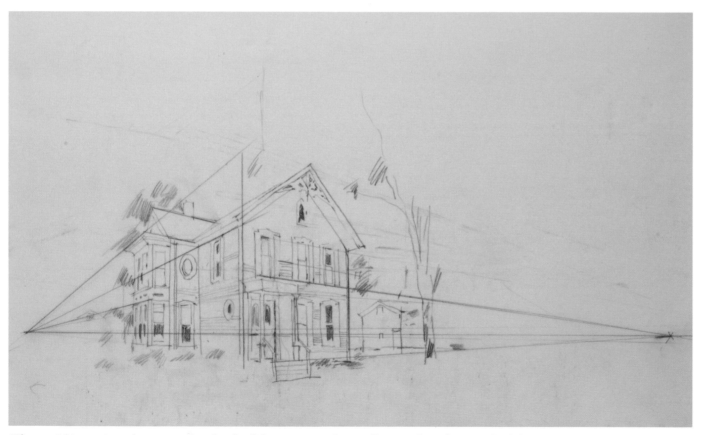

The vanishing points drawn on this sketch of the Victorian house illustrate how far outside the main picture area these points may be.

USING ANGLE-MEASURING TOOLS

You can measure angles with a pencil held out at arm's length (see page 17), but for greater accuracy, use a measuring device. You can buy one or make your own simple and effective version. Cut two strips of cardboard each about 2 x 10 in. (5 x 25 cm). Then join them together at one end with a metal paper fastener so they can open and close like scissors.

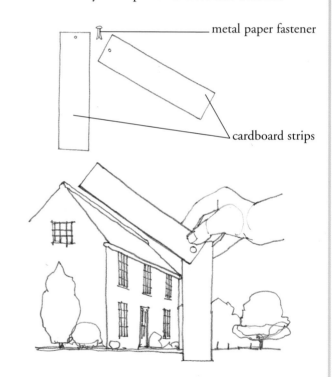

metal paper fastener

cardboard strips

To use the device, hold it out at arm's length and open it until the angle matches the angle you are measuring. Then place it in the corresponding position on your drawing and draw in the angle.

You will need

- Basic equipment (see page 8)
- Sheet of smooth drawing paper
- 7B pencil
- Colored pencils: Venetian red, vermilion, Naples yellow, gunmetal gray, pale slate gray, light olive green, juniper green, pale blue (see page 70 for advice on choosing and using colored pencils)
- Putty eraser
- Long ruler
- Spare paper

1 Using the 7B pencil, draw a light line across the page to represent the eye line. In this picture this is just above the steps leading up to the front door. Sketch in the vertical lines that form the corners of the house and add the slope of the roof. Plot in a few details, like the eaves and the outline of windows.

2 Still working very lightly, sketch in more features of the building—the porch, some of the windows, the side bay. Lay your long ruler over the drawing, pivoting it from the vanishing points to check angles. Consider every move carefully and erase any marks that are wrong and try again.

3 Work slowly across the house, noticing where lines intersect and checking that things are in the right place. The number of windows may seem daunting, but they will be convincing if you continuously check the angles with the ruler so that they line up correctly. Add some roof details.

Note how the artist is holding his pencil well back from the tip (see page 29). Try to work loosely and freely at this stage. Details can come later.

Artist's tip

Take plenty of time at this early stage to get the "scaffolding" for your drawing set up accurately. Work slowly, taking measurements with your pencil or an angle-measuring device and assessing your marks carefully.

If you get things wrong at the beginning, your building won't look solid and convincing, so be prepared to make adjustments to this preliminary drawing. Once you're happy that the underdrawing is correct, you can turn to your colored pencils. (For details on measured drawing, see page 17.)

4 Now turn your attention to the left-hand end of the house. Again use the eye-line that you've drawn to check the angles of the roof and the windows. You need to get these right to make the building look solid and convincing. Hold your pencil out at arm's length so it matches the angle you are looking at, then check the angle of the pencil against your drawing to make sure you've got it right. At this stage, add a few lines of foreground detail and lightly indicate the background to give the building a sense of place. Use your ruler to draw in just one or two of the clapboards to establish their angles.

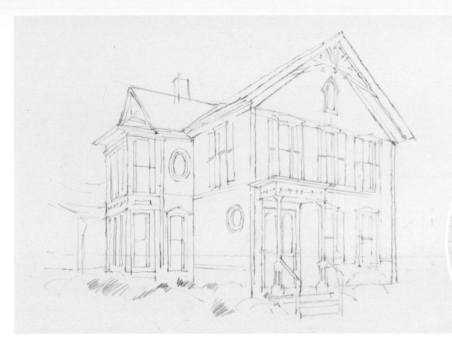

Up close
Used with care, a ruler can be a handy drawing tool. The artist has used it to draw in one or two boards, but only as guidelines to help him draw in the rest freehand later on. If they were all drawn with a ruler, the finished effect would be too rigid.

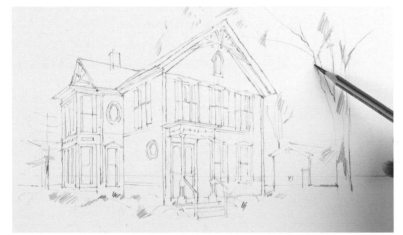

5 Now that most of the main house is in place, sketch in the outbuilding in the background. You could edit it out, but it adds interest to the composition. The tree on the right gives a sense of location and forms a natural frame, so sketch it in roughly and indicate some areas of foliage.

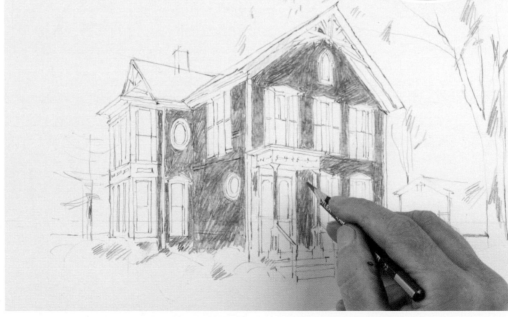

6 Begin to add some color. Use Venetian red for the clapboards, leaving areas of the paper white for the brightest patches of dappled sunlight. Note the areas of light and shade and vary the pressure on the pencil to achieve different red tones. Keep the marks loose and open.

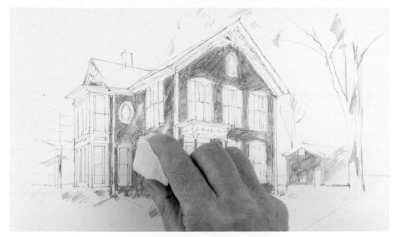

7 Add Venetian red to the outbuilding. Then add a little vermilion to brighten the red here and there on both buildings, but don't use it all over. Use the putty eraser to lift color off in the lightest areas, and darken the shadows with more Venetian red.

9 Define the windows a little more with the pencil, then use Naples yellow lightly on the eaves and window frames. Just add a suggestion of color and avoid coloring in with heavy marks. Use the gunmetal-gray pencil for the roof and the dark areas on the windows. Vary the pressure on the pencil for different tones.

Artist's tip
Try not to "color in" your drawing. Keep the marks free and work in different directions to create an interesting surface texture. Turn the pencil as you work to maintain a point, and increase pressure on the pencil for the darkest tones in the shadow areas.

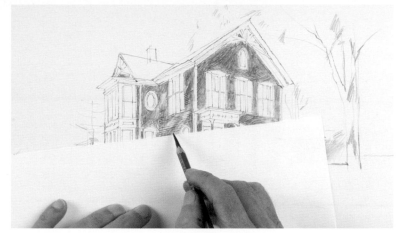

8 Use the 7B pencil to draw in some more of the clapboards. Don't draw in every one; just add enough to inform, but not so many that the image becomes lifeless. Check the angles occasionally with the ruler or the edge of a piece of paper, but draw them mostly by eye so your drawing isn't too mechanical.

Up close
Where the artist has used Naples yellow, the colored pencil has picked up some of the graphite powder left by the 7B pencil. A little gray, therefore, has mingled with the yellow. However, this isn't a problem. The artist has been able to use this happy accident to help express the shadow areas under the eaves.

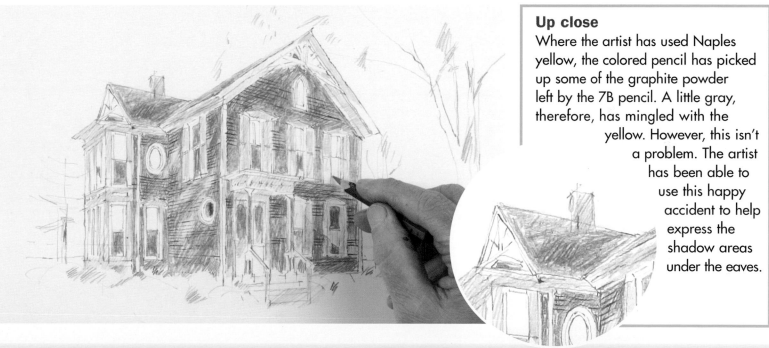

10 Use pale slate gray for the lightest tones on the windows. Then use the 7B pencil to sharpen up the dark edges—over the front door and around the window frames, for example.

Using the 7B pencil and the two grays for the dark, mid- and light tones, balance the gray tones in the shadowy porch and on the roof.

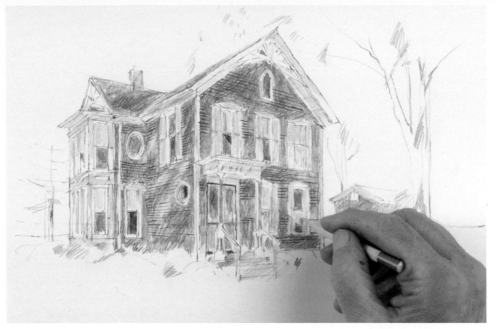

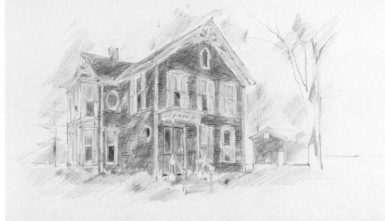

11 Use light olive green to hint at the foliage around the house and the lawn in the foreground. Notice the dappled light on the lawn and leave some areas of white paper. Scribble in a little sky with pale blue. Work loosely with free, open marks as an expressive contrast to the tighter accuracy of the house.

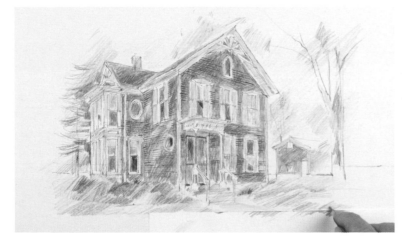

Artist's tip

You can create a straight edge at the bottom of the picture by coloring against a spare sheet of paper. The line this creates and the trees on either side frame the house to make a pleasing composition.

12 Using the juniper-green pencil, add darker areas to the foliage and grass. Add deeper tones to the tree at the left of the house, using strokes that more or less follow the direction of growth. This will help bring the building forward.

13 Indicate the foliage on the right-hand tree, then use the 7B pencil to pick out some more of the darkest areas and generally make things crisper. Add the shadow on the tree trunk and indicate the front path. Finally, use the putty eraser to take out any construction lines and carefully clean up your picture.

Victorian house

finished drawing

In this drawing the red clapboard house stands out against the surrounding greens of the foliage and grass. The artist has chosen to use colored pencils to create a lively and informative impression of the house. He makes suggestions and lets the viewer's eye fill in the rest.

Careful observation and measuring at the start create a solid and believable framework on which to hang the drawing. The house is drawn with careful accuracy and detail while still keeping the colored marks lively, open, and expressive.

Just a few quick marks with a dark green pencil are enough to reveal the species of the tree. The dark green brings the house forward from the background.

The foliage and grass around the house are expressed freely in a variety of greens with almost scribbled marks. This makes a lively contrast with the crisp precision of the house.

The tall tree acts as a natural frame that stops the eye from wandering out of the picture. It is loosely expressed so it doesn't draw the attention away from the house.

You only need to draw a few of the boards. Once the suggestion is there, the eye will fill in the rest. If you try to draw too many, the drawing will become flat and dull.

The warm red tone of the boarding is created with layers of free, open marks that keep the image lively and visually exciting.

QUICK REVIEW

The artist approached this complex subject by beginning with an accurate underdrawing so the perspective was correct before color was added.

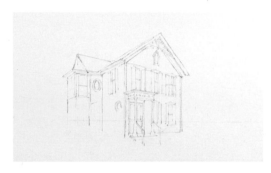
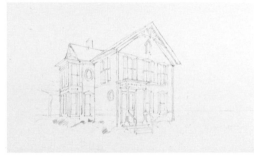
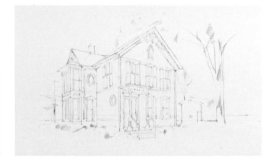
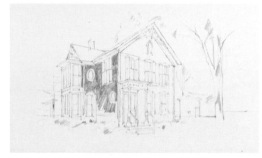

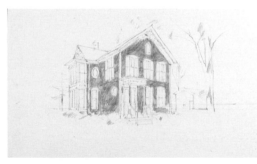
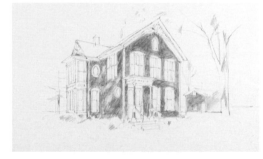
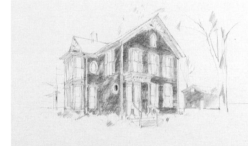
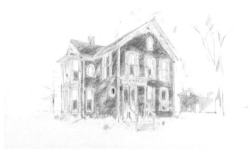

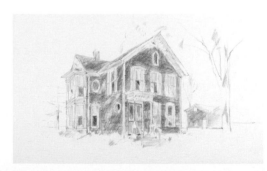
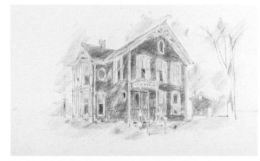
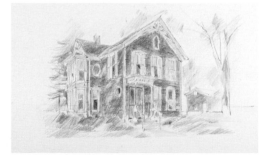
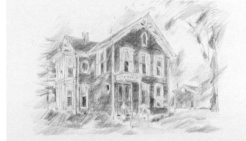

People and portraits

Drawing people and portraits

For the artist the human form is possibly the most exciting, challenging, and rewarding subject of all, but for the beginner it can be utterly terrifying! We see people every day, and our apparent familiarity with the human form can make us draw what we think we know instead of what we actually see. The result is frequently an unsatisfactory drawing. Even if you don't yet want to tackle portraits of family and friends, drawing human figures convincingly is an important skill to learn since they are often part of a wider scene, and if they don't look right, they can ruin the drawing.

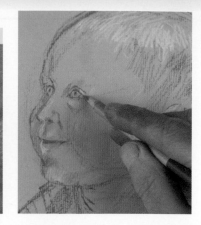

UNDERSTANDING THE HUMAN FORM

Before you put pencil to paper, rely on your powers of observation and banish any preconceived ideas about how bodies are formed or how faces look. Then get started by using the simple-shape technique. See the body you are drawing as a collection of three-dimensional geometric shapes and you'll be well on the way to constructing a solid and believable figure. Working this way also helps reduce the fear of working with a human model!

FINDING MODELS

If figure drawing interests you, there are no shortage of subjects to draw. Friends and family usually make tolerant models. Or make quick sketches of people when you're out and about. Practice wherever and whenever you can and your drawing will quickly improve. Tackle the challenge of moving figures once your skill has developed and instead draw children when they are asleep or absorbed in a book. Over time, you will be recording your child's growth while continuously developing your skills.

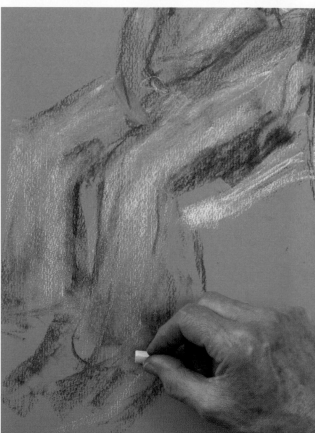

Adult figures

When you draw the human figure, the key to success, as with any other subject, is keen observation. You must draw exactly what you see, not what you think you know. Identifying simple shapes and a few key measurements taken with an outstretched pencil (see page 17) will help you achieve a properly proportioned figure that looks well balanced, solid, and believable.

Keep in mind how and where the body articulates; you'll understand this well enough from your own body. And remember, too, the essential differences in the physiques of men and women. Men have broader, squarer shoulders that are generally wider than the hips, and they have no waist. Women have narrower, sloping shoulders and wider hips in relation to their waists.

Translate what you see into simple three-dimensional shapes. The head is an egg shape, the legs and arms are a series of cylindrical forms of varying proportions, and the torso is a rounded cube. These are all linked at the points of articulation—neck, shoulders, elbows, hips, knees, and ankles.

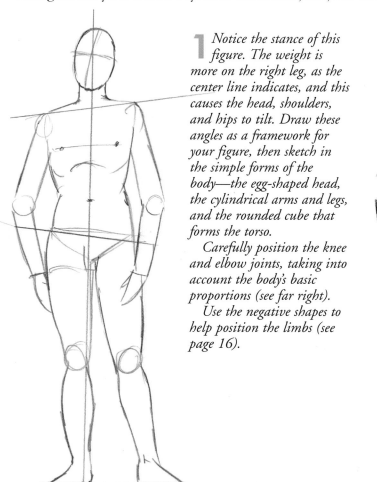

1 *Notice the stance of this figure. The weight is more on the right leg, as the center line indicates, and this causes the head, shoulders, and hips to tilt. Draw these angles as a framework for your figure, then sketch in the simple forms of the body—the egg-shaped head, the cylindrical arms and legs, and the rounded cube that forms the torso.*

Carefully position the knee and elbow joints, taking into account the body's basic proportions (see far right).

Use the negative shapes to help position the limbs (see page 16).

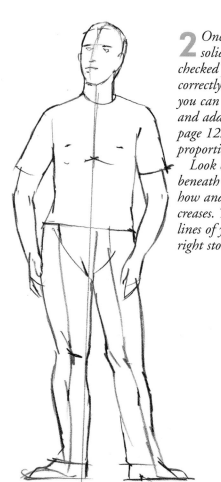

2 *Once you've established a solid, believable figure, checked proportions, and correctly balanced the body, you can clothe the figure and add facial features (see page 122 for basic facial proportions).*

Look carefully; the forms beneath the clothes dictate how and where the cloth creases. Try to make sure the lines of your drawing tell the right story.

BASIC PROPORTIONS

It's useful to study the body's average proportions:

In the adult male and female standing figure, the body height is generally about seven and a half times the head measurement.

The halfway point is around hip level.

The span of the outstretched arms is roughly the same measurement as the height.

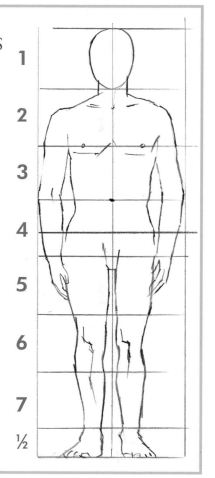

Adult faces

When you draw a face, you'll want to achieve a reasonable likeness, so start with faces that you know well. Family and friends often make willing models, and there's your own face if you are nervous about working with a model.

A successful portrait conveys a sense of character as well as an accurate representation of the face. To achieve this, you first need to establish the shape of the head and face and the size and relative positions of the features. You can unlock this subject in the same way as any other. Observe carefully, take a few key measurements, and keep it simple. Draw only what you see.

Work lightly at first so you can adjust lines later. Once you have achieved an accurate foundation, you can start adding the facial details.

Heads come in a variety of shapes and sizes—long and narrow, round, or square. However, they have the same basic proportions, which you can use to help construct a convincing portrait. The eyes sit in the hollows of the eye sockets, while the lips are fleshy additions to the facial contours. The nose is a protruding three-dimensional form. Try lighting the model's face from the side and using the shadows that this creates to help convey the forms.

DRAWING A FACE FROM THE FRONT

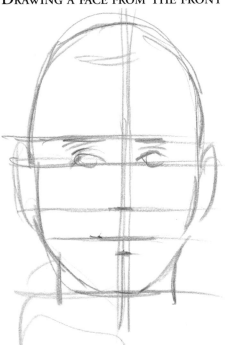

1 *Loosely sketch the overall shape of the face. Mark the center line and the positions of the eyes, ears, nose, and mouth (see far right). Don't attempt to move on until these are right.*

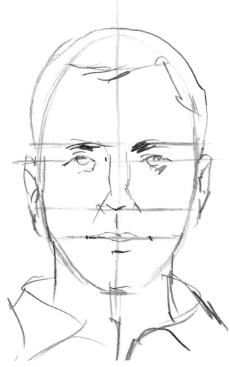

2 *Add a little definition to the eyebrows and eyes; observe them carefully because they are essential to the character of the face. Indicate the shape of the nose and mouth, then sketch in the hair.*

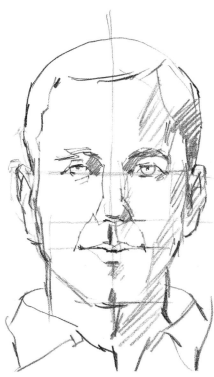

3 *Refine the features, filling in the face as a whole. Notice the shadow areas and use these to help indicate the hollow of the cheek and the shape of the nose.*

BASIC PROPORTIONS

Seen from the front, the head is basically a modified egg shape. From the side the overall shape is squarer.

The basic proportions for the positions of the features are roughly the same for all faces, so consider these when doing portraits.

The eyes, surprisingly, are halfway between the top of the head and the chin. The ears extend from the level of the eyes to the base of the nose. The mouth sits roughly one third of the way down between the base of the nose and the chin.

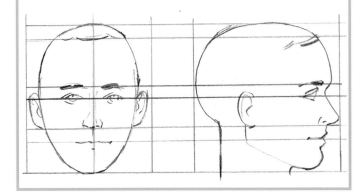

Adult profiles

Viewed from the side, an adult head more or less fits into a square box, with the nose and the back of the head touching the sides. Look carefully at the shape of the head and see how it grows from the neck. Notice the shape of the hair sitting on top of the skull. The nose and mouth are unique to the individual, so observe their shapes carefully. Be sure their relative positions and proportions are right before you commit to any detail. Draw exactly what you see; don't generalize.

DRAWING A FACE IN PROFILE

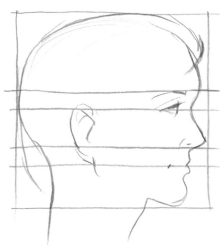

1 *Lightly draw the square framework around the head. Measure the level of the eyes and the length of the nose and ears. Then plot the curve of the back of the head and the shape of the forehead, nose, and chin.*

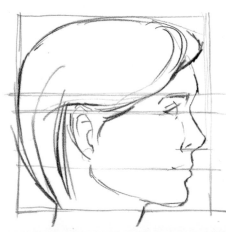

2 *Fill in the features a little, then draw the shape of the hair, indicating the way it lies on the head. Refine the profile, adjusting shapes. Use the negative shapes surrounding the head to help with these adjustments.*

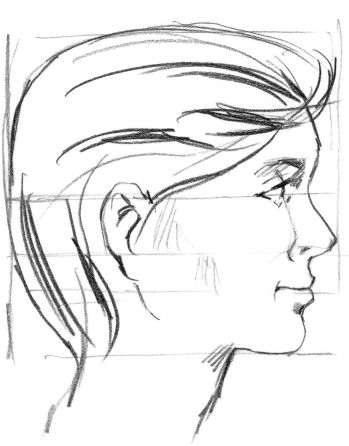

3 *Give more character to the hair, using marks that suggest its texture, and add detail to the features. To help describe the forms, draw shadows—in the eye socket, below the mouth and chin, and on the side of the face.*

CHANGING YOUR VIEWPOINT

When the head is tilted, it changes radically. If the chin goes down, the dome of the head is evident and foreshortening compresses the features. If the chin goes up, the lower half of the face becomes larger.

Contour lines will help you understand forms. Trust your eyes, take measurements, and get the basic underlying shape right before adding detail.

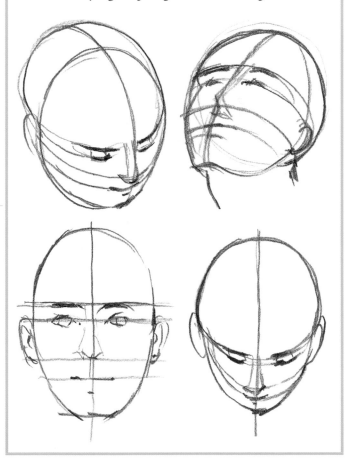

Hands and feet

Very often a new artist will work hard to draw a figure realistically, only to lose confidence when it comes to the hands and feet, which then fade into vague out-of-proportion generalizations. If you ignore the hands and feet, you're omitting important elements that help express mood and character.

When you start to analyze hands, you'll see that fingers are simply jointed cylinders. Using good concentration and a keen eye, you can establish their basic underlying shapes. Notice their relative proportions and positions, and attempt to detail only when solid and convincing forms are established. Practice with your own hand reflected in a mirror. Draw it when it is relaxed, then holding a cup or a pencil. Observe the relationships between the fingers in each pose.

Feet are larger than hands and built for load-bearing. The toes are modified fingers with the same number of joints, but shorter. Study and draw your own feet reflected in a mirror. If your model's feet are hidden in shoes or sandals, make sure these look sufficiently deep and wide to accommodate the solid forms inside. Check that sandal straps curve to fit the foot.

Most important, in the context of a figure drawing, make sure the hands and feet are in proportion to the rest of the body (see below). It's easy to underestimate their size, so measure carefully (see page 17). And when hands or feet are together, notice the negative spaces between them and use these to help you depict them correctly.

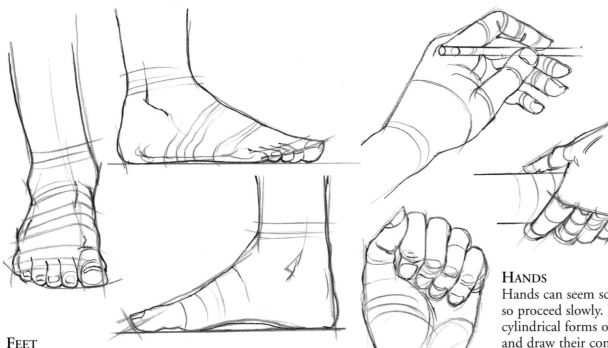

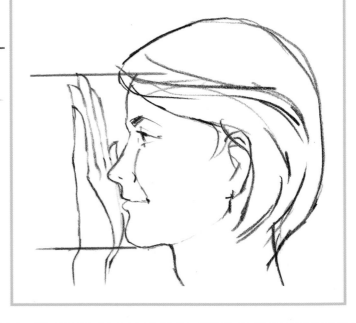

BASIC PROPORTIONS

Beginners often make the mistake of drawing hands too small. In reality, they are surprisingly large, usually the length of the face. Make sure you draw these in proportion so your drawing looks credible.

FEET

Seen from the front, the foot appears shorter. Measure carefully to make sure you draw what you see, not what you know about the foot. Side views show clearly how the foot rests on the floor. Use contour lines that follow the shape of the foot to give a sense of solidity and volume.

HANDS

Hands can seem scarily complex, so proceed slowly. Remember the cylindrical forms of the fingers and draw their contours to make them look solid. Consider the position of each finger and give it space. It's easy to cram fingers together too tightly, which makes them look like lifeless sausages.

Children

Children of any age make delightful, if challenging, subjects to draw. Because they are seldom still, drawing them from life can be tricky. Begin with moments when they are absorbed in a game, reading a book, or, better still, asleep! As your confidence grows and you learn to make quick and accurate visual notes, you can tackle moving subjects. Another alternative is to work from photographs.

As always, careful observation is the key. Study your subject before you make a single mark. A drawing that captures the essence of a particular child will be treasured for many years, and a sketchbook devoted to the subject makes a fascinating and very personal record of the child's progress through those precious early years.

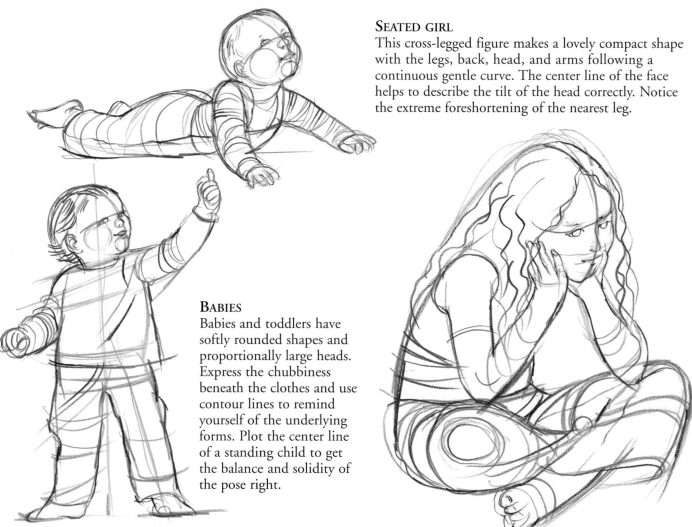

SEATED GIRL
This cross-legged figure makes a lovely compact shape with the legs, back, head, and arms following a continuous gentle curve. The center line of the face helps to describe the tilt of the head correctly. Notice the extreme foreshortening of the nearest leg.

BABIES
Babies and toddlers have softly rounded shapes and proportionally large heads. Express the chubbiness beneath the clothes and use contour lines to remind yourself of the underlying forms. Plot the center line of a standing child to get the balance and solidity of the pose right.

CHANGING BODY PROPORTIONS

Children are not miniature adults. They have very different shapes and proportions, and these change as they grow.

For example, a baby's head is large in proportion to the body, measuring about one quarter of their body height. The head grows with the child, but because the body gets taller in comparison, the head-to-body ratio changes.
These proportions for a one-year-old, a two-year-old, and a ten-year-old provide basic guidelines for a growing child.

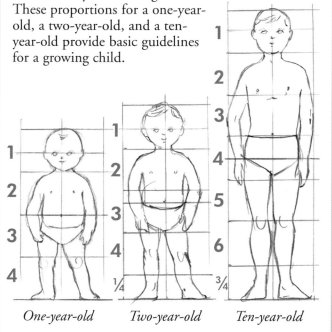

One-year-old *Two-year-old* *Ten-year-old*

Children's faces

In a portrait drawing of a child, you have more scope to study and capture those special endearing characteristics—the roundness of the cheeks, the softness of the skin, and the light in the eyes. Children's faces are unlike those of adults, so you must trust your eyes and draw what you see. If you don't, you may end up with a drawing of a miniature adult. Each child's face is unique, of course, but in general their cheeks are rounder, their foreheads higher, their mouths smaller, and their eyes larger in proportion to their face and set wider apart than those of an adult.

BABY
Babies have round cheeks, high foreheads, small button noses, and indefinite chins. The hair is often fine and wispy, so in a finished drawing make your marks soft to reflect this texture.

LITTLE BOY
By the age of seven or eight the face has lengthened. The eyes are still set wide apart, but they have moved higher in the face. The mouth and nose are more distinct and beginning to assume definite character.

GIRL
At the age of twelve this girl's face still has the soft curves and delicate shape of a child, but her features are larger and becoming more adult in their proportions.

CHANGING FACIAL PROPORTIONS

Children's faces change dramatically as they grow. In a small baby the features are clustered together in the lower half of the face beneath a high, domed forehead, and the eyes are set wide apart. But as the child grows, the face lengthens and the position and relative proportions of the features change. Eventually, in adolescence the face becomes more adult.

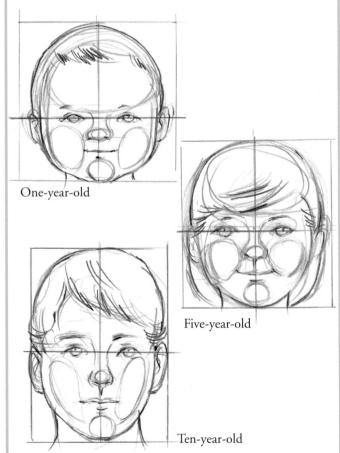

One-year-old

Five-year-old

Ten-year-old

①Baby in overalls
a study of a toddler in classic conté

Babies and young children are fun subjects to draw—all soft curves and rounded forms, with nothing angular or hard anywhere. Moreover, they grow and change so quickly that a sensitive drawing that captures a moment in a new life will become a significant family treasure. You could even reproduce the piece for a very special greeting card or frame it as a gift for proud grandparents.

Unless they are asleep, babies won't be still long enough for you to make a finished drawing, so you may want to work from a photograph. Ideally, take several shots and make exploratory sketches from them. This will give you a greater insight into your little subject and you can then choose the photo that best captures the essence of the child. If you decide to work from life, approach it in the same way, with plenty of quick sketches and visual notes that you can use to help create a finished drawing. The sketchbook itself will be a delightful record of childhood.

Our artist took a classic approach to the subject, using sanguine (a rich red-brown) and white conté on toned paper—a method of working frequently used by Old Masters for figure drawing. Essentially you are working with three colors—white for high notes, sanguine for dark tones, and the paper color for the mid-range.

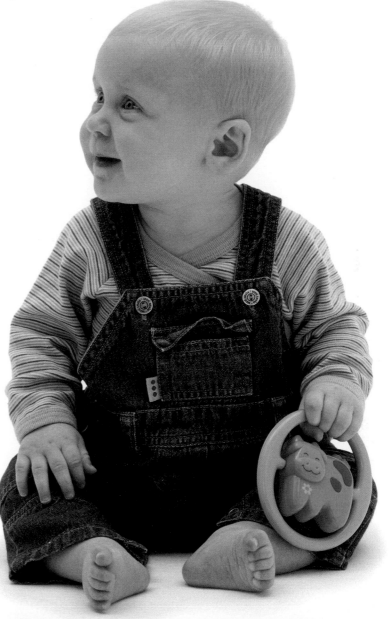

This photograph was shot with soft lighting, which creates subtle tonal differences. A stronger side light will create more obvious lights and darks. ▶

Using conté crayons and pencils

Conté is a monochrome medium and is slightly harder than pastel. The limited range of colors includes brown, sanguine, black, and white, and these provide tonal effects, not actual color. Traditionally only two conté colors are used—white for highlights and sanguine for dark tones—on a colored paper, which serves for the mid-tones in the subject. You can see numerous examples of this technique in the softly molded figure and portrait drawings of the Old Masters.

Conté in practice

Conté can be used successfully for both line and tone work. Use pencils for fine lines and detailed drawing, and create tone with hatching techniques. Use sticks to create broad areas of tone. For linear work, use a corner of the stick or sharpen the tip to a point with sandpaper or a craft knife.

Scribble using pencil

Short marks using pencil

Crosshatching using pencil

Lines using stick end

Tone using side of stick

Tone using stick end

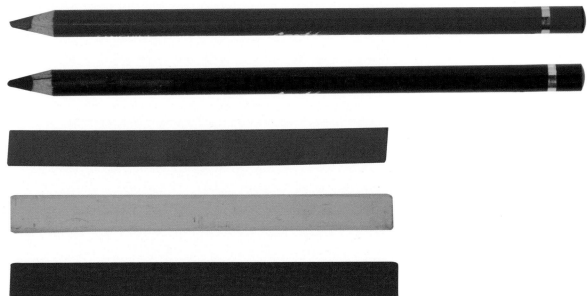

Conté is available as square-shaped sticks or pencils. It is made from clay, and this provides its natural, earthy colors. Marks can't be erased completely, but a putty eraser can tone down mistakes.

Artist's tip

Charcoal paper, also known as Ingres paper, is well worth using. It's a pastel paper, but it is also perfect for charcoal and conté work. The lines within the paper show through the pigment and create an interesting surface texture that you can harness in your drawing.

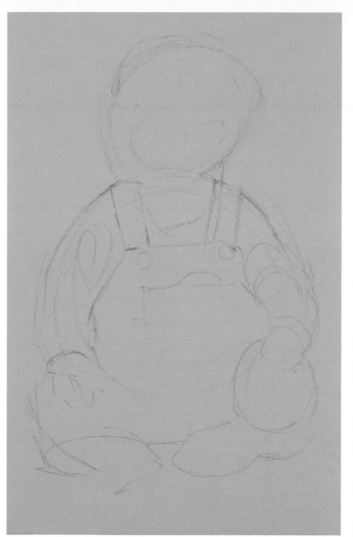

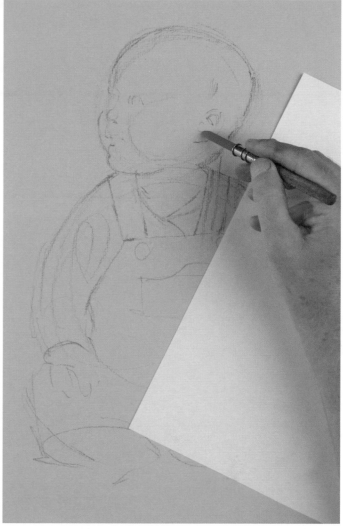

1 Use the conté stick to lightly sketch in the basic shapes of the baby's seated figure, aiming to get the proportions right. Note the foreshortening of the legs from this straight-on viewpoint. Indicate the position of the feet and hands.

2 Start to refine things a little. Notice how large the head appears in relation to the body. Measure to get this right, and look carefully at the exaggerated curve of the back of the head. Begin to plot the shape and position of the facial features, covering the drawing with a spare sheet of paper to prevent smudging when necessary.

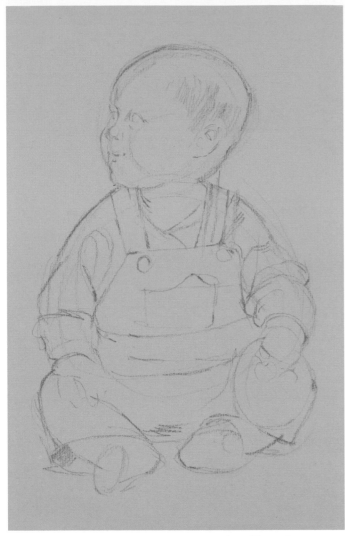

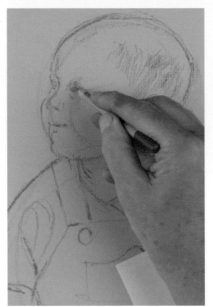

4 The placement of the eyes is crucial. Once they are there, the character emerges, so look carefully and draw what you see, relating them to the other features all the time. Use the harder, sanguine colored pencil to add the details, along with a touch of definition to the mouth.

Up close
The proportions of a baby's face are very different from those of older children or adults (see page 126). The spacing of the eyes and the shape of the eyelids in particular need careful attention. As always, draw exactly what you see— once the eyes are right, the drawing comes alive.

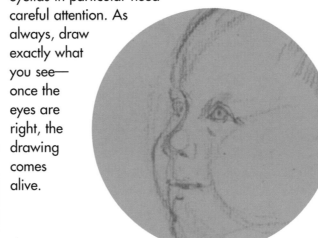

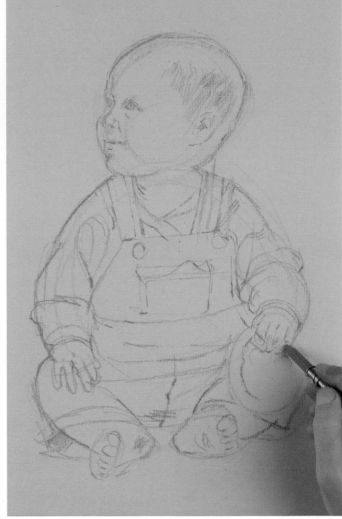

3 Work on the arms—again, note the effect of foreshortening and remember to draw only what you see. Add the subtle shadow on the head to indicate the shape of the skull, then draw the face a little more to position the features. Add a few stripes on the shirt, keeping in mind that their direction gives valuable clues to the form beneath.

5 Return to the sanguine conté stick to add a little more soft tone to the face. Now look at the chubby baby hands. See how they are made and the forms they have. Assess their size in relation to the legs and feet. Firm up the arms, add detail to the feet, and feel the shape of the legs beneath the overalls.

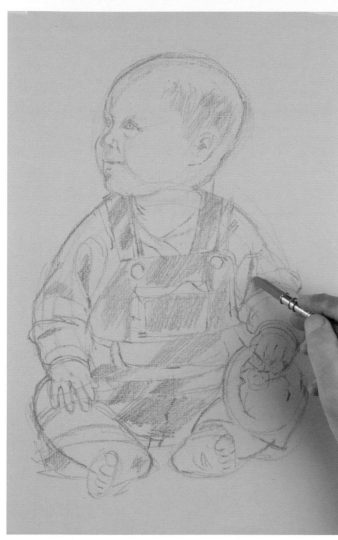

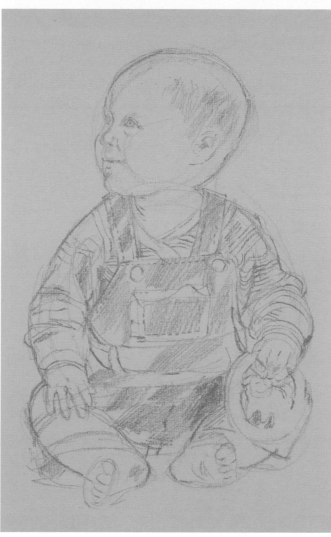

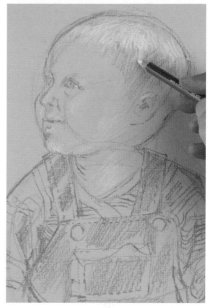

8 Now use the white conté pencil to stroke in the highlights on the head, face, and neck. These help to convey the solid form and suggest the roundness of the chubby baby cheeks.

6 The soft, generalized lighting of this subject makes the changes in tone very subtle. However, you can detect them if you look carefully, so add some loose shading with the sanguine conté stick. Work lightly and don't make anything too definite yet. For the moment, simply establish the main areas of shadow on the baby's overalls and shirt.

7 Look again at the stripes on the shirt. Notice what happens to them at the elbow. Use the conté stick to suggest a few of the stripes but don't labor the point; let the viewer's eye fill in the rest. Refine the shapes of the arms as you work. Then add some detail to the overalls and the rattle.

Artist's tip
Use the sanguine colored pencil for a tighter line to suggest the topstitching often used to decorate denim garments. These touches of telling detail give added information about the texture and nature of the garment.

Artist's tip

Since this baby's head is seen in partial profile, it's impossible to avoid having to draw an ear. It looks complicated at first, but if you take your time, look carefully, and draw what you see, then you'll get a successful likeness. We all know what ears look like, but try not to draw what you think you know. Draw what you see.

Up close

The artist has used some telling details to provide both visual and descriptive interest. Here, he's varied the thickness of the lines on the shirt to suggest folds in the fabric by changing the pressure on the pencil.

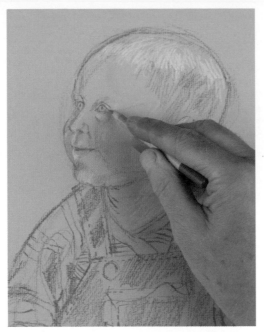

9 Develop the face more with the colored pencil. Firm up the features if you're happy they are in the right place. Look for the highlights and add these to mold the face. Take your time with this; work slowly and thoughtfully and, as always, draw just exactly what you see—don't invent.

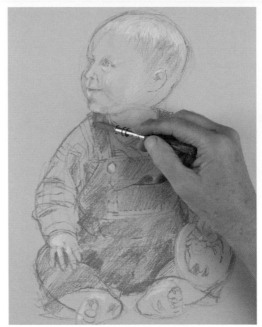

10 Add white highlights to the hands, feet, and legs. Then move around the drawing, bringing it all into focus. Use the conté stick to darken the tones in the shadow areas. Keep your marks open; just use a little more pressure on the conté stick to create the deeper tones.

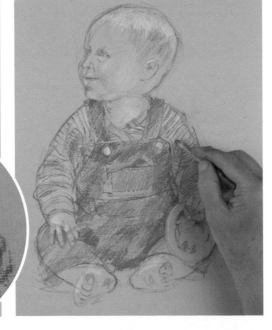

11 Strengthen the dark tones some more, still working lightly. However, don't scribble randomly; get a rhythm of movement going. Then pick out some of the stripes with the white before using the pencil again to define them a little more.

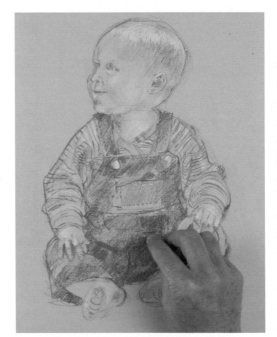

12 Finally, add a bit more detail here and there, such as on the ears, feet, and hands. Add some dark tone to the inside of the legs of the overalls. Use the side of the conté stick for final broad sweeps of tone. Notice how the surface of the paper shows through, adding textural interest.

Baby in overalls
finished drawing

The key to drawing a convincing picture of a baby is to get the proportions right. A baby's head is very large in relation to its body. Make sure you look and measure carefully; don't underestimate it. For this project, you are using only light and dark drawing tools. Varied pressure on the conté creates a variety of darks, but the mid-tone is provided by the paper.

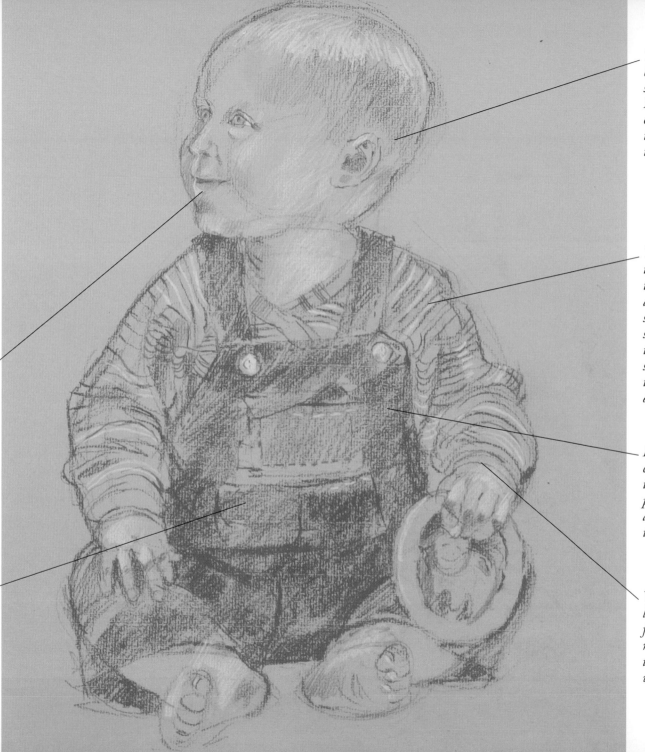

Look carefully at the baby's features; their relative position and proportions are very different from those of an adult. Make sure you draw what's there, or you may end up with a drawing of a miniature adult.

The Ingres paper has natural lines in it that create an interesting surface pattern. This is perfect for expressing the texture of the fabric.

There's no strong light on this baby, so the areas of light and shade on the head are very subtle. However, you need to search them out and use them to help convey the shape of the chubby face and the softness of the head.

The stripes on the garment follow the contours of the body, so use them to give a sense of volume and solidity. Don't draw every stripe; a select few will tell the story. Alter the pressure and turn the stick as you work so that the stripes will vary in thickness. If they're all a uniform weight, the drawing will be dull and lifeless.

Energetic use of the flat side of the conté stick gives a lively texture to the denim overalls. Increase the pressure to deepen the tone. Use a sharpened end to add a little telling detail to the garment.

When viewed straight on, the legs and arms are considerably foreshortened. Keep in mind the rounded forms of the body under the clothes, but draw only exactly what you see.

QUICK REVIEW

The artist created a lifelike drawing of this baby that faithfully captured the forms within the body. At first sight this seems like a difficult subject, but by concentrating on the basic shapes and then moving on to add details, you will achieve good results.

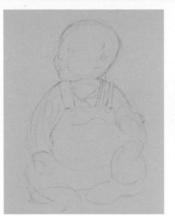
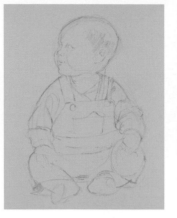
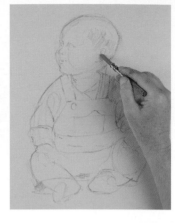

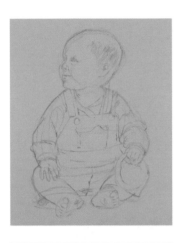
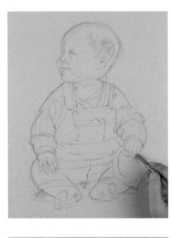
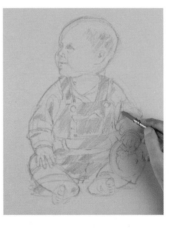
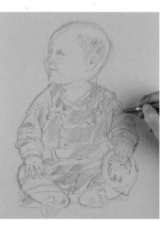
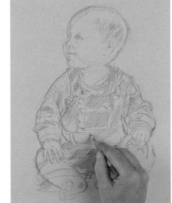

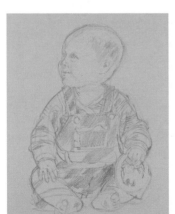
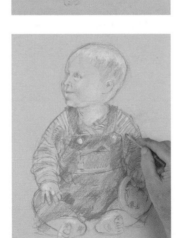
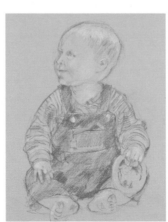
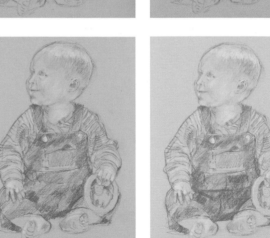

2 Portrait of a girl

a drawing in pastel pencils

Portraiture presents something of a challenge to the artist. The object is not just to draw a face convincingly, but also to give clues to the person's unique character. This demands a considerable degree of accuracy, but if you approach it in the same way as any other subject, you won't find it as hard as you initially think.

Before you start, sit and study your model for a while. Most faces are asymmetrical, so be sure to notice the irregularities that make this particular person interesting. The key, as always, is to be aware of the underlying forms—remember the hard structure of the skull beneath the softness of the face. Look carefully and make every mark represent something you actually see—don't invent anything.

Whether you plan to draw from life or from a photograph, consider the setup carefully. A strong directional light will create distinct areas of light and shade that help to explain the form. It's a good idea to keep background detail to a minimum and beware of cast shadows or reflected light that could be confusing.

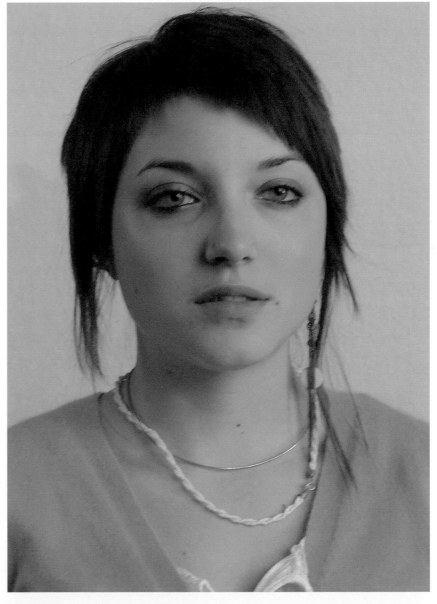

A young model will possess a smooth complexion, making her the ideal subject for a beginner. ▶

Eyes and mouths

Before you attempt to capture a good likeness of someone, you need to study the shapes, sizes, and relative positions of their eyes, nose, and mouth and recognize the underlying anatomy that gives them their three-dimensional form. Make sure eyes and mouths are the right size and in the right place before you get too detailed. Starting with your own features reflected in a mirror, practice drawing them in your sketchbook from different angles and with different expressions.

Observe eyes from the side and you'll see that they are spheres nestling in the hollows of their sockets. Keep these spheres in mind as you draw.

Notice the highlights on the lids of closed eyes. Include these to describe the curvature of the eyeball beneath the lid.

When the mouth is closed, the lips relax and appear softer and fuller. Indicate the shapes with tonal changes and sensitive lines.

Notice how the light falls on the lower lip, creating a shadow underneath. The top lip meanwhile is often in shadow.

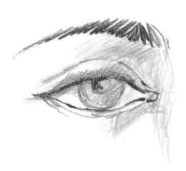

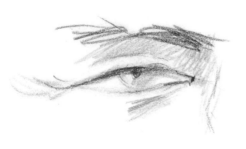

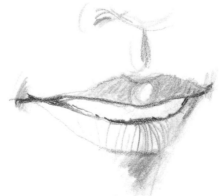

The eyelids follow the curve of the eyeball. The highlight reflects the light source and conveys the shape of the eyeball.

The shape of the eyes changes with different expressions. In a smiling face, the cheeks lift and the eyes narrow.

Lips curve to cover the teeth. Notice how the lips of a smiling, open mouth tighten and stretch, and how the rest of the face is affected.

In an older face the lips are generally thinner and the lines around the mouth are more pronounced.

Noses and ears

As always, concentrate on drawing exactly what you see. Facial features are unique in each person, so incorporate the characteristics and irregularities that make your model recognizable. When depicting noses and ears, remember to think in terms of tone, not line. Observe them from all directions to study their three-dimensional form, and notice the information that the variations of tone convey. Ears are as individual as any other feature, so take time to look at them carefully.

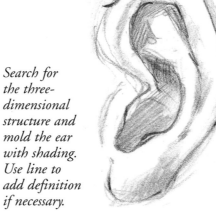

Seen straight on, highlights are evident on the front of the nose and the curve of the nostrils. Use these tonal changes to convey the shape.

In a three-quarter view, the nose casts a shadow on one side of the face. Use this change of tone to show the shape of the nose.

Search for the three-dimensional structure and mold the ear with shading. Use line to add definition if necessary.

The complex structure of ears is daunting, and they're often glossed over. Practice drawing them from every angle.

In profile the nose shape can be represented with line. The curve of the nostril, however, can still be depicted with tone.

A baby's features are closer together than those of an older child. The nose is a fleshy button and the ears relatively large.

Position the ears carefully before filling in detail.

Observing the variety of lobe shapes will help you discover their individuality.

Artist's tip

Most beginners try to capture a likeness by drawing detailed features. The result is often lifeless and unconvincing. For this project the artist has chosen to work in a much looser style, without precise detail, concentrating first on identifying the broad areas of light and dark tones.

To do this, hold your pencil very lightly up toward the end of the shaft and work from the wrist with your hand off the paper.

This method will make you look at your subject in a whole new light! (For more on holding pencils, see page 29.)

1 With the white pastel pencil, plot the lightest areas of the face. Add light ochre to begin adding tone. Then use soft rose-pink to indicate the shadow areas. Only slight emphasis is necessary to suggest features.

2 Use pale cocoa brown to add slight definition to the eyes, eyebrows, and mouth. Deepen the tone on the shadow side of the nose and then use Van Dyke brown to softly block in the hair.

The pastel pigment has been laid on very lightly at this stage—it's just colored dust sitting on the surface of the paper. Careful dabbing with a putty eraser will lift it off without smudging or disturbing the surrounding areas, so you can remove any mistakes and make adjustments.

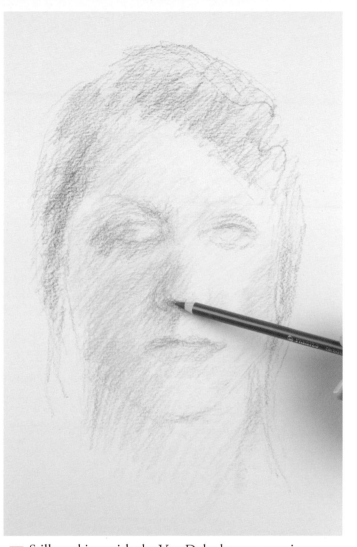

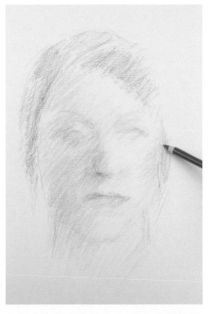

3 With soft rose-pink gently stroke in the mouth and use it to clarify some of the shadow areas—under the eyebrows, around the eyes and eyelids, and on the side of the nose. Use your putty eraser to adjust things if necessary, then add a little pink tone to suggest the blush on the cheek that faces the light.

4 Go back to light ochre and use it freely and lightly over the areas of pale skin tone to enrich the color slightly. Hint at the color of the irises with pale blue-gray. Use Van Dyke brown to work into the hair a little, deepening the tone of the darkest areas around the face.

5 Still working with the Van Dyke brown, continue drawing into the hair and then reinforce the darker shadows in the eye socket and on the side of the nose a bit more. Begin to mold the nose and the nostril carefully and work on the eyes, defining the lids and sharpening things up a little.

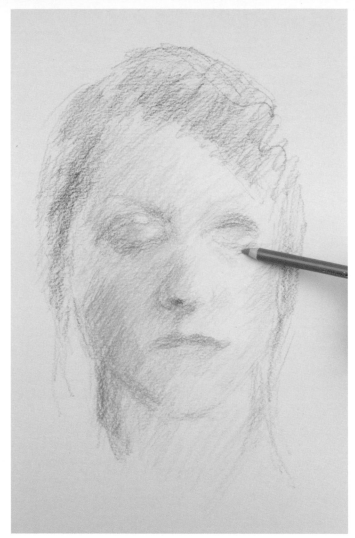

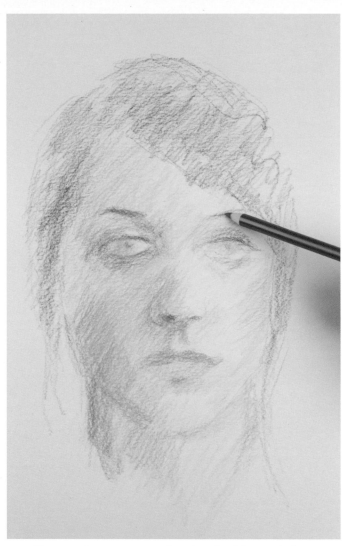

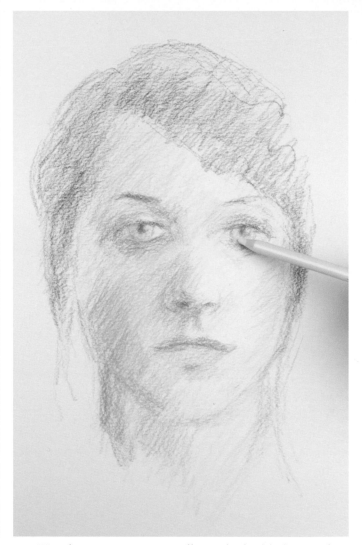

6 Light ochre and soft rose-pink are warm colors, so use a light dusting of pale blue-gray to cool the skin tones down a bit on the shadow side of the face. Add the same color to the shadows under the eyes, then use the pale cocoa brown to adjust the skin tones further. Add a little more emphasis to the mouth.

7 Constantly assess your drawing, looking at it from a distance to see the effect you are creating. Correct things as you go—here the artist has adjusted the hairline with Van Dyke brown. With the same color, define the eyebrows and eyelids. Now the face is beginning to emerge on the paper.

8 Use the putty eraser to pull out the highlights on the forehead and side of the face. Deepen the tones in the hair and define the eyes some more, strengthening the color of the irises. Add the pupils in the eyes and include the highlights. Define the nose and mouth with a little more shading detail.

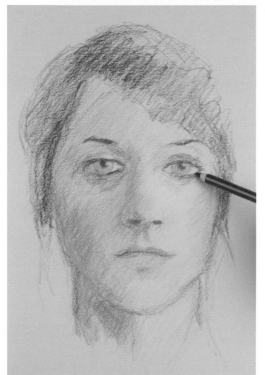

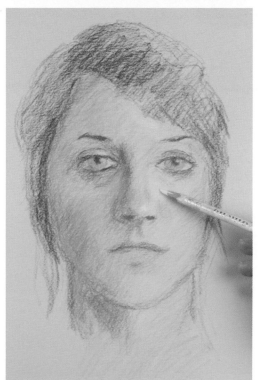

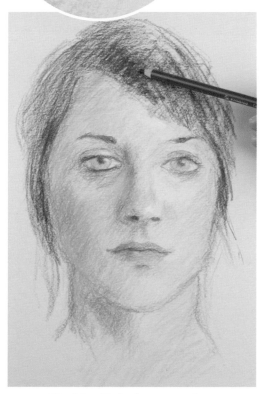

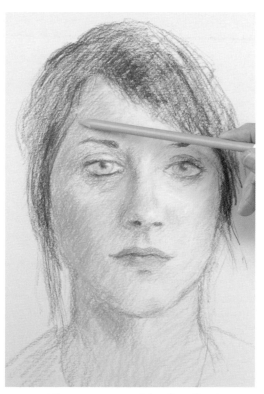

9 Develop the eyes with Van Dyke brown. Then continue to mold the face, adjusting and balancing the form and tone with light ochre and pale cocoa brown. Add more pale blue-gray to the shadows under the eyes.

10 Use light marks and deepen shadows with Van Dyke brown. Warm things up with cocoa brown and light ochre, and add cooler tones with pale blue-gray. Use white to lighten some of the tones and add highlights.

11 Use Van Dyke brown and strong, layered marks to indicate the thickness and texture of the hair. Select elements for emphasis, such as the mouth, eyes, and nose. Sharpen these up and enhance the darker tonal values.

12 You can now add a few final touches—add some more texture to the hair, develop the neck a little, and suggest clothing. Give a final tweak to the skin tones, and add a little more highlight to the forehead and cheek.

Artist's tip
As you add successive layers of color, don't just continually go over old marks or your work may become dull and muddy. Instead, make fresh marks with each new layer of colored pencil, keeping things light and open so the eye can mix the colors.

Portrait of a girl

finished drawing

Pastel pencils are available in a wide range of colors, but no single color will suffice for skin tones and their subtle variations. The artist achieved the right shade by lightly dusting on layers of color and using the variations in tone to mold the face without the need for harsh lines.

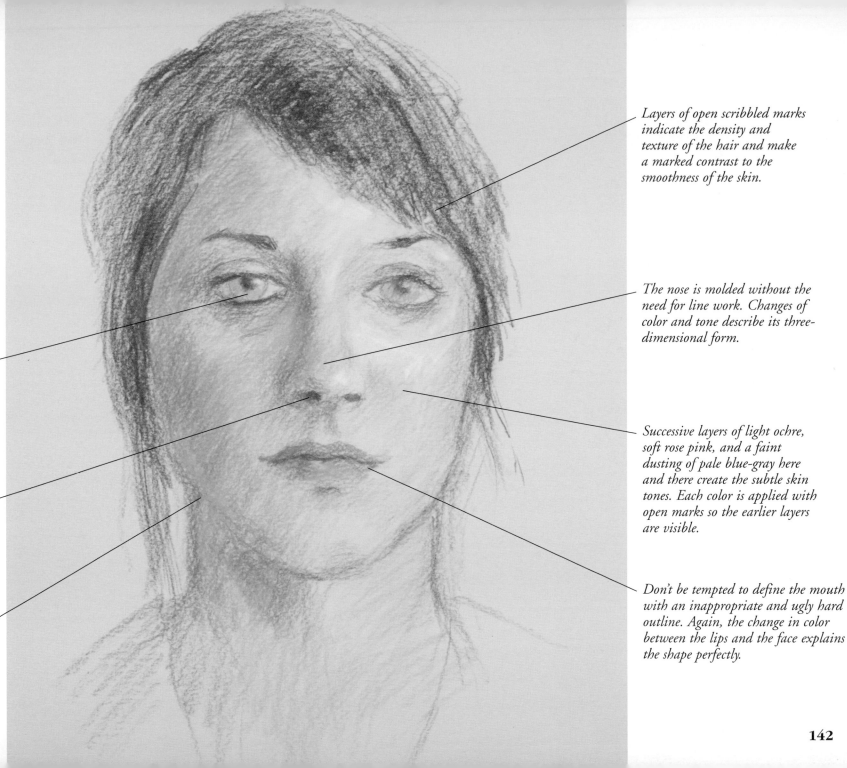

Look closely at the eyes. They help to convey mood and character. Their shape, color, and the position of the highlight are carefully drawn.

Small areas of dark brown—the eyebrows and lashes, the nostrils, and the shadow between the lips—echo across the image and conduct the eye around the face.

Even in deep shadow, the skin tones aren't gray. They take on a warm glow by building up the pinky brown tones.

Layers of open scribbled marks indicate the density and texture of the hair and make a marked contrast to the smoothness of the skin.

The nose is molded without the need for line work. Changes of color and tone describe its three-dimensional form.

Successive layers of light ochre, soft rose pink, and a faint dusting of pale blue-gray here and there create the subtle skin tones. Each color is applied with open marks so the earlier layers are visible.

Don't be tempted to define the mouth with an inappropriate and ugly hard outline. Again, the change in color between the lips and the face explains the shape perfectly.

QUICK REVIEW

This step-by-step review shows how the artist has created a portrait by building up blocks of color. She began by suggesting areas of skin and hair. Then she worked in more color to capture areas of light and shade. More controlled application of color and tone helped to define the model's features.

 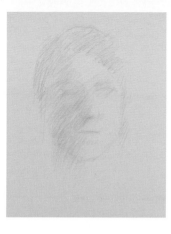 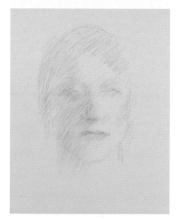 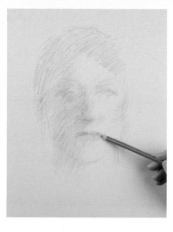

 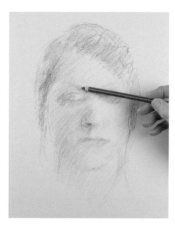 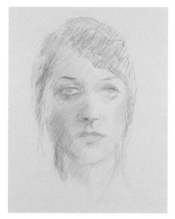 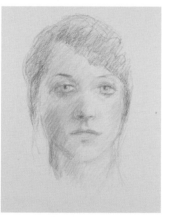 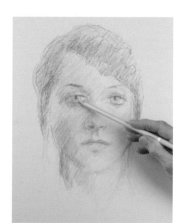

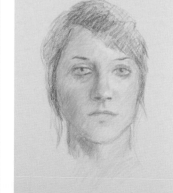 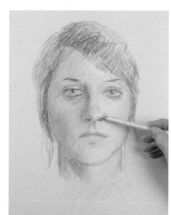 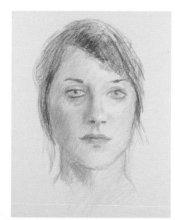 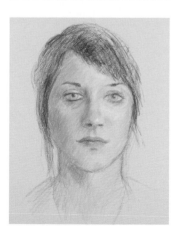 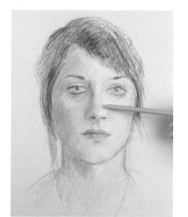

3 Seated pose
a study in chalk, charcoal, and conté

Unlike portrait drawing, you don't have to go for an exact facial likeness when you draw a seated figure. Instead, look for characteristic poses and body proportions. If you observe carefully and represent what you see accurately, your drawing will successfully convey the essence of your model. As with any other subject, it's worth making a few quick sketches to become familiar with your subject before you begin work on your finished drawing.

Always bear in mind the simple geometric shapes beneath the clothes, and use these to help construct the seated figure—keep feeling for a sense of roundness and weight as you draw. Our artist started with blocks of tone to establish a sense of solidity in her seated figure. She added line work to define things only once she was happy that everything was in place. The orange tone of the pastel paper serves for the mid-tones, with the charcoal, conté, and chalk creating the dark and light tones in the subject.

If you work from life, be kind to your model! Let them have breaks every so often, but mark the position of key points, such as the feet, with small pieces of masking tape so the same position can be returned to easily—if these are in the right place, the rest of the body will follow.

Encourage your model to sit in a position that he or she can hold comfortably and return to easily after a break. Once the model is settled, move around to look at the subject from different viewpoints. ▶

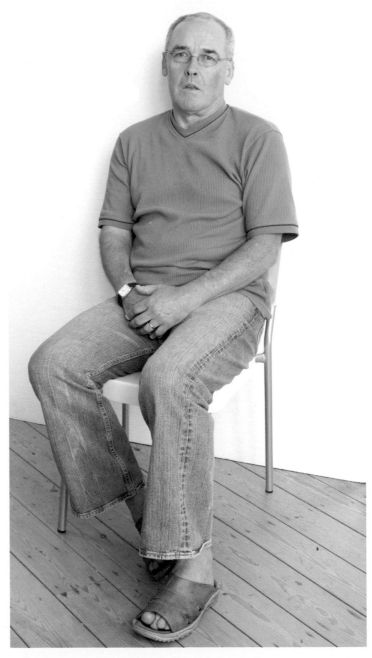

Drawing simple seated figures

It's easy to see the basic body proportions of a standing figure. Seated figures, however, pose a different kind of challenge. One that, more than ever, requires you to look carefully and take measurements. With a seated figure, you might have to handle a large amount of foreshortening. To deal with this effectively, forget what you know about basic proportions and draw exactly what you see, even if it looks strange. Use the simple-shape approach for information (see pages 12–15).

Artist's tip
A three-quarter view is easier to draw than a full frontal. There's less foreshortening to deal with, and the forms of the body and legs are more apparent.

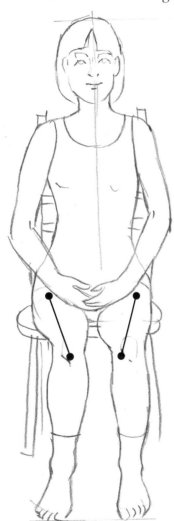

The rules of basic body proportions won't help much when things are foreshortened (see page 121). To see and understand this clearly, walk around a person seated on an upright chair. You'll notice that things change as you move to the front. The thighs appear substantially shorter (see arrows), and the length of the feet is all but lost.

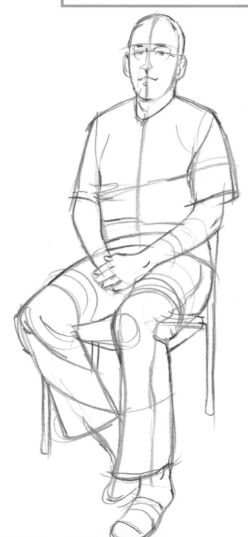

It's essential to create the impression that the figure is sitting firmly on the chair. Look for the underlying simple forms first, and use contour lines to help convey their volume.

Use the negative shapes created by the chair to position the legs and check their relative position and size, and notice the foreshortening of the left thigh. Take careful measurements to help you (see page 17).

Drawing complex seated poses

As well as using the simple-shape approach for representing the body's form, make use of the negative shapes (see page 16). These will help you relate the limbs to each other, which is useful in complex poses such as a figure curled up on a couch. Both these techniques will enable you to draw a figure that sits squarely and has a convincing sense of weight instead of mysteriously floating.

(see page 16)

Artist's tip
Try drawing a model in a tight striped top. The stripes follow the curves of the body, and you can use them to convey the three-dimensional form.

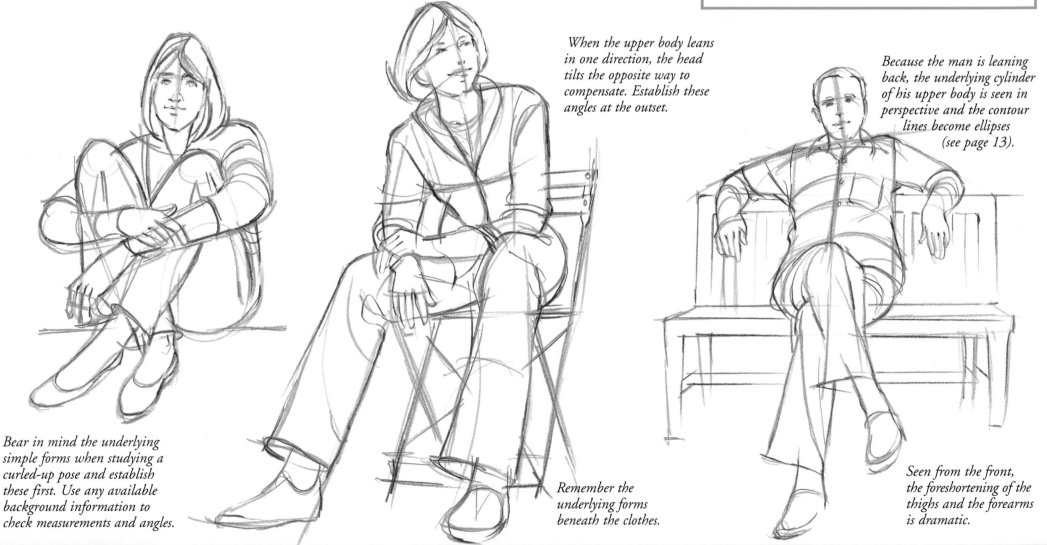

When the upper body leans in one direction, the head tilts the opposite way to compensate. Establish these angles at the outset.

Because the man is leaning back, the underlying cylinder of his upper body is seen in perspective and the contour lines become ellipses (see page 13).

Bear in mind the underlying simple forms when studying a curled-up pose and establish these first. Use any available background information to check measurements and angles.

Remember the underlying forms beneath the clothes.

Seen from the front, the foreshortening of the thighs and the forearms is dramatic.

Artist's tip

When you work with several colors to create a tonal drawing, introduce them all at the outset and work with them from the beginning. Don't be tempted to do a charcoal drawing first, for example, and then add white to it. You will already have established a drawing that works in monotone, and it will be difficult to change it convincingly.

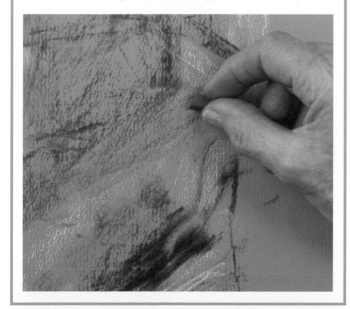

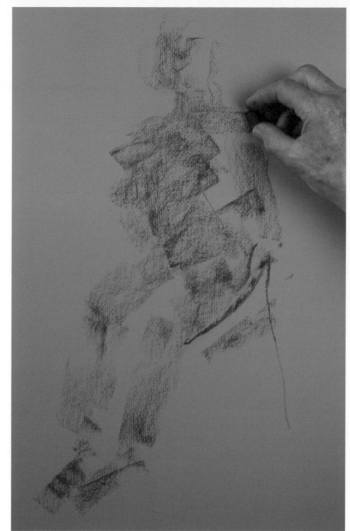

1 Break off a short length of charcoal stick and use the side of it to begin mapping the figure on the paper. Work broadly and loosely to establish the main bulk of the figure. Indicate the chair legs with a few lines.

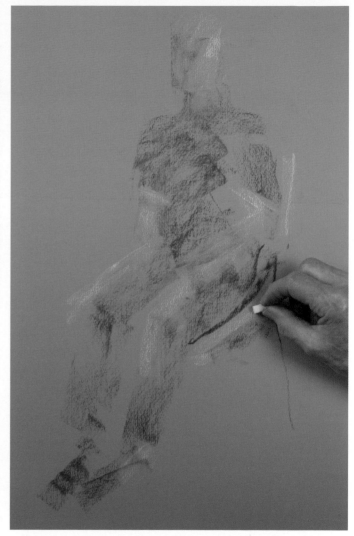

2 Use the flat side of the white chalk to block in the lightest areas—look at the figure through half-closed eyes to identify these more easily. The white will pick up some charcoal dust and create a variety of gray tones.

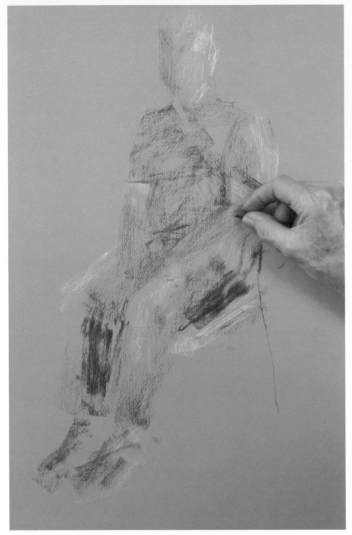

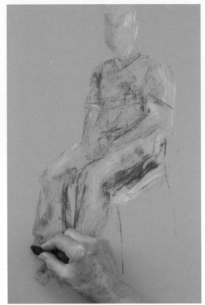

4 Using the sharp edge of a piece of charcoal, begin to define the positions and forms of the legs and arms a little more. Work lightly, assessing and adjusting as you go, constantly checking positions and proportions—here, the artist corrects the position of the model's right leg.

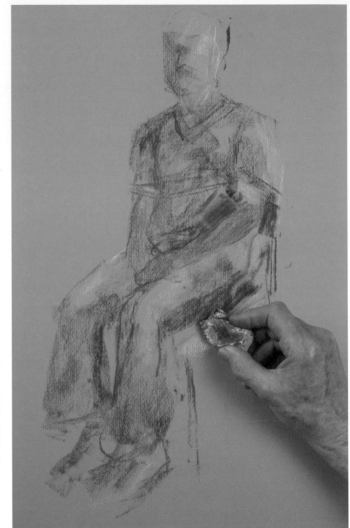

3 Now stroke the brown conté over the white chalk to knock back the brightness. Use the charcoal again and begin adding darker areas. Adjust some of the lighter tones with more white chalk. Work with all three mediums, continually adjusting and balancing the tones.

Artist's tip

Notice the negative space left between the chair leg and the model's left leg. Look for other negative shapes—under the chair, for example. Getting these right helps you draw the figure more accurately.

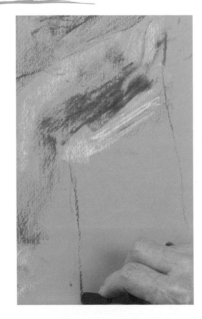

5 Suggest the forms of the arms a little more by deepening the shadow areas on the T-shirt and the back of the chair. Add brown tone to the arms. Begin to indicate the position of the facial features. The pigment is laid on very lightly so you can lift off any wrong marks easily with the putty eraser—knead it occasionally to get a clean surface to use.

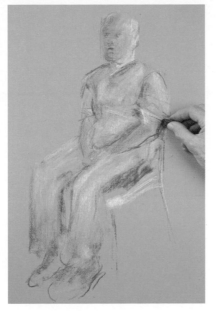

7 Now start fine-tuning things a little, working with all three colors. Add more white to the front of the body, using your marks to express the form beneath the T-shirt. Add brown tones to the face and arms, then use the edge of the charcoal to draw into the face and define the figure a little more.

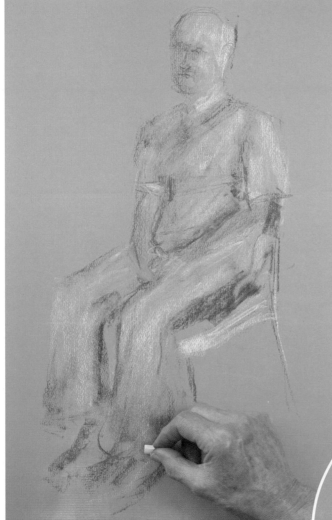

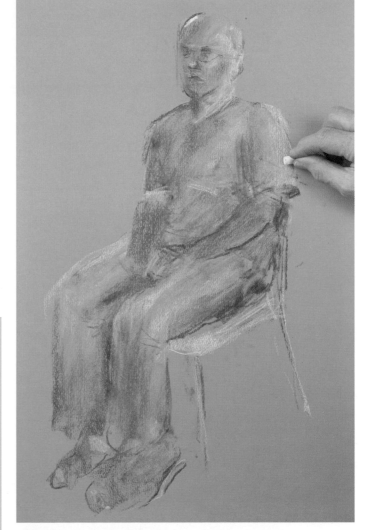

Up close
When drawing feet, it's important to get them in proportion—too large or too small and the whole figure will look wrong. Look carefully and measure them against the rest of the body. Making just a few accurate marks in the early stages of the drawing will help plot their size and position.

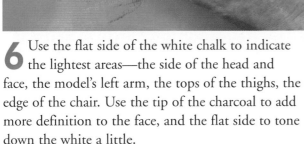

6 Use the flat side of the white chalk to indicate the lightest areas—the side of the head and face, the model's left arm, the tops of the thighs, the edge of the chair. Use the tip of the charcoal to add more definition to the face, and the flat side to tone down the white a little.

8 Have your model adopt a suitable expression so you can add more detail to the face. Adjust the tones in the image, then darken the shadow areas on the sleeves and pants. Stroke in more brown for the warm mid-tones and lighten the front edge of the chair and the nearest sleeve. Then add a highlight to the top of the head. Develop everything together—don't get bogged down in one area.

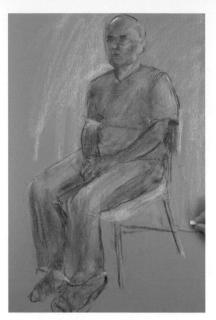

9 To achieve the gray mid-tones, use white first and then lay the darks sparingly on top—it can be hard to lighten dark tones effectively. Work on the hands, then carry on adjusting tones and defining the whole figure. Scrub in a little light background tone to lift the figure away from the paper.

Up close
Use a sharp edge of the charcoal to draw with more precision. Add detail to the face, for example, by observing carefully and using just small touches. A little means a lot—if you overdo it, the result will be dull and muddy.

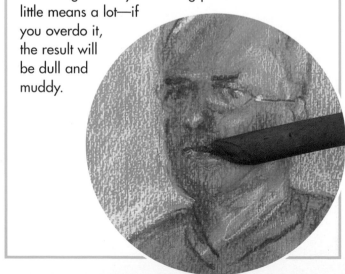

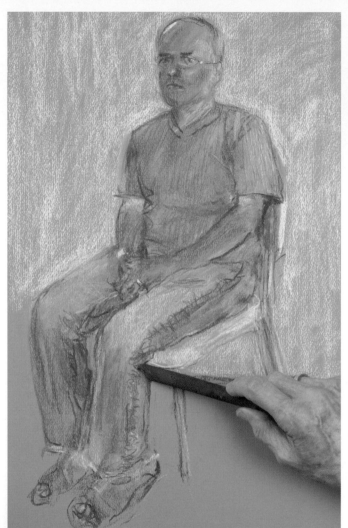

10 Use the tip of the chalk to add textural lines to the T-shirt and to add some bright highlights. Work with the tip of the charcoal to add detail to the face, hands, and feet. Use it to suggest the small creases in the pant seam. Twist the charcoal as you work to maintain a sharp edge, and vary the marks you make. Be subtle and work with a light touch.

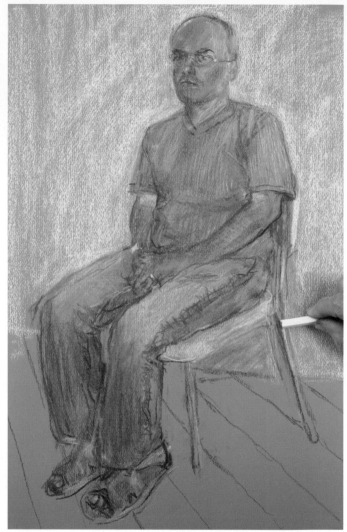

11 Now it's time to make adjustments, if necessary. Scrub in some more light background tone, keeping the texture open. Add a few floorboards to give a clue to the setting and help to position the chair firmly on the floor. Use the white chalk to add any final highlights, or lift areas off using the putty eraser.

Seated pose

finished drawing

Bright orange paper makes an eye-catching background for this drawing. The paper color serves as the mid-tones and provides local color for some of the skin tones. Meanwhile, the chalk adds the lightest tones, and the charcoal and brown conté provide the dark tones. In some places all three blend for a softly shaded effect.

Without going into detail, a hint of background gives the figure a sense of place. The chair sits firmly on the floorboards, and the white wall behind enhances the seated figure. Rough scrubbing marks provide a lively texture.

The feet are represented in a generalized way but are still convincing. Check the size of the feet in relation to the rest of the body.

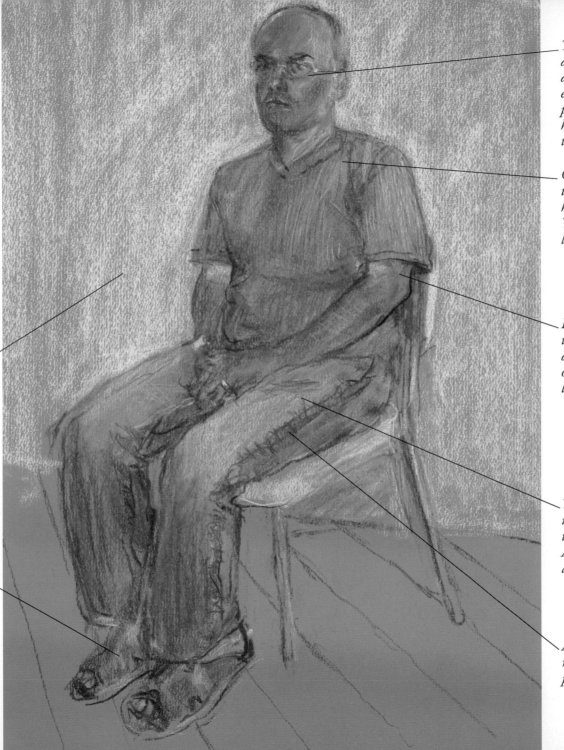

The face is simply molded with all three drawing tools. They don't allow for delicate detail, but small touches convey enough information. The merest hints of pure white highlight on the top of the head, the lips, and the spectacles bring the face to life.

Charcoal and white chalk blend together to create a range of gray mid-tones that help to give form and texture to the T-shirt. The sharp edges of both add lines that suggest the fabric.

Brown conté adds warmth to the skin tones. Increased pressure on the stick deepens the tone in the shadow area of the arms, and white chalk lifts the lighter areas.

The flat side of the charcoal stick blocks in the darker tones on the pants, while the white chalk picks out the light areas. A mist of white over the charcoal creates a useful gray tone.

A sharpened edge of charcoal adds linear marks that indicate the seam on the pants and the creases in the fabric.

QUICK REVIEW

In this seated portrait, the artist built up the image in blocks of tone before drawing in any finer details. The strongly colored paper acts as the darker of the mid-tones in the drawing.

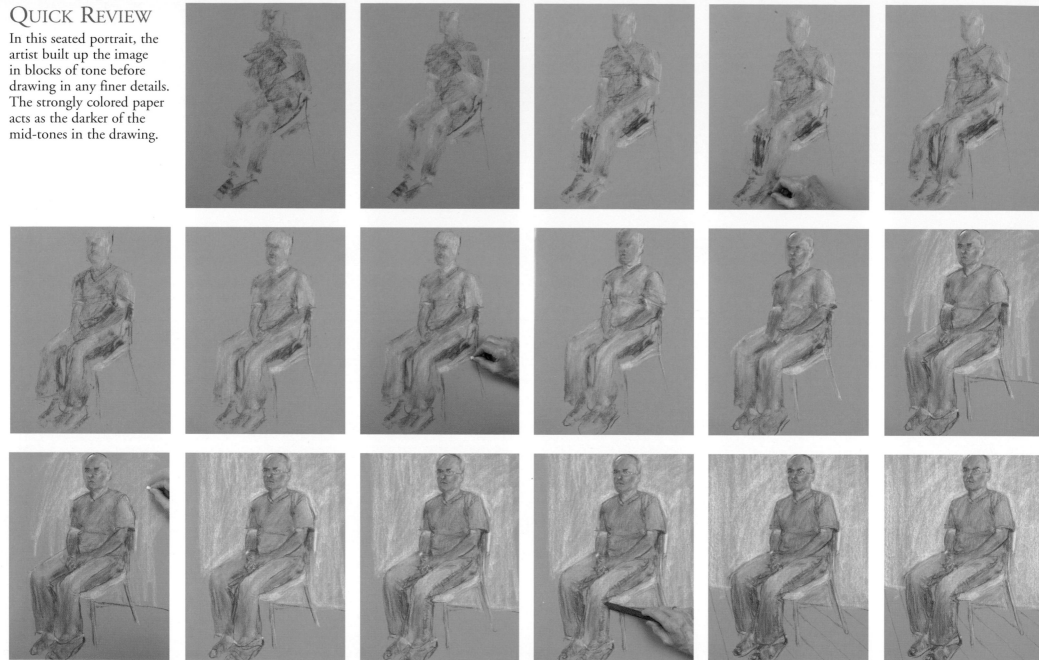

Animals

Drawing animals

The animal kingdom offers a multitude of intriguing subjects to draw. Even town dwellers have access to animals and birds in parks and zoos, and many of us have pets at home that make ideal models, so there's no shortage of inspiration. You may want to achieve a passable likeness of a loved pet or include animals in a landscape, and you need to convey recognizable forms even at a distance to make your drawings believable.

THE SIMPLE-SHAPE APPROACH

At first glance an animal's structure seems complex, and fur often obscures the form of the body beneath. However, most animals can be assembled with the aid of the sphere, cylinder, cone, and cube. Use these shapes to give your drawing a firm foundation with a sense of solidity before you consider details.

FINDING LIVE MODELS

You can work from photographs, but try drawing from life, too. If you have a pet, you have a perfect opportunity to practice your drawing techniques and fine-tune your powers of observation. What's more, stroking your pet will teach you about the anatomy beneath the fur.

For more exotic wildlife, visit a zoo. With unfamiliar species, you have to concentrate and draw exactly what you see, which is excellent practice. Farm animals also provide interesting subjects. If animal drawing really interests you, study a book on animal anatomy to help you understand underlying muscle and bone.

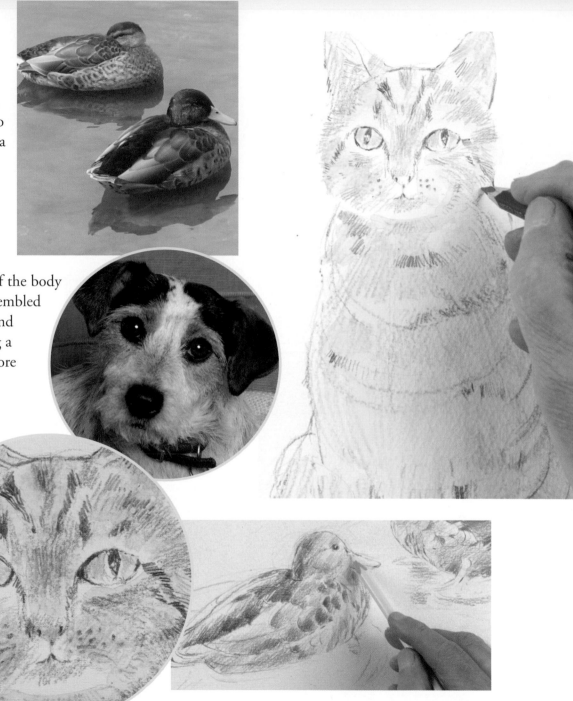

Cats

Cats obligingly sleep for large parts of the day or simply sit and stare, thus providing hours and hours of uncomplaining modeling. This allows you plenty of time to observe and draw without having to rush things—ideal for the tentative beginner. And if the cat does move, it will undoubtedly return to the same pose later so you can complete your drawing.

Start by drawing the simple shapes underneath the fur, and feel the rhythm of its body. Notice what happens to the different parts of the anatomy when the cat stands, sits, or lies curled up. Some parts will be compressed, others elongated. If the cat is having a glorious stretch, the whole body is taut and full of energy. The head and face, too, can be broken down into simple shapes so they look solid and realistic.

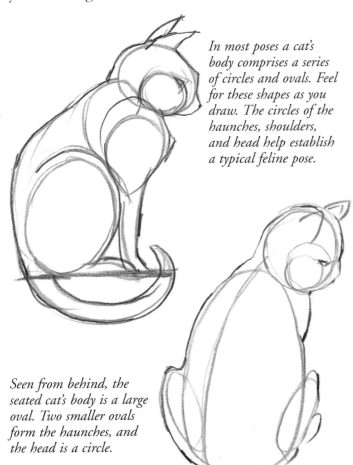

In most poses a cat's body comprises a series of circles and ovals. Feel for these shapes as you draw. The circles of the haunches, shoulders, and head help establish a typical feline pose.

Seen from behind, the seated cat's body is a large oval. Two smaller ovals form the haunches, and the head is a circle.

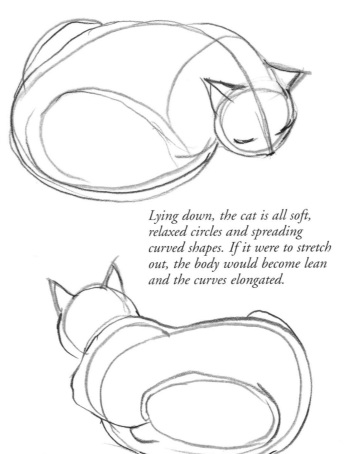

Lying down, the cat is all soft, relaxed circles and spreading curved shapes. If it were to stretch out, the body would become lean and the curves elongated.

DRAWING A CAT'S FACE

Cats have perfectly symmetrical faces, with level, wide-set eyes. However, different breeds have different face shapes. A tabby has a round face with a short nose, while exotic breeds, like Siamese and Burmese, have aristocratic long, pointed faces. Notice the shape of your cat's unique face and the shape, position, and size of the eyes, nose, and mouth. You need to capture these characteristics for a good likeness.

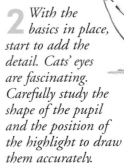

1 *Draw the center line, then the line of the eyes. Next, plot the positions of the features. The ears are basically triangles. Some cats have proportionally large ears set high on the head; others have small ears set low.*

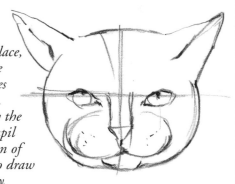

2 *With the basics in place, start to add the detail. Cats' eyes are fascinating. Carefully study the shape of the pupil and the position of the highlight to draw them accurately.*

Dogs

Dogs come in a huge variety of distinctive shapes and sizes. However, all breeds have the same essential anatomy; the difference lies mainly in the proportions. Generally, dogs are more animated and active than cats, with characteristic and eloquent ways of communicating—the tilt of the head, the prick of the ears, and the angle of the tail. You need to observe and convey these features to capture the essential nature of the dog. Fortunately, like cats, dogs sleep a lot, so be kind to yourself and start drawing when the animal is still. You can tackle more animated poses as your confidence grows.

Begin with the basic shapes beneath the fur. Use contour lines to convey the solidity of the forms, and check the proportions continually. Work to get these foundations right before you add any fur details.

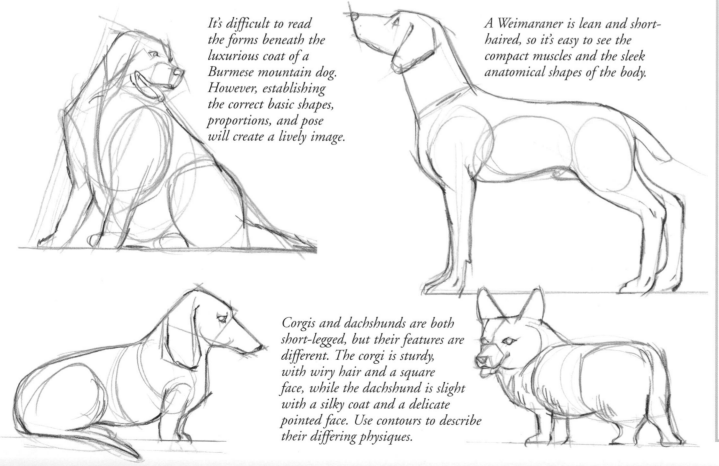

It's difficult to read the forms beneath the luxurious coat of a Burmese mountain dog. However, establishing the correct basic shapes, proportions, and pose will create a lively image.

A Weimaraner is lean and short-haired, so it's easy to see the compact muscles and the sleek anatomical shapes of the body.

Corgis and dachshunds are both short-legged, but their features are different. The corgi is sturdy, with wiry hair and a square face, while the dachshund is slight with a silky coat and a delicate pointed face. Use contours to describe their differing physiques.

DRAWING A DOG'S FACE

Dogs have animated and expressive faces and make perfect subjects for portraits. Each breed has its own characteristic facial shape, so capture this first. Then pay careful attention to the features—the position of the eyes, for example, is crucial. For details use lively and animated marks in keeping with the subject.

In profile the shape of the dog's head and the set of the neck are clear. Every breed is different, but most have long wedge-shaped noses. Look for this basic underlying shape and take measurements to achieve the right size.

From the front the length of the nose is lost. The only way to cope with this foreshortening is to forget what you know about the shape of the dog's face and draw exactly what you see. A few construction lines and a feeling for the basic shapes will help you.

Horses

Horses are compelling creatures to draw, from majestic cart horses to streamlined thoroughbreds or shaggy ponies. However, they can seem difficult to depict, and it helps to familiarize yourself with their basic anatomy before you start.

Notice their powerful muscle structure and the way the legs articulate at the key joints. Then use the simple-shape approach, together with a few key measurements taken with a pencil held at arm's length (see page 17), to construct a believable animal that has solidity, energy, and movement. Use the size of the head to check proportions.

You can work from photographs, but be brave and try drawing from life. The more you observe and draw, the more you'll understand, and the better the results will be. Start with an animal that is grazing lazily in a field so you can take time to render the subject accurately.

A SIDE VIEW

1 *The body of the horse is a rectangle, and the neck and head modified triangles. Large circles represent the muscular hindquarters and shoulders, and the smaller ones the knee joints.*

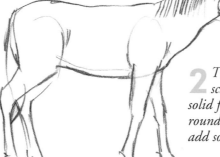

2 *The geometric scaffolding creates a solid foundation. Now round out the forms and add some details.*

A THREE-QUARTER VIEW

1 *From this angle the body is foreshortened. The swell of the belly and the curve of the shoulders are more apparent. Follow the curve of the spine down the neck to the head.*

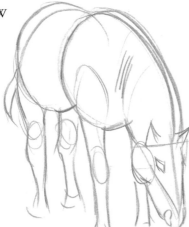

2 *With the horse now standing firmly in your drawing, add facial details and refine the rounded shapes. Indicate the mane with lines that follow the three-dimensional contours.*

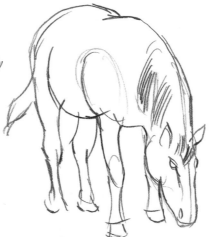

DRAWING A HORSE'S HEAD

Just as the body of the horse can be seen as a collection of geometric shapes, the head can be represented with circles, triangles, and rectangles.

1 *Start with a modified three-dimensional rectangle that tapers toward the nose. On top of this, superimpose a large circle for the cheek and position the eye a little more than halfway up the face. Add perky triangles for the ears and convey the form with some contour lines.*

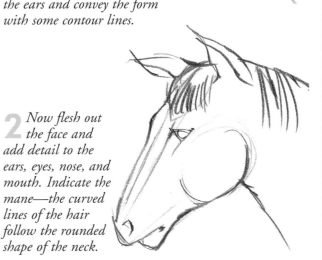

2 *Now flesh out the face and add detail to the ears, eyes, nose, and mouth. Indicate the mane—the curved lines of the hair follow the rounded shape of the neck.*

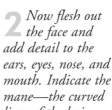

Cows and pigs

Cows and pigs are likely contenders for a guest appearance in a landscape. They each have their own recognizable shape and proportions. If you familiarize yourself with their different forms and learn to draw them convincingly close up, you'll be able to use an expressive shorthand to suggest them at a distance in a landscape. Look for basic shapes—combinations of cubes, cylinders, spheres, and cones. These will help you achieve credible drawings of these animals from any viewpoint.

Sketch them from life if possible. They're fairly sedentary, so you'll have plenty of time to study them. Cows and pigs have short-haired coats, so their basic forms are easily observed.

Cow

1 *Seen from the side, a cow's body looks rectangular, and the head and neck form a series of triangles. First, lightly sketch the curves of the belly, shoulders, and hindquarters.*

2 *Round out the body all along its outline and curve the chest and neck. Then add form to the legs, noting where the legs swell at the joints.*

3 *Firm up the lines and add a few contour marks to subtly suggest the three-dimensional form. Lastly, add detail to the face.*

Pig

1 *A pig's body is a generous cylinder; the haunches and shoulders and neck and cheek are plump ellipses and circles; the ears are triangles.*

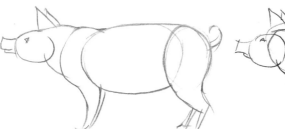

2 *Keeping the shapes of the pig heavy and rounded, start to soften the divisions between the basic forms and draw in a curly tail.*

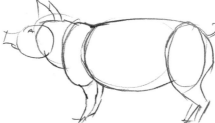

3 *Observe the eye and mouth and refine these. Finish with a few contour marks on the belly to hint at the three-dimensionality.*

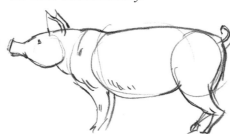

Drawing back views

If animals wander away from you, don't give up! Seen from behind, they're likely to make interesting studies that reveal intriguing shapes you hadn't noticed before. And you'll want a variety of views if they are to be part of a larger drawing.

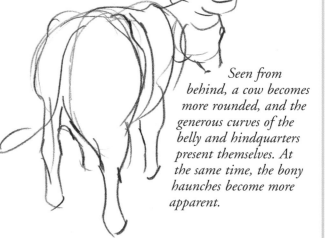

Seen from behind, a cow becomes more rounded, and the generous curves of the belly and hindquarters present themselves. At the same time, the bony haunches become more apparent.

A pig from behind is much as you'd expect—rotund and spherical. Its body looks like a series of diminishing rubber tires seen in perspective. Let your pencil exploit those delicious plump shapes to express the essence of a pig.

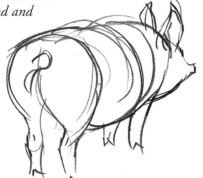

Sheep and goats

Unless it's recently been sheared, a sheep is little more than a woolly barrel on surprisingly thin legs. The thick fleece hides the underlying structure of the body so you have to find another approach, perhaps starting out with shorn sheep to learn more about the anatomy. A goat's shape is easier to read than a sheep's, even if its coat is quite long.

To practice your life studies of these animals, find subjects that are fairly still, and practice drawing them from different viewpoints.

SHEEP

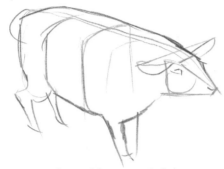

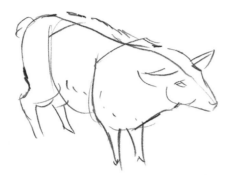

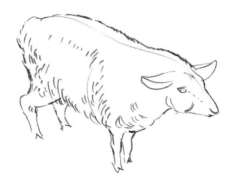

1 Use the visible external shapes to define the sheep's form. The body is a cube, while the hindquarters and shoulders swell into bulky curved shapes. The head is a slender cone.

2 The way the wool lies and changes direction give important clues to the forms beneath. Follow these to start rounding the shapes to give solidity to the animal.

3 Represent the fleece with a few informative marks. Short, curved lines suggest the curly fleece and the shape of the body. Add detail to the eye and mouth to liven up the creature.

GOAT

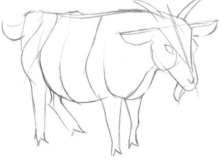

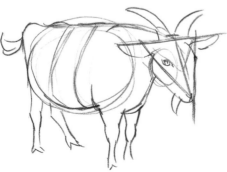

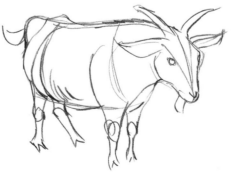

1 A goat is shaped like a small cow, with angular haunches that contrast with a heavy swelling belly. The head and face are a flattened cone.

2 The ears stick out straight to each side. A goat has thin legs, so make sure they are proportioned correctly and the joints are in the right positions.

3 Use contour lines to show the shape of the belly and the curve of the neck. Use them, too, to highlight the bony haunches.

DRAWING ANIMAL HEADS

If you want your animal drawings to look believable, pay as much attention to the heads and faces as to the bodies. If you master these, your animals will be easily recognizable even if they play only a small part in a larger scene.

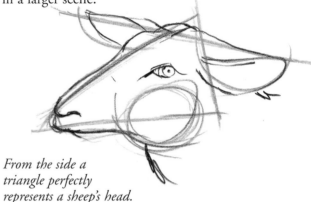

From the side a triangle perfectly represents a sheep's head.
A straight line across the top of the head marks the position of the ears, and the eye sits almost in the middle of the triangle. A small circle creates the curve of the cheek.

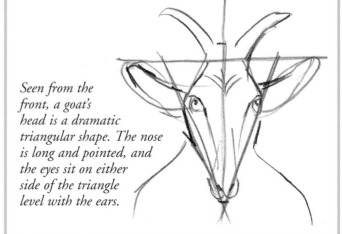

Seen from the front, a goat's head is a dramatic triangular shape. The nose is long and pointed, and the eyes sit on either side of the triangle level with the ears.

Birds

Birds make great subjects, with their astonishing diversity of size, shape, and plumage. Unfortunately, because they are constantly on the move and often nervous, they can be difficult to draw from life. For this reason it's best to work from photographs until you gain enough confidence to tackle the real thing.

You can practice on exotic and colorful birds in captivity for life drawings. Or on a more mundane front, ducks, geese, and domestic fowl make excellent models. They are usually used to humans and will oblige by staying close so you can make plenty of sketches.

Before you put pencil to paper, just sit and watch. Look for the distinguishing features and proportions that identify each species—the shape and size of the body, head, and beak; the length of the neck; the angle and size of the tail; the color and pattern of the plumage. Watch for characteristic stances and typical movements. Then discover the simple geometric shapes beneath the forms to help you draw them convincingly.

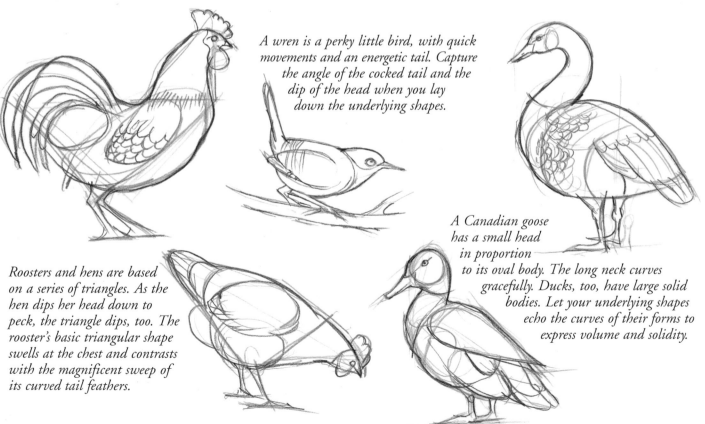

A wren is a perky little bird, with quick movements and an energetic tail. Capture the angle of the cocked tail and the dip of the head when you lay down the underlying shapes.

Roosters and hens are based on a series of triangles. As the hen dips her head down to peck, the triangle dips, too. The rooster's basic triangular shape swells at the chest and contrasts with the magnificent sweep of its curved tail feathers.

A Canadian goose has a small head in proportion to its oval body. The long neck curves gracefully. Ducks, too, have large solid bodies. Let your underlying shapes echo the curves of their forms to express volume and solidity.

BIRDS IN FLIGHT

Even at a distance, when no details are visible, birds in flight have silhouettes that make them recognizable. The shape and spread of the wings and tail and the angle and form of the head all give clues as to the species. So even if you draw birds as simple distant shapes, represent them with meaningful lines.

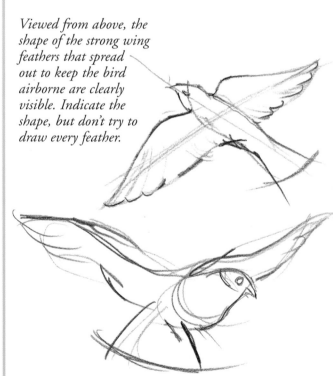

Viewed from above, the shape of the strong wing feathers that spread out to keep the bird airborne are clearly visible. Indicate the shape, but don't try to draw every feather.

Seen from underneath, the bird takes on a different shape. You can see the swelling chest and the tail feathers in landing position. Very few lines express this energetic movement.

1 Tabby cat
a pet study in watercolor pencils

Cats seem to spend a large amount of time asleep or just sitting and staring, so they make perfect models! Before you start to draw, spend time watching the cat as it sleeps or sits, and notice its habitual poses. Study its face both in profile and straight on. Each cat has its own unique features that differ from those of other cats, so you need to try to portray this individuality in your drawing. The color, thickness, and markings of the fur are also distinctive, so try to convey these, too.

The patterns on a tabby's coat may seem complex, but there's no need to draw every marking. Stripes generally follow the curves of the body beneath the fur, so use a select few in your drawing to help convey the solid form of the cat.

When you are going to draw an animal, begin by identifying the basic shapes that make up its body. Leave the details until later. ▶

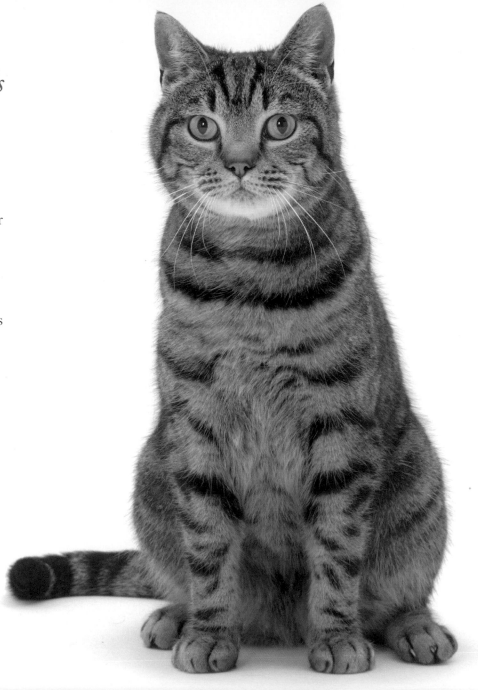

Using watercolor pencils

Watercolor pencils combine drawing and painting in one convenient, versatile, and portable drawing tool. You can use them dry in the same way as ordinary colored pencils, and you can combine them with water in a number of ways to create softened lines and wash effects. Use them to create a wash as a background for linear details, as our artist did for the tabby cat drawing, or draw first and then add water to blend and merge colors and soften lines in selected areas. The quality of the pencil and the amount of water you add—anything from a dampened finger or sponge to a loaded brush—dictate the kind of wash created and the amount of line that remains visible. Use a paper that won't pucker when wet. Textured watercolor papers are ideal.

Watercolor pencils in practice

Begin with a line drawing using linear color-mixing techniques and add water to blend colors and lines. Or wet the paper or the pencil tip with clean water for a variety of soft pencil marks. Keep it fresh and simple or the effects may become muddy and dull.

Wetting scribbles

Scribbling into water

Wetting to blend color

Wetting crosshatching

Mixing color into water

Wetting broken color

Watercolor pencils vary. The harder they are, the less readily they dissolve; the weaker the wash they create, the more linear marks remain. Try several different kinds to see which give you the effects you want. There's no need to buy dozens of different colors; just a small selection will give you plenty of color-mixing options.

You will need

- Basic equipment (see page 8)
- Spare paper for sketches
- Sheet of rough watercolor paper
- Graphite pencils—2B, 4B, and 7B
- Watercolor pencils: raw sienna, Naples yellow, pale lime yellow, pale pink, burnt umber, chocolate brown, gunmetal gray, silver-gray
- Watercolor brush
- Cup of clean water
- Craft knife
- Putty eraser

Artist's tip

If watercolor pencils are a new medium for you and you prefer to work just with graphite pencils for your first attempt, you can still produce a drawing that reflects the personality and look of the cat. Observe the way the fur lies on different parts of the body. This will give you valuable clues to the forms hidden beneath the coat and aid you when trying to depict the texture of the fur.

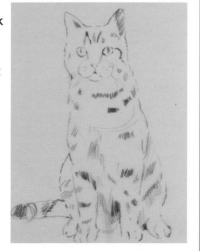

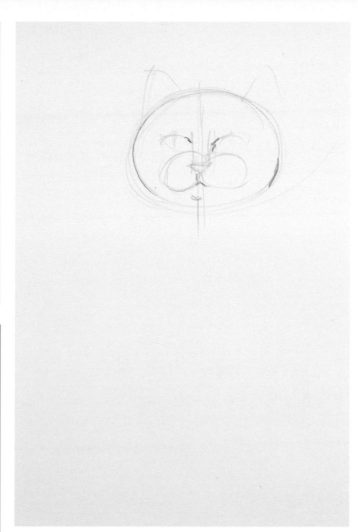

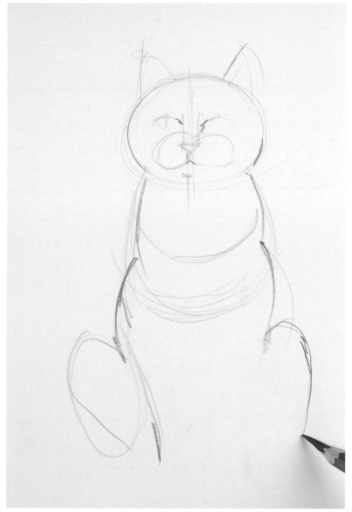

1 Take a spare sheet of paper and a pencil and start to work your way into the subject. Begin with a circle for the head and indicate the muzzle and the eyes. Draw in a center line. Remember you are only making a rough sketch at this stage, so forget about details and work quickly. If you are not happy with the sketch, it's easy to do another one.

2 As you move down the body, keep your pencil moving loosely around and around in continual motion, feeling the curves and sensing the volume of the body. Check that the head and body are in proportion to each other. There can be a temptation to squash the body if you haven't left enough to room to fit it comfortably on the paper.

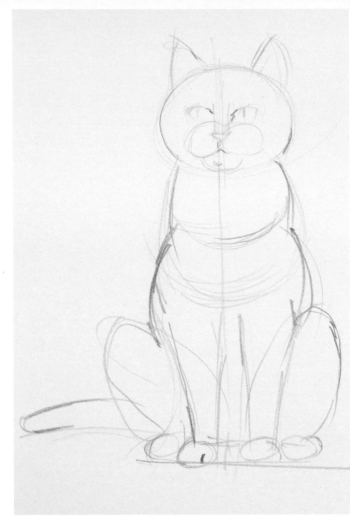

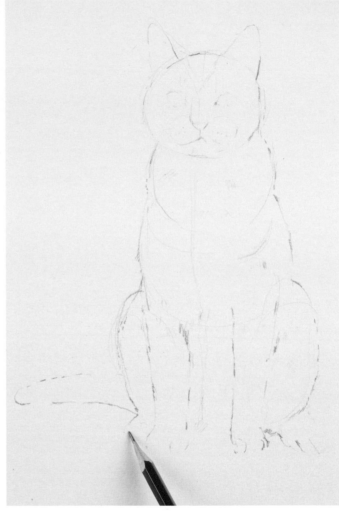

3 Study your finished sketch and make more sketches until you are satisfied with the proportions and the way the image is fitting on the page. This stage shouldn't be a chore. Many artists find these quick sketches satisfying to do, and the results can be very appealing.

4 On watercolor paper start to lightly sketch in the cat with your 2B pencil, bearing in mind the basic shapes beneath the tabby's form. As for your sketch, draw a circle for the face, adding a center line. Plot the positions of the eyes, nose, mouth, and ears—these sit more or less symmetrically on the center line.

5 Follow the center line down through the body—it's not quite vertical because the cat isn't sitting absolutely straight. Still working lightly, begin to sketch in the position of the front legs, the curve of the haunches, and the placement of the feet.

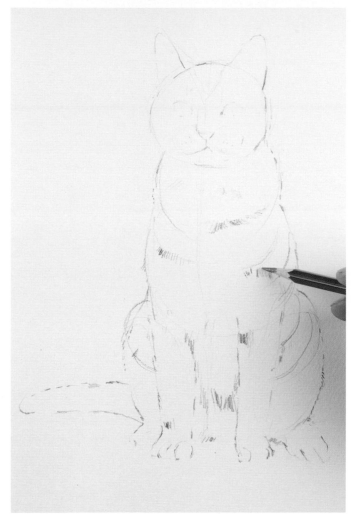

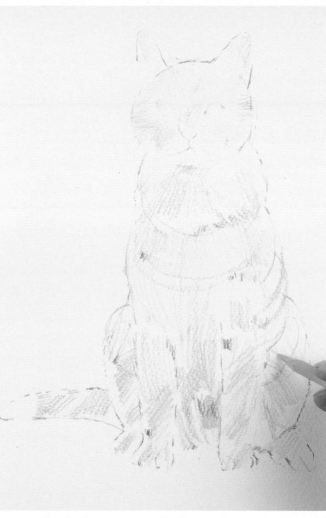

Brushing water over watercolor pencil creates a wash that serves as an initial base on which to overlay more marks to suggest the density of the fur. Use just a little water on your brush to create this base—too much will obliterate your initial marks and you will be left with a flat wash with no texture.

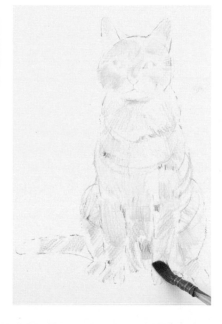

6 Use the 4B pencil to begin to indicate some of the stripes. These follow the curves of the body beneath the fur, so they are useful in your drawing to help you describe the shape of the cat. Remember that fur is soft in texture, so avoid using hard outlines.

7 Work a little more into the face, refining the shape of the eyes. Now use the Naples yellow and raw sienna to scribble in a little local color on the fur. Work loosely with marks that follow the direction in which the hair grows and the shape of the form beneath.

8 Add a subtle touch of pale lime yellow to the eyes. Now use a watercolor brush and clean water to spread the color on the fur. Don't saturate the paper with too much water. Let the wash dry thoroughly before moving on to the next step.

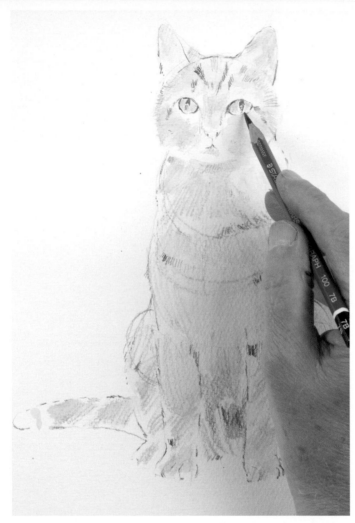

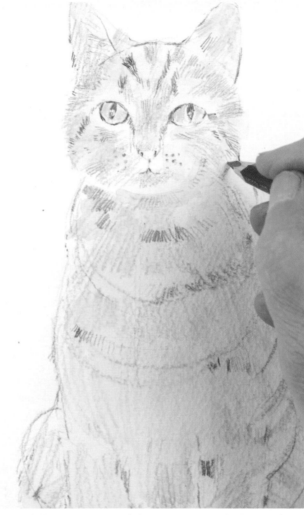

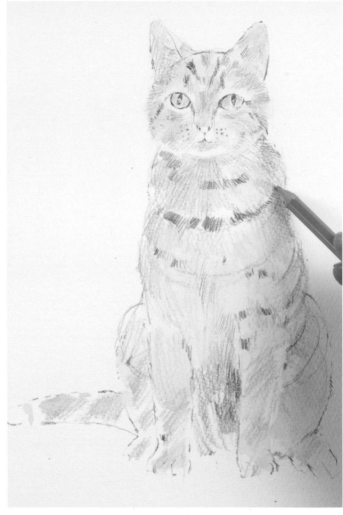

9 When the drawing is dry, lift off any initial outlines with a putty eraser. Use burnt umber to work into the eyes and nose, refining their shapes. Use gunmetal gray to add mid-tones to the fine, silky areas on the head. Draw into the eyes some more with the 7B pencil for added definition, and make small marks in the direction of hair growth to indicate some of the stripes.

10. With the 4B pencil draw in some whiskers. Then use burnt umber very lightly over the raw sienna and Naples yellow wash to tone down the brightness a little. Again, make marks that follow the direction in which the fur grows.

11 Use your 4B pencil on the body for some of the darker markings, still following the direction of growth. Use chocolate brown on the areas of the tummy that are in shadow and around the base of the neck. Add a little raw sienna to adjust the color values.

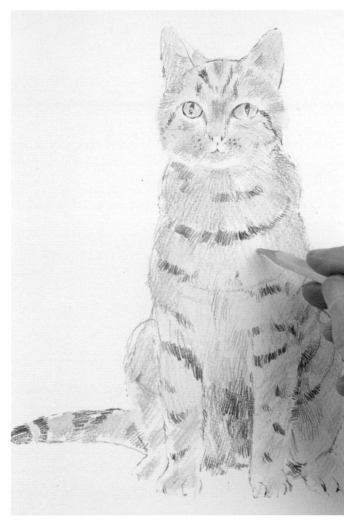

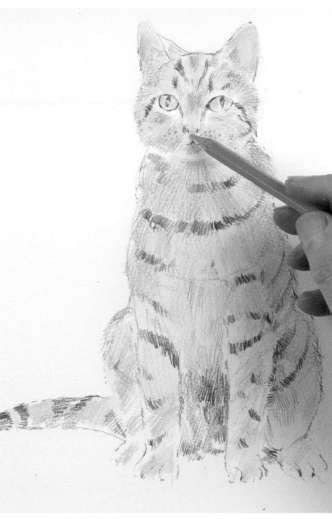

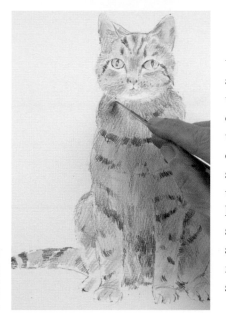

14 Assess your picture and then make any final adjustments. Here the area beneath the chin and on the tummy have been darkened with raw sienna. Finally, use the tip of the craft knife to scratch out some of the whiskers and then draw a few more back in with a sharp 7B pencil.

12 Use the 7B pencil for the darkest marks on the tummy and tail, always following the direction of growth with your marks. Add silver-gray over the yellow underwash to tone the color down even more if necessary, or add more yellow in places to brighten it up a little.

13 Return to the eyes if you feel they need further defining. Add a touch of pink to the nose and inside the ears. Tone it down with a little water if it's too strong, and overlay with silver-gray.

Up close
Whiskers are important detecting devices for a cat. Here the artist has scratched into his drawing to reveal fine lines of white paper for some of the whiskers; he has drawn others in with the

sharp point of his 7B pencil. Notice how well this combination of techniques makes the whiskers show up against the colored fur without looking stiff and unnatural.

Tabby cat

finished drawing

Animal hair is dense and often fine in texture and frequently obscures the shape of the body beneath. You need to keep the underlying forms in mind as you work and use marks that reflect the solid shapes under the fur.

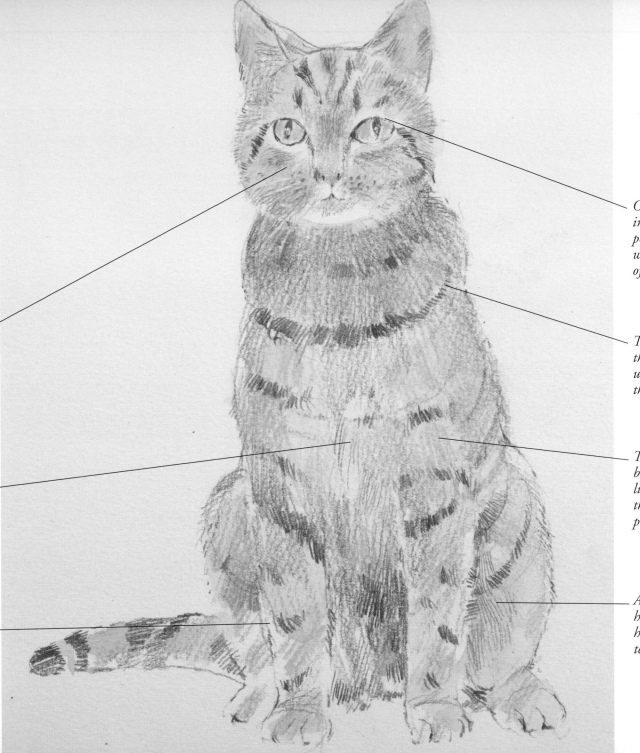

Draw in some of the whiskers with a sharp pencil. Then gently scratch out some more whiskers with the tip of a craft knife for a subtle but effective result.

Layers of marks build up the density of the hair. Make brief staccato marks where the hair is short and fine, such as on the face. Show the long, fine hair on the tummy with longer marks.

The surface of the rough watercolor paper breaks up the wash and the pencil marks to enhance the sense of furriness.

Observe the eyes carefully. It is important to get their shape, position, and color right if you want to capture the character of your cat.

The striped tabby markings follow the curves of the body, so they are useful to help describe the shape of the cat and give a sense of solidity.

The watercolor pencils provide the basis for the cat's fur. Apply just a little water to add more texture to the fur, while leaving some of the pencil marks.

Always follow the direction of hair growth with your marks to help you accurately depict the fur texture.

Quick Review

By understanding the basic forms beneath the fur, the artist has faithfully captured this tabby cat.

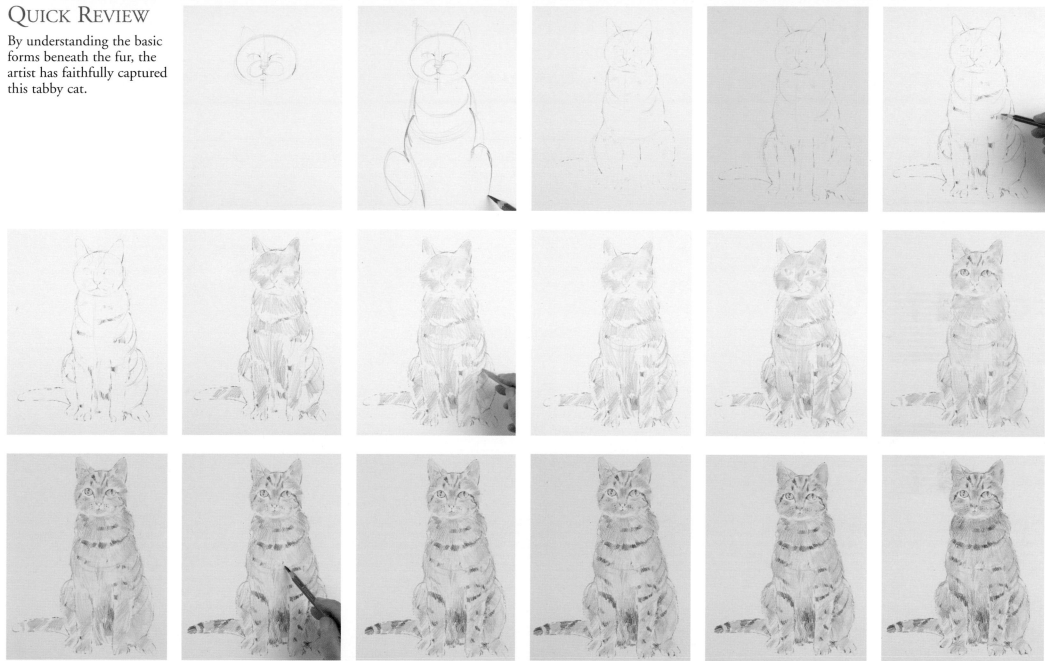

2 Jack Russell terrier
a drawing of a dog in conté crayon

A dog is an important member of the family and makes a rewarding subject. This little dog, Teasel, is a captivating creature with an exceedingly animated face and eloquent eyes. It was difficult to choose the pose that most accurately captured her lively and playful personality. Any dog you choose to draw will also have many typical poses and facial expressions, so spend time watching and recording its various moods in photographs or sketches.

◀ *Our artist took lots of photographs of Teasel and selected a few that seemed to catch her unique character. Then he made a series of sketches to see which would make the most expressive portrait. At this stage he simply tried to capture the basic shape and character of the animal—especially the head and face—without going into detail.*

Depicting fur

Animal fur can be short or long, curly or straight, fine or coarse, soft or wiry. It can be striped, spotted, brindled, or plain. Each species and breed has its own recognizable coat, and whatever animal you draw, you need to look at this and find ways to represent it convincingly.

First, though, you need to establish the basic underlying forms of the animal, and fur can obscure these. Even a thick coat gives clues to the anatomy. Notice where it changes direction, look for highlights and shadow areas, and notice the direction of growth from the nose backward along the body. These clues help you understand what's going on beneath the fur.

Look also at the animal's markings. Stripes follow the curves of the body; use them to express solidity and roundness. Notice how the quality of the fur varies on different parts of the animal's body, and find a shorthand way to suggest these varied textures. Never attempt to draw every hair, stripe, and spot or your drawing will look flat and lifeless.

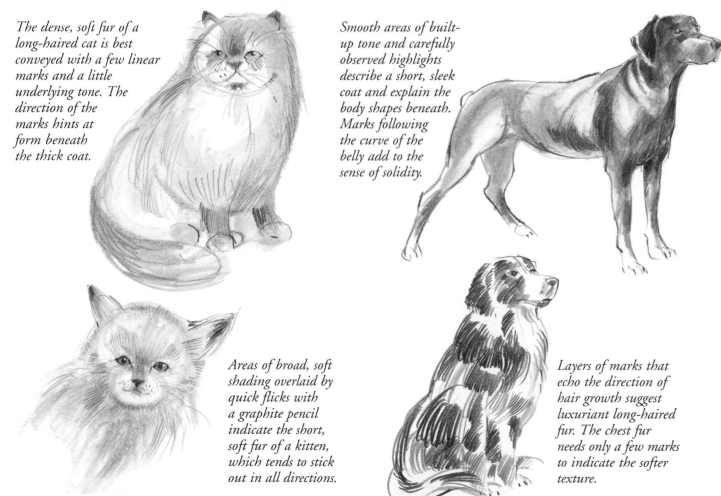

The dense, soft fur of a long-haired cat is best conveyed with a few linear marks and a little underlying tone. The direction of the marks hints at form beneath the thick coat.

Smooth areas of built-up tone and carefully observed highlights describe a short, sleek coat and explain the body shapes beneath. Marks following the curve of the belly add to the sense of solidity.

A wash of color provides a background tone for linear marks that indicate the patterned coat of a cat. The marks follow the direction of hair growth, and the patterns on the coat follow the curve of the body.

Areas of broad, soft shading overlaid by quick flicks with a graphite pencil indicate the short, soft fur of a kitten, which tends to stick out in all directions.

Layers of marks that echo the direction of hair growth suggest luxuriant long-haired fur. The chest fur needs only a few marks to indicate the softer texture.

Emphatic linear marks describe a terrier's vigorous wiry hair. For the softer, shorter hair, the marks are smudged.

You will need

- Basic equipment (see page 8)
- Sheet of light brown pastel paper
- Conté sticks: black, sanguine, white
- Spare sheet of paper or sketchbook
- Putty eraser

Artist's tip

Make sure your initial drawing is right before you use color. If everything is in the correct position, you'll have a good foundation for your portrait. If you are not happy with your drawing, do a few sketches to get to know your subject better. As you work, try to see the subject in its entirety and develop everything at the same pace. That way, you'll see the picture emerge from the page as a whole. If you concentrate too much on one part, working up that area of the drawing to a finished level, you will end up with an unbalanced final result.

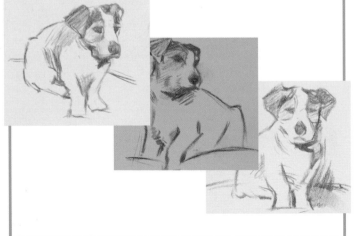

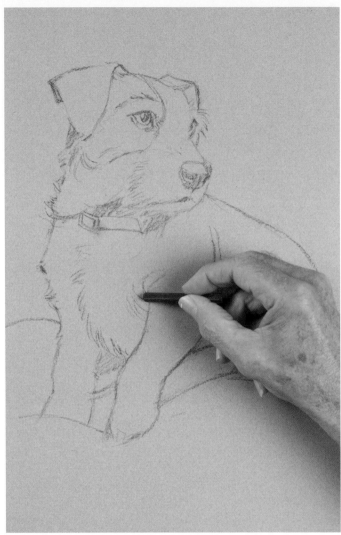

1 Use black conté to sketch the dog lightly. Remember to look for the basic shapes beneath the form—the plump cylinder of the body, the sphere of the head with the cone-shaped muzzle.

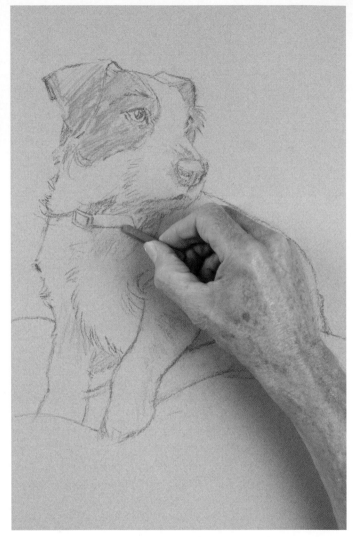

2 Use the sanguine conté to add color to the ears, face, and nose where the brown tone is strongest. Then use the same crayon more lightly on the upper chest and to stroke in a whisper of color on the front legs.

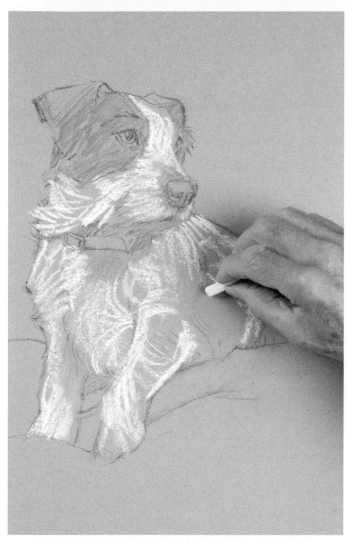

4 Use black conté for the darkest tones on the ears, where the fur is smoother. You can reflect this by creating more closely worked areas of tone. Keep marks separate to express the texture of the more wiry hair on the forehead. Blow away particles of pigment that collect on the surface of the paper as you work.

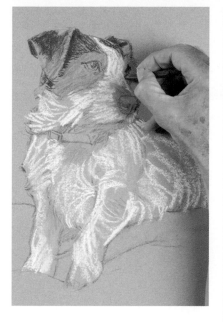

Up close

If you look closely, you'll see how the dog has a variety of fur textures on different parts of the body. The artist has used strong, linear marks where the hair is long and wiry. He's used the flat side of the stick for broader marks where the hair is short and wiry. Softer, less defined marks, smudged with the tip of a finger, suggest the fine hairs.

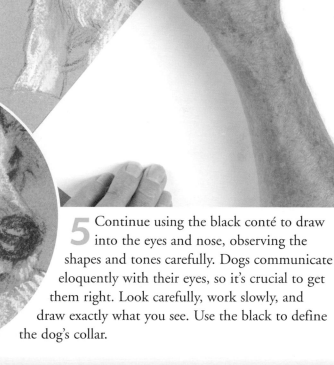

3 Add the light fur tones with white conté. Keep your marks loose, light, and open. Work in the direction of the hair growth, noticing the varied textures of the fur in different parts of the body. Smudge the marks a little in areas of fine fur on the legs and nose. Then use the flat edge of the conté stick to make broader marks on the back where the hair is short and wiry.

5 Continue using the black conté to draw into the eyes and nose, observing the shapes and tones carefully. Dogs communicate eloquently with their eyes, so it's crucial to get them right. Look carefully, work slowly, and draw exactly what you see. Use the black to define the dog's collar.

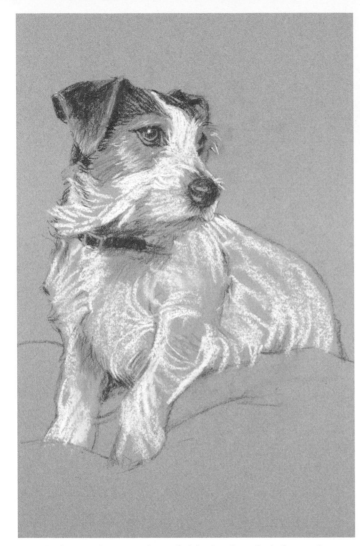

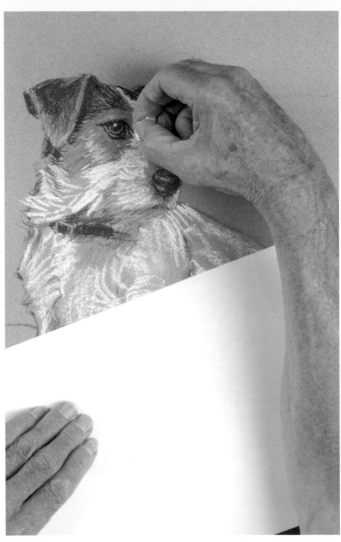

Much of this dog's fur is coarse and wiry. To describe this quality and the way the fur grows, you can try using brisk, flicking movements as you draw. Starting with firm pressure on the conté stick, flick it across the paper and then lift it up in a quick motion. The marks you make will start thick and end up thin at the tip. At this stage, you are building on the initial marks you laid down earlier to add to the texture and density of the fur.

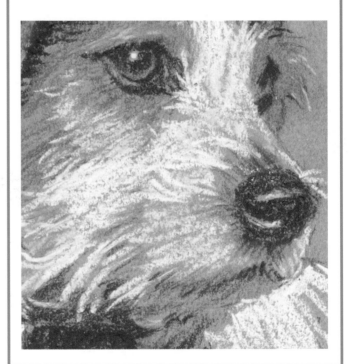

6 Indicate the mouth with black, then lightly stroke in the darker fur under the chin and on the chest and tummy. Follow the direction the hair grows with your marks. Return to the white conté to indicate the light tone on the cheek and to add highlights to the eye and the nose.

7 Now use the sanguine and black conté to adjust the color on the ears and to strengthen the tones. Stroke white onto the ear tip and then use a sharp edge of the conté to indicate the wiry hairs above the eyes and around the nose. Use sanguine and white for the hairs around the collar and add more color to the eye with sanguine.

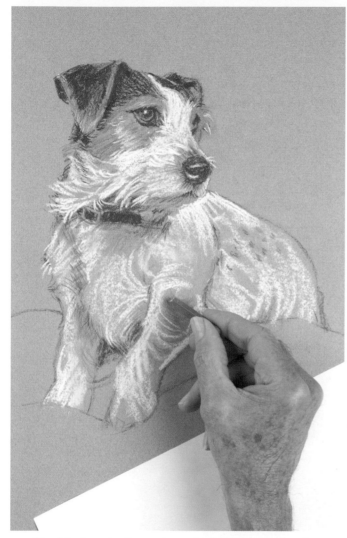

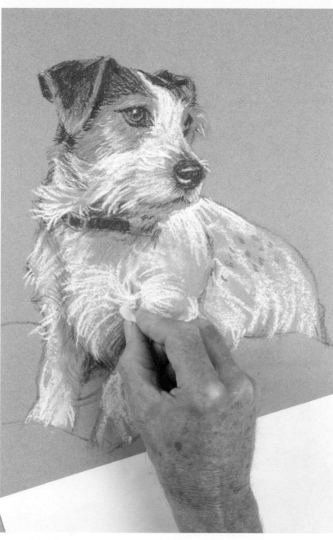

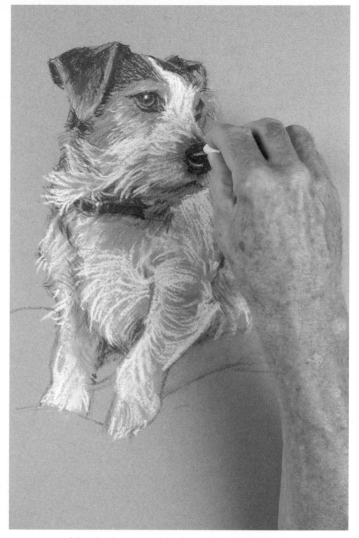

8 Use black to indicate the soft, dark fur on the chest; then suggest the brindle markings on the back. The hair is short and wiry here, so smudge the marks a little with your finger. Make soft generalized marks on the legs with sanguine to add a pale tone.

9 Continue moving around the image, working it all up to the same level. Add sanguine flicks around the nose and cheek, black flicks under the mouth, more white to the chest and legs. Fur is a natural texture, so keep the marks lively.

10 Add a little more black to the tummy. This fur is soft and short, so make less emphatic marks to describe the different texture. Now sit back and assess your drawing. You can add a few extra tweaks here and there to make adjustments, but don't overwork things.

Jack Russell terrier

finished drawing

This little dog's fur provides a wealth of opportunity for lots of energetic and expressive marks. You need to use the conté sticks in different ways to express the various fur textures on the body. She's quite a character, so the artist had to make sure he captured her pose right: the tilt of the head, the prick of the ears, as well as the expression in the eyes.

The ears are soft and silky, with no individual hairs visible, so be sure to reflect this with broad, blended marks. The angle of the ears is crucial to the dog's expression, so check that you've got them right.

Where the hair is long and wiry use quick, clearly defined marks. Again, work in the direction that the hair grows, starting at the base and flicking outward with the conté stick.

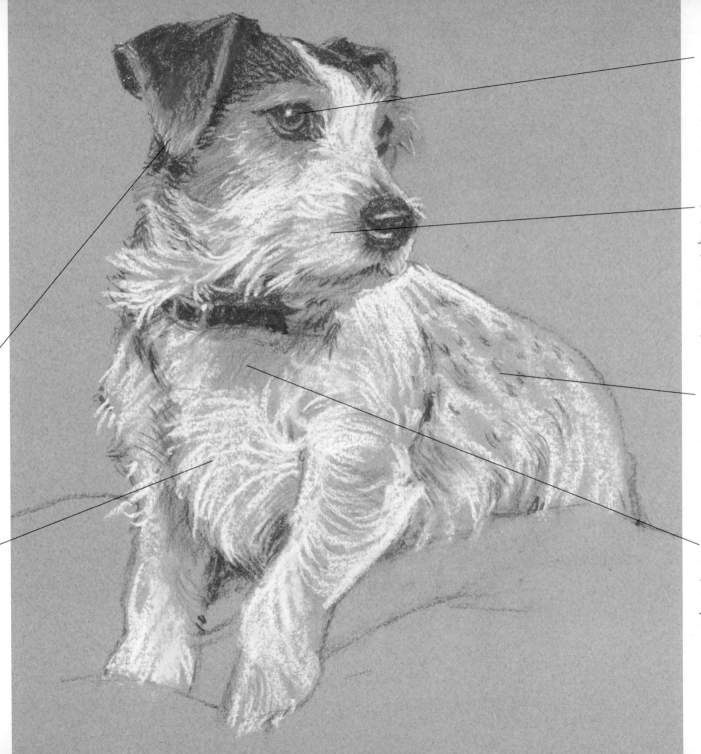

The eyes have a liquid expressive quality that needs to be captured. Look carefully, get the shape and position right, then add the color and the highlight.

Short flicks with the chalk indicate the bristly fur around the muzzle. Make sure your marks imitate the direction that the hair grows. Contrast this with smoothly blended marks for the shiny nose.

Use the flat side of the conté stick and smudge the marks a little for the short wiry hair on the dog's back. Don't try to draw the individual hairs.

On the chest the hair is soft and long. Make more generalized marks and smudge them with your finger to indicate the different texture.

QUICK REVIEW

A review of this dog portrait shows how the artist began with a strong underdrawing, taking care to get the pose and features right before laying on any color. He then used just three different-colored conté sticks to express the texture of the fur.

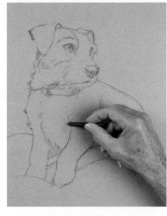
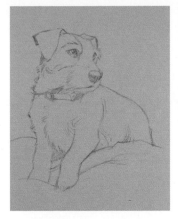
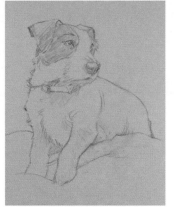
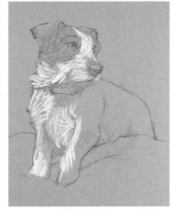
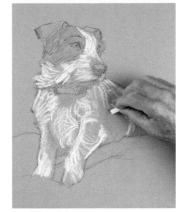

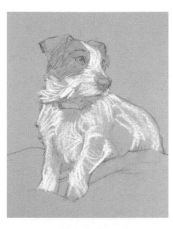
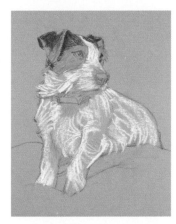
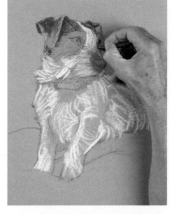
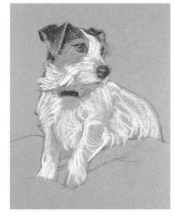
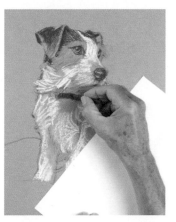
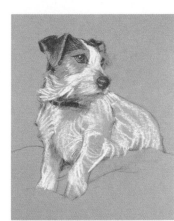

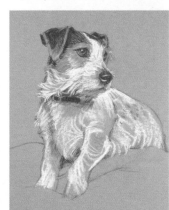
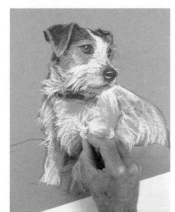
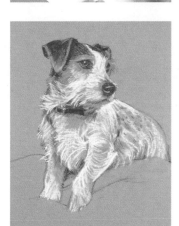
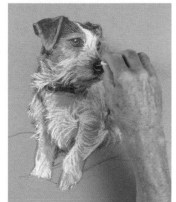

3 Ducks on the pond

a wildlife study in colored pencil

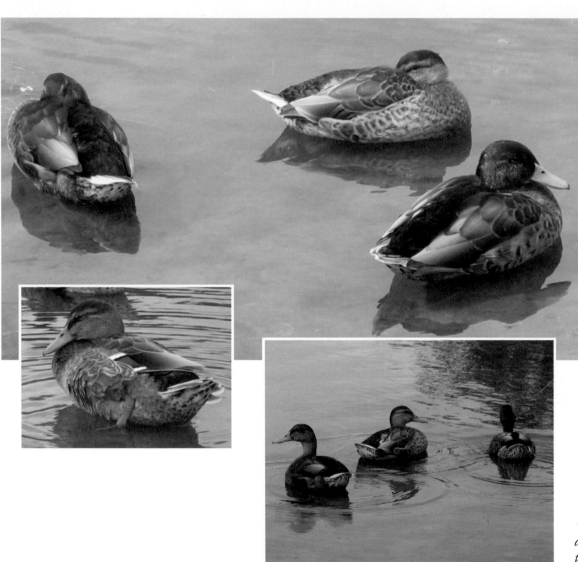

Ducks can be very peaceful to watch, and even a plain brown duck has beautiful feather markings and textures—sometimes with surprising and unexpected splashes of intense color. However, like most birds, they seldom oblige an artist by posing for a pleasing group portrait, so you need to find some way to record them that will allow you to make a finished drawing at your leisure.

Many artists use a combination of photographs and sketches to create a final drawing. This isn't cheating! Making quick sketches on the spot trains your powers of observation, while photographs give you a chance to study your subject at your convenience.

◀ *For the finished drawing, the artist has taken ducks from different photographs and combined them in a pleasing composition.*

Depicting plumage

It's not just exotic birds that have beautiful plumage. Even common species in your own backyard have intriguing feathers in many subtle colors. It is important, however, to describe the plumage simply and expressively; drawing in every little detail can produce a dull end result.

Feathers are never a uniform size, shape, and texture all over the body. They vary from the large strong wing and tail feathers that aid flight to the finest down on the chest. They lie in orderly groups and patterns that are often defined by changes in color and marking and indicate the form beneath.

Remember you're not making a scientifically accurate ornithological study. Don't try to draw every feather. Use varied marks to suggest the different textures, indicate a few individual feathers, and let the mind read the rest by the hints you've given.

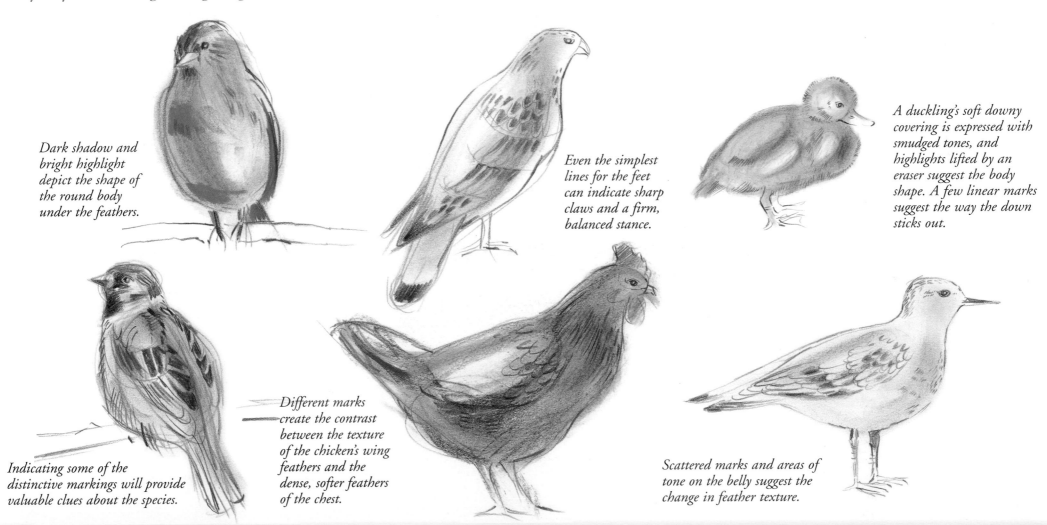

Dark shadow and bright highlight depict the shape of the round body under the feathers.

Even the simplest lines for the feet can indicate sharp claws and a firm, balanced stance.

A duckling's soft downy covering is expressed with smudged tones, and highlights lifted by an eraser suggest the body shape. A few linear marks suggest the way the down sticks out.

Indicating some of the distinctive markings will provide valuable clues about the species.

Different marks create the contrast between the texture of the chicken's wing feathers and the dense, softer feathers of the chest.

Scattered marks and areas of tone on the belly suggest the change in feather texture.

You will need

- Basic equipment (see page 8)
- Pearl gray cold-pressed watercolor paper
- 7B pencil
- Colored pencils: raw umber, sepia, Naples yellow, lemon yellow, orange, leaf green, olive green, jade green, mineral green, ultramarine blue, light violet, dove gray (see page 70 for advice on choosing and using colored pencils)
- Putty eraser

1 When you have selected the birds you want to feature in your drawing, do some quick sketches to help you find the best grouping for a pleasing and balanced composition. Making small thumbnail-size sketches is fine.

Often an odd number works better than an even one, and here the three ducks form a triangle that leads the eye effortlessly from bird to bird. Notice how the direction each duck faces helps lead the eye as well.

2 Use the 7B pencil to plot the positions, shapes, and relative proportions of the birds, following the composition created in your sketches. Work very lightly so you can erase and adjust things. Remember the underlying forms and use these to help you convey the solidity and roundness of the ducks.

3 Refine the shapes and add a little more detail. Position the eyes carefully; these crucial features need to be in the right place. Begin to indicate the feather groupings and keep feeling for the roundness of the forms. There are lots of nice curves and ovals—no straight lines or sharp edges anywhere. Even the ripples in the water add rhythm to the scene.

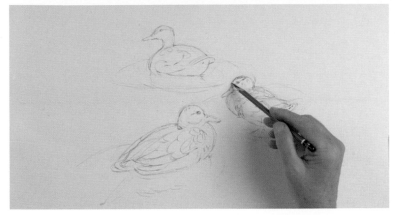

4 Add some more feather details—the way they lie follows the curve of the body, so use them to indicate the shape and volume of the forms beneath. Refine and firm up some of your lines. Notice the colors and familiarize yourself with what's there for when you start to use the colored pencils.

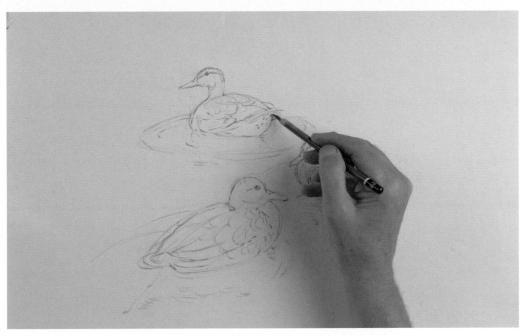

5 Look at the reflections in the water and the way the ripples break them up, and indicate these. Their interesting curved shapes echo the roundness of the ducks and add background interest. Check that everything is now in the correct place.

6 Now look for the mid-tone feather areas and use raw umber to add these. They create echoes that carry the eye around the picture and help to unify things. Use a light pressure on the pencil so your marks aren't too emphatic—you can always deepen the color later. Use the same color to hint at the reflections. Now you have a base tone to build upon.

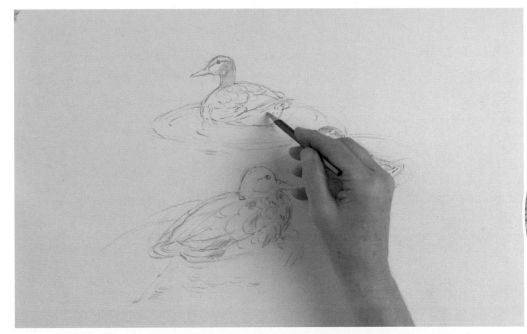

Up close
When you start to use the colored pencils, let the pale gray of the paper stand for the lightest feather tones. This way, you can work from light to dark, building up the mid- and dark tones and reserving the paper tone for the brightest areas.

7 The head of the drake is a wonderfully intense color. Use jade green for a base color and then tone it down a little with forest green, ultramarine, and a light whisper of black with the 7B pencil. Then add dove gray and a touch of Naples yellow for the lighter feathers on the wing area, and sepia for the darkest plumage.

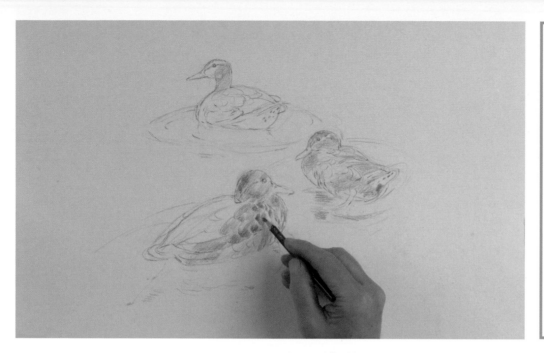

Artist's tip
The plumage on the head is so smooth that the individual feathers are not visible, so use your pencils in a way that echoes this. Look for the highlighted area to help convey the satiny quality, and make softly shaded marks in the direction the feathers lie. Add further colors in the same way to adjust and deepen the tone.

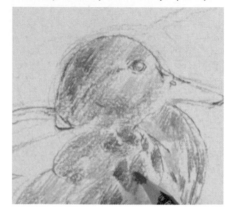

Up close
The way that a bird's feathers lie gives a clue to the shape of its body beneath. The artist has indicated the direction the feathers grow in this drawing in order to give a convincing sense of form and volume.

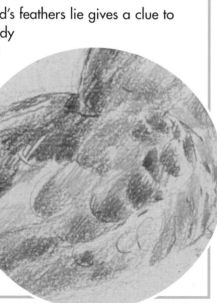

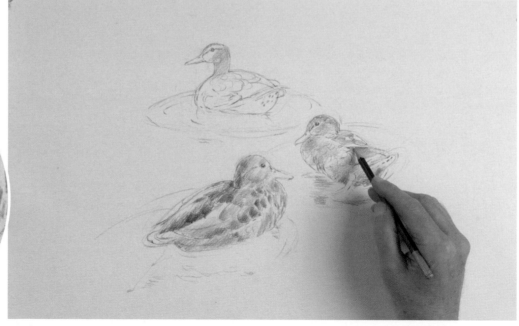

8 Continue using your sepia pencil for the darkest feathers on the drake's back, using your marks to follow the direction that the feathers lie. Then move on to the second duck and begin to plot the main areas of color. Use dove gray, Naples yellow, and sepia as before and notice the violet flash on the wing. Use light, open marks to help create a sense of texture in the plumage.

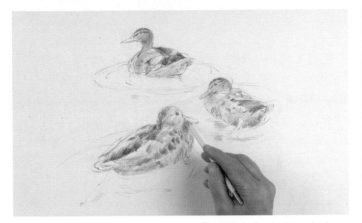

9 Now turn your attention to the third duck. Use light violet with a touch of Naples yellow for the lighter areas on the head, then darken the top of the head and the back with sepia. Then use the 7B pencil to intensify the areas on the back that are almost black. Use lemon yellow for all the ducks' beaks.

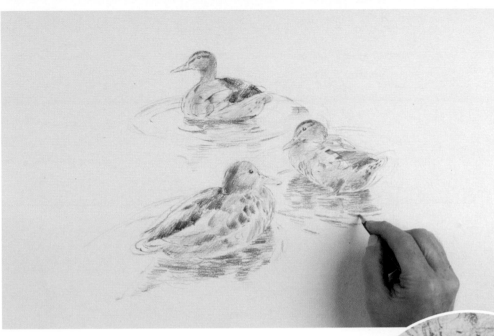

10 Use the orange pencil to draw in the second duck's leg and to indicate the reflection in the water. Work on the reflections using loose marks that follow the ripples. Use olive green for the water, then add raw umber with touches of Naples yellow and leaf green. Use less emphasis for the ripples beneath the far duck.

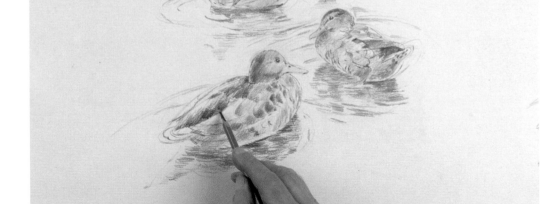

11 Pick out some of the darkest areas on the water beneath the ducks with your 7B pencil and sharpen up the ripples. Add the beady eyes of the ducks, leaving the color of the paper for the bright highlights. Add finishing touches by emphasizing some of your earlier lines.

Up close
The ripples create gentle curves that give a sense of movement to the picture. To break up the reflections, the artist has used soft, open marks that suggest the way the surface of the water is disturbed as the ducks paddle. He worked lightly into the farthest ripples to create a feeling of distance.

Ducks on the pond

finished drawing

The way feathers lie indicates the shape of the form beneath, so make sure you observe the direction of growth carefully in your drawing. And don't attempt to draw every feather. Notice the different feather textures on wing, chest, and head. You will need a variety of marks to express these.

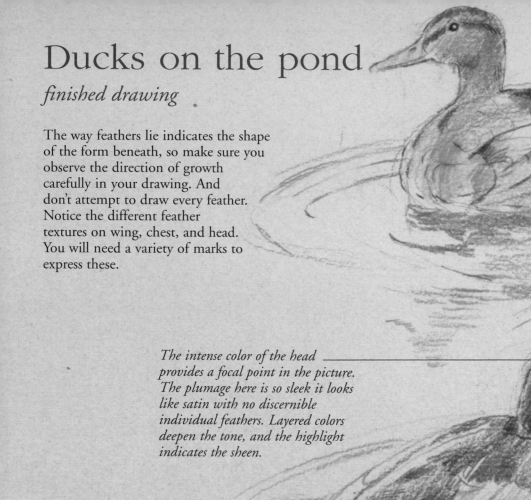

The position of the beady eyes is important. Look carefully and get it right to make the ducks convincing.

Indicate a few of the strong wing feathers, and look carefully at the markings on the plumage. This duck has a purple flash on his wing, and his orange leg is another splash of strong color that helps lead the eye around the picture.

The intense color of the head provides a focal point in the picture. The plumage here is so sleek it looks like satin with no discernible individual feathers. Layered colors deepen the tone, and the highlight indicates the sheen.

The watercolor paper adds a slight surface interest to the drawing but doesn't break up the color too much. It adds to the watery feel of the ripples and helps imply the texture of the feathers.

You can see clearly how the feathers follow the rounded shape of the body beneath. Draw them exactly as they lie to convey a sense of solidity and form.

The chest feathers are smooth and downy, so make softer, more generalized marks for these, even smudging them a little.

The ripples break the reflections into curves that echo the shape of the ducks. Include just enough to convey a sense of water.

QUICK REVIEW

The artist chose a watercolor paper that adds to the surface texture of the drawing but doesn't break up the colors too much. He kept his marks light and sketchy to give the final drawing a feeling of immediacy, as if it were drawn from life rather than a photograph.

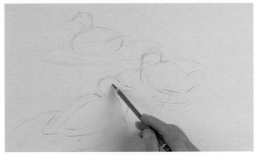

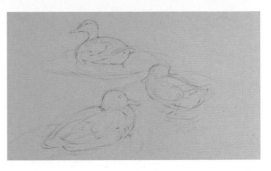

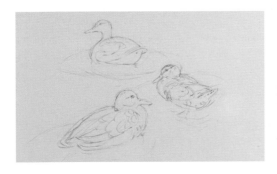

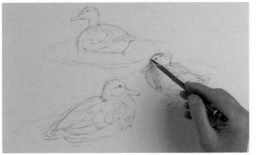

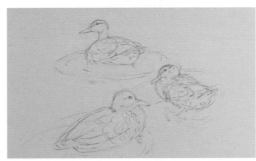

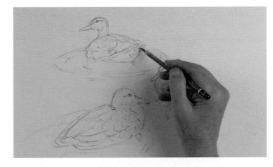

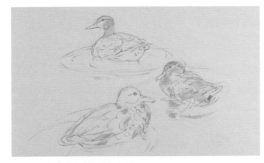

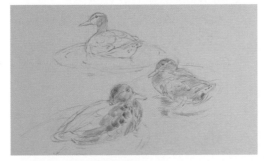

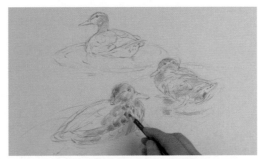

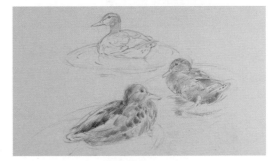

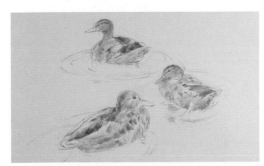

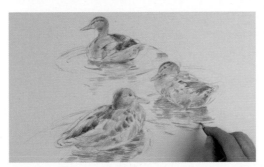

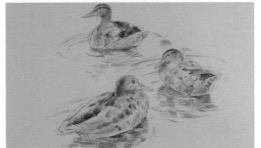

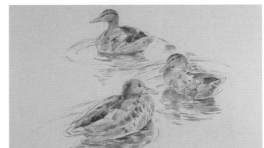

Developing your skills

Practicing your drawing

The only way to develop your drawing skills is to practice, practice, practice. Be consistent—like a runner training for a marathon, you need to limber up every day if possible, and if you neglect your training for a few weeks, you'll have to make up the ground you've lost and build up your confidence again.

KEEP LEARNING

Each time you put pencil to paper you'll learn something new, surprise yourself with a new mark that you haven't made before, uncover something you didn't know the pencil could do, or discover a way to describe something in a clever shorthand you've not tried before. Go

back to some of the projects in this book and read through the steps. You won't have absorbed everything the first time around, so you can practice using some of the techniques and mediums again.

USE A SKETCHBOOK

Of course you can use any paper that comes to hand, but loose scraps of paper will get lost. A sketchbook keeps your work conveniently together for future reference. Remember, your sketchbook doesn't have to be filled with perfectly finished drawings. It's your private practice book, so use it to develop both your drawing skills and your powers of observation. And use it simply to make marks and build up a library of the different effects that your drawing mediums can achieve.

Take it with you wherever you go. A small sketchbook and a couple of pencils make a discreet sketching kit. And guess what—the more you practice, the less self-conscious you'll be about drawing in public!

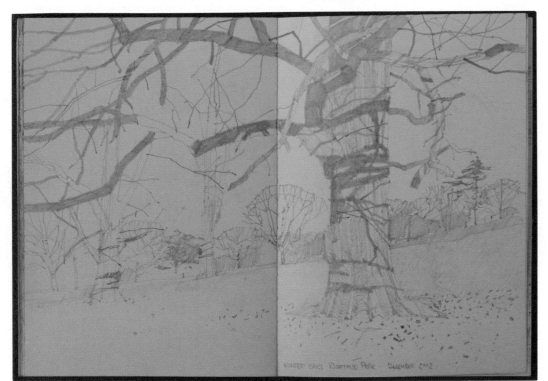

Sketchbooks in practice

All successful artists use every opportunity to observe and record absolutely anything that interests them. Here are a few pages from the sketchbooks of artists who worked on the projects in this book to inspire you to do the same. Draw whatever takes your eye. Making sketches will improve your drawing skills, but they are also a good way to make notes for future drawings. You never know when your quick visual notes might provide just the right sky, exactly the pose or the perfect building to include in a finished drawing. And a sketchbook is a lot more personal and unique than a photograph album.

The artist who did our duck drawing spent time in his local park observing and sketching ducks to collect the information he needed for his final picture.

Birds seldom remain still, so he only had a few seconds for each drawing, with no time for detail. And, of course, they didn't remain in nice groups for long. Instead he went for the basic shapes and characters of individual ducks, and just hinted at the feathers with a few expressive marks.

Later in the studio he chose three of the birds to group together in his final composition.

Making your own sketchbook

A store-bought sketchbook can be very expensive, so much so that it can take considerable courage to make the first mark in it! However, if you make your own, you'll not only save money but you can make it exactly the way you want it.

Most sketchbooks contain just one type of paper, often plain white with a smooth texture. If you make your own, you can customize it to contain a selection of your favorite papers. Buy large sheets to cut to the size you want. A few large sheets are enough to make several sketchbooks. An even less expensive option is to use leftover pieces of paper that you've trimmed from other drawings. You can include rough and smooth papers, colored, white, or handmade papers. Even brown wrapping paper makes a good background for most mediums.

HOW TO MAKE THE SKETCHBOOK

You'll need strong cardboard for the back and front covers of the sketchbook, paper for the pages, and a shoelace for tying it all together. The tools required are a craft knife, a ruler, a pencil, and a hole punch.

1 First, decide what page size you want in your sketchbook. A landscape shape, a long horizontal rectangle, is probably the most versatile shape for your initial sketchbook. Use the ruler and pencil to mark the page shape on your paper. Cut the pages out with the craft knife.

2 Then cut two pieces of cardboard about ¼ in. (3 mm) larger all around than the finished page size. Punch two holes about ⅜ in. (5 mm) from the left-hand edge of each piece. Make corresponding pairs of holes in each sheet of paper.

3 Place the sheets of paper between the cardboard covers so all the holes match, thread the shoelace through the holes and tie at the front. Do not tie the book together too tightly; you should be able to open the pages so that they turn easily and can be opened flat.

4 For an added touch of class you can cover the cardboard with fabric before you punch the holes.

Index

Acknowledgments

ARTISTS FOR STEP-BY-STEP PROJECTS:

Household objects (pages 27–35): Albany Wiseman

Fruit (pages 36–45): Ian Sidaway

Kitchen objects (pages 46–54): Valerie Wiffen

Winter tree (pages 60–68): Ian Sidaway

Four roses (pages 69–77): Janet Whittle

Summer display (pages 78–85): Valerie Wiffen

Mountain scene (pages 91–101): Terry Longhurst

Avenue of trees (pages 102–109): Albany Wiseman

Victorian house (pages 110–118): Albany Wiseman

Baby in overalls (pages 127–134): Albany Wiseman

Portrait of a girl (pages 135–143): Valerie Wiffen

Seated pose (pages 144–152): Valerie Wiffen

Tabby cat (pages 161–169): Albany Wiseman

Jack Russell terrier (pages 170–177): Terry Longhurst

Ducks on the pond (pages 178–185): Albany Wiseman

INSTRUCTIONAL ARTWORK:

Ian Sidaway pages 9–19, 24–25, 29, 38, 48, 61–62, 70–71, 79–80, 88–89, 92, 103–104, 111–112, 128, 162.

Albany Wiseman pages 57–59, 121–126, 136–137, 145–146, 155–159, 171, 179.

Sketchbooks kindly lent by Ian Sidaway and Albany Wiseman.

PHOTOGRAPHY

All original photography for this book is by Andrew Sydenham except for the Four roses project photographed by David Marsden.

PICTURE CREDITS for photographs used as artist's reference:

Winter tree (page 60) Ian Sidaway; Roses (page 69) Janet Whittle; Mountain scene (page 91) Corbis; Avenue of trees (pages 102 and 104) Garden Collection; Victorian House (page 110) Michelle Garrett; Baby in overalls (page 127) Warren Photographic; Tabby cat (page 161) Warren Photographic; Ducks on pond (page 178) Jessie Coulson.